*Eternal
current
events*

CHRIS MARKER

Eternal current events

early writings

selected & translated by Jackson B. Smith
MERCURIAL EDITIONS

Published by Mercurial Editions
An imprint of Inpatient Press
New York City, 2024

Time is only wounded. It does not stop.

THE DEVIANT MUSICIAN. Master Cortot,

March 1947

perched upon a family tree, held a piece of cheese in his beak: the regency of Music, a part of the Family, in Vichy. In this respect, he made a few enemies out of the musicians that were ousted under his care, that still had a bone to pizzicato with him. Whence a temporary ban on public appearances after the Liberation. The time having come, here he is announcing concerts. But no matter: the musicians heckle him, and every city in which he announces his arrival makes him turn back and leave. An odd performance for a pianist, everyone sending him on his way, as in a game of puff billiards. Since he is legally proven innocent, and furthermore, an audience eager to see him again even contests the time that he was banned, only one observation is essential: that on both sides, we agree to regard the Law as invalid, and official decisions as a joke. It is perhaps in this limited, but secure field that research into the founding principles of French Unity should be carried out.

June 1947

POLES. Because, in our minds, the "around-the-world trip" pretty much always occurred parallel to the Equator, because the two tropics seemed to us like the normal boundaries of the crosswalk that allows us to traverse the Earth, because the Earth itself stays standing up like a big kid, and that in order to study it more closely our classes gave us a flat and deformed image, we didn't imagine that one day the shortest paths could go over the North Pole, nor that in order to have a clear vision of a given geographical conjuncture, it was suitable to look at our globe from above. It was therefore necessary for American journals to disillusion us, demonstrating with excellent sketches that distances (as the bomb flies most realistically between the United States and the U.S.S.R.) are drawn from one edge of the Arctic Ocean to the other and that what they call the Musk Ox drill (whose theme, as you remember, was "an attack from the North") unsettles the map of great invasions. Let's dream about this for a bit: is it possible for the world to change its perspective, for future planispheres to make the great enemy nations form a whole in their true connections, while it's our turn, in old Europe, to be

spread out in the corners just as Greenland and Siberia are right now? Is it possible that the role of the path, of the crossroads, of the crater of a civilization that the old world had attributed to the Mediterranean, is now to be taken on by the North Pole? After the warm melting pot that joined the Christians and Islam, might the new era show Marxism and capitalism coming face to face over sterile and icy regions? Let's admit that this would be quite a fitting symbol.

August 1947 *NEWS BRIEF. On Friday July 4, 1947 every newspaper published a summary report on the cowl conspiracy (which—when one adds it to the cassock conspiracy, and the sandal conspiracy that came just before it—succeeds in drawing on our horizon the well-known silhouette of the Confidants of the Holy Office). Each defendant was the object of a short paragraph in which his present situation was exhibited and commented upon with precision in its documentation and objectivity in its conclusions, qualities for which the French press is so deservedly praised.*

And so, here is what they've come up with regarding Max Vignon:

FRANC-TIREUR. — "It has been established that the journalist Max Vignon, apprehended yesterday, has no links to the clandestine newspaper *Le Réseau*. The police realized that they had in fact mistaken one Vignon for another. That other is Pascal Vignon, ex-militiaman, leader at *Le Réseau*. He is the one they have been looking for. As for Max—a Resistance fighter beginning in September '40 as part of the Georges-France network, the ex-political director of *XXᵉ siècle*, and founder of a clandestine newspaper under the occupation—he was swiftly released by the judge."

L'HUMANITÉ. — "The intelligence service of the French police interrogated Max Vignon. And the former collaborator from Radio-Paris had the audacity to flaunt a certificate of 'resistance' signed by Lieutenant-Colonel Josset

from the information service of the Free French Forces. Decidedly, some high-ranking officers in de Gaulle's circle will do whatever it takes to save their friends who are caught up in the Cowl conspiracy...The fact remains that the examining magistrate, Lévy, did not waver before granting him temporary release. Did he not, however, recently promise that the cowlers would be punished?"

L'ÉPOQUE. — "After his hearing with Mr. Robert Lévy, the examining magistrate, Max Vignon, the former political director of *XXᵉ siècle*, was set free. 'I have,' he said 'no declarations to make, on account of the secret nature of the inquiry. I can nevertheless specify that a meticulous investigation established that another individual made use of my name as part of a criminal affair.'"

As our great comrade Pascal said, all men's misery comes from not being able to stick with one newspaper.

January 1951 CROSS MY HEART AND HOP A TRAIN. In Plön (Schleswig-Holstein), I board the train for Kiel. There's the Baltic rain that contains a touch of lavender, as everyone knows, and just enough melancholia to turn your soul belligerent. *Die Haare, die Haare, sind grau von Baltikum...*There he is, in my compartment: the belligerent. He's the conductor. He belongs to the generation—basically impossible to find in Germany today—of people who were twenty years old in 1940. Apart from that, short, very light eyes, very pink complexion, his *Deutsche Reischsbahn* visor bent like a mountain trooper's cap—and that inimitable look of a military brat—he's shamefully conventional. Once he's picked up on my accent, he sits down across from me, offers me a cigarette and declares: "I'm not familiar with France."

It's a shame, but this made me rather happy. I had already resigned myself to suffering through the story of his garrisons in Bayonne or in Deauville—the thirtieth one since the start of my trip. To think that they believe it makes us happy to hear

about home. Like this one guy, in Lübeck: "I arrived in Paris in July '44, but we had to head out immediately"—then, taking me as his witness: "What bad luck!"

He's not familiar with France, but just barely so: Belgium, Holland, Italy, Greece, Ukraine, he did all that, between '40 and '45. Recruited in '38, held prisoner for one year—in total, eight years of war. Add his parents, buried beneath the fragments of their house, his province made inaccessible, unemployed for two years, impossible for him to go back to school, now the railroad. An ideal recruit for the Stockholm Appeal. But I don't need to talk to him about that. Without any transition, he gets to the heart of the matter: "The Russian," he says (in Germany, they say *the* Americans, like we say *the* mosquitoes, and *the* Russian—*der Russe, der Ivan*—like the thunder; in Germany, everything that counts, even when it comes to fear, must be abstract), "The Russian, in the Eastern Zone, is reducing us to slavery. He's making an attempt on the dignity of man..." Five minutes follow, devoted to a list of the Russian's wrongdoings, "and we're strictly opposed to that!"

With that, the train arrives at the station. The conductor hurries onto the platform and starts roaring names of stations in the tone of Wotan's Farewell, leaving me just enough time to reflect on how former members of the Wehrmacht are strictly opposed to the degradation of man—and presto!—he's already back in his seat. "For that matter," he says, "Eisenhower's a moron."

Well, there's someone who's not kind to his future commander-in-chief. I ask him for clarifications. He provides them: "In 1945, the Americans were strong, the army of West Germany was almost unharmed; we should've jumped on the Russians right away. Eisenhower missed his chance, and now it's too late."

Try as you might, these kinds of declarations always make your jaw drop. "In 1945," I patiently say, "the Americans were at war with you. And I don't think that the GIs who had just discovered the concentration camps would have easily tolerated you as allies. It took five years for them to forget that."

"*Ach*, always with the concentration camps," he moans.

"You have to look at both sides of the story—*wir müssen objectiv sein*. Now you're the occupying forces, you have to understand. If I was part of a resistance movement against the occupying authorities, you would put me in a concentration camp, you're compelled to."

"As for *me*, I don't believe that I would put you in a concentration camp," I say.

"Well, you have prisons in France. It's the same thing…"

"It's not the same thing. Where I come from, the abasement of man is not an industry…"

"…and anyhow, now we have to be friends again, we must forget all of that."

"We must not forget anything at all. My best friend died in a concentration camp, and now for five years I've been educating the working-class of Germany—because I have no hatred for the German people. But it's actually by forgetting nothing, by remembering the concentration camps together, that we will perhaps manage to work together toward a world without concentration camps. I'm not asking you to forget the bombings…" (And I'm thinking about the two-part bombing of Mainz: a first, incendiary wave—then, one hour later, houses burning, people out in the streets, the rescue parties at work, a second wave…)

He then makes that gesture of erasure that only Germans know how to make, moving his forearm in front of his face like a windshield wiper—a magical gesture, an exorcism that makes it so that the rejected thing ceases to be, truly ceases to be, to have ever been—a gesture that makes clear the meaning of "we must forget all of that." The same gesture in 1945, and five years of war in the West were erased; the guy was ready to fight the Russians alongside this morning's enemies, with no ulterior motive. "The houses, the dead…" he says, and then erases. "But the soul, there's the soul…We must defend Christian Europe."

I swear that I'm not making this up. All of this happened at once: regretting that there was no war against the Russians; defending the concentration camps and Christian Europe. While the train rolls slowly through the fog on a morning similar to every wartime morning—with the same noise, the same

frost on the windows, and Anglo-Norwegian soldiers wandering the aisles to put the finishing touches on the memory—I try to respond to him, which, after an all-nighter, faced with such confusion, and while speaking German, is a feat in itself. I speak to him about the dangers of easing one's conscience, of our responsibility for the world, of the illusion of putting out a fire with a fire that's worse than war and, cautiously (the Russian is only a few kilometers away), of the need for revolution. He listens to me in earnest. "The Americans really can build a wall against the Russians, and that wall will be built over our bodies." "Communism is built from all the transgressions of Christians"; he likes these expressions, he agrees. But I don't have the ambition to change the *Weltanschauung* of a *Deutsche Reichsbahn* conductor between Plön and Kiel. And when, quite genially, we part ways on the platform, I still wonder the extent to which he might carry, buried beneath all of his well-meaning contradictory reasons, a nostalgia for conquest.

I'll see many more of them before returning home: bespectacled professors straight out of *The Blue Angel*, students endowed with the insatiable curiosity of the *Elephant's Child*, giants pale as ghosts that will buoyantly shake my hand because if all men were brothers, the world would be a better place, burly men with womanly passions that cry with joy upon hearing about the Schuman Plan and have a seizure when someone speaks about Mao Zedong—turned to pacifists out of weariness, warmongers by intuition, confusionists since birth—bursting with knowledge and devoid of culture—they're big babies that you must not frighten, as well as simple minds that you must not lead astray and, to boot, negroes that you must not offend—complacent, polite, haunted, sensitive, animated, irritating, disarming—if I dare say...

THE DOG AND THE BREAD. For some time
June 1947
now, I've noticed that Oxyde—the loving dog, pride and joy of my home—has been obstinately refusing to eat even the tiniest scrap of bread. Demonstrating my breed's charming selfishness, I was hardly worried about this at all until

an inadvertent reminder taught me that Oxyde the dog had lost all interest in bread the same day that it underwent a number of modifications required by the government. It never ceases to impress me. Oxyde doesn't read the newspapers, never goes out: the observation could therefore have only come from him. So then, what gets added to this bread, Lord, that disgusts a moderately sophisticated animal to such a degree? Every day, I attempt the same experiment, my heart racing. His refusal is persistent. The neighbors have taken an interest. Bets have been placed. How clever of the government, to give us our bread and our games, all at the same time, in the same form, and, like the dark sorcerer, make us eat our riddles...

February 1957 IMPORTED FROM AMERICA. When, in the darkness of a New York movie theater, our Don Juan of Brooklyn brushed against a velvety fur smelling of musk, immediately he imagined the tender creature who had been luxuriously dressed by a businessman and who would bring him, with just a glance, peace of heart and the gratification of being taken care of. And without further ado, his hand—well-groomed toward the fingers that extensive experience fated to be adorned with gems and dressed with blood—drifted. What a great surprise it was therefore to encounter, at the end of the splendid fur, a hooked claw, albeit a trimmed one, couched in the bristle like a steel trap. And when his gaze, accustomed to the darkness, discovered that, where he was expecting a half-veil and mascara, was the snout of a very handsome bear, on the double Don Juan was on his way to Management to put up a fight against the admission of plantigrade animals into the movie theaters of Broadway. On came Management, cautiously, to the bear's other neighbor and said to him: "Sir, would this happen to be your bear?" —"Why of course it is," responded the man. —"How is it," Management answered back, "that you find it reasonable to bring a bear to see a film?" —"Perhaps I was wrong," the man admitted in a sheepish tone, "but you know, he liked the novel so much..."

March 1947

THE THREE LITTLE PIGS. That's what I would refer to them as if I were the Big Bad Wolf. Who? Hold on—perhaps, when you think of the Spanish Civil War, you have three titles that come to mind as the most beautiful expressions of this tragic event: "For Whom the Bell Tolls," "Man's Hope," and "Spanish Testament." I'll stop you right there. All you have do to understand that Hemingway is "not a lefty" is read "For Whom the Bell Tolls"? I'm not the one who's saying it—it's somebody who's way more "in the party line." And did you know that Koestler, just before being arrested by the Francoists, said that he had nothing to fear? (Courtade, in Action*). Suspicious, isn't it? As for Malraux, it would be in poor taste to belabor the point. All the same, it's a shame, when you think about it, that the heroic history of the proletariat (the text from a prewar ad in* Europe *for "The Time of Contempt") was written by fascists.*

The Living and the Dead

by Chris Mayor

*...For unto the angels hath he not
put in subjection the world to come...*
Heb. 11:5.

I<small>N THE CAR</small>, gleaming and buzzing like an insect, the driver puttered along. Once he had stopped beside the garden and the traveler had handsomely rewarded him, he waited till the sun was lower before heading back out into a city of coral. This pause allowed the traveler to retrace his steps. His wide-brimmed white hat and his loose-fitting coat glimmered with silver. He came to the car, opened the door, picked up from the seat a strange, perfectly round, flimsy, luminous thing that floated for a moment above his head before he pulled down his hat and was on his way, slightly hunched with an imperious gait. It is only then that the driver recognized the archangel Gabriel.

Gabriel was hurrying on his way through the twilight's deserted gardens. High winds from lost lands in the East were already bringing along the smells and sights of next winter. The sun was breaking apart, and its splinters of frosted glass, picked up by the grey of the river, were creating a gloomy leadlight beneath the bridges' pointed arches. The city was feebly folding away its trees into the avenues. Gripped with fear at

the approach of the icy season's silent giants, it was lighting up an untidy and flickering constellation of fires and warning lamps. The sky, straight like the brow of a sick child, was showing a feverish pinkness. Gabriel was listening absent-mindedly to the city groan and quiver like somebody sleeping, and to the steady rhythm of its powerful beating: the steps of men-at-arms in distant streets. The enemy army did not enter into these royal gardens, populated with sad statues. The cold world of haze and metal that the army was carrying around, amid its bright smudges and flags, came to a halt at the borders of this dead power. The soldiers themselves would withdraw before the intense suffering of its stone sentinels who remembered having been men. Farther off, among rearing horses, was the entrance into a radiant plaza where, like a dagger's handle, stood a boundary of mysteries—then the triumphant avenue filled with flickering images—then, at the other end, the arch, distinct and unmoving, a hefty magnet attracting the starry filings of houses and fog. The noises were slowly deadening, a retreating sea, leaving an interlacing of deserted streets behind it like seaweed. And Gabriel was thinking about this nocturnal population that was waiting for the tide.

Someone appeared among the trees. Gabriel recognized the boy who had asked him for this strange meeting and took a few steps forward to meet him. He was struck by the harshness of the boy's gaze. The warriors in whose faces he had seen a cold harshness did not have these rich, luminous shadows under their eyes, these secret depths of a forbidden realm.

—I made you wait, he said. And with the same level tone: My name is Vincent.

— You are right, said Gabriel.

— I apologize for this meeting. Later, we'll go to my place... but I couldn't really wait for you there. This...this is not a place for angels. You...He hesitated and then quickly said: you don't believe. And then...

— You were looking for someplace free, Gabriel finished.

Vincent blushed: Free, you think so too? It's such an extraordinary place. They don't come here. His gaze grew even harsher. Don't think for a second that I'm afraid...of them.

Only, it's like speaking about demons: you have to choose a place that they've deserted. It doesn't make you angry that I'm speaking about demons?

—I know many of them, Gabriel earnestly replied.

—Of course...Vincent looked at him strangely...Do you also know about Hell?

—No. That is perhaps the only point on which you are more...advanced than us. Hell is separation. We are never separated.

—He...Vincent started to laugh. I was going to say something dumb...I was going to say that you're lacking something.

—It is true, Gabriel said, we are lacking reconciliation.

The sun crackled on the tops of the hills. Suddenly, the shadows stretched out until they blended into the fog. And these ever-darker tints were prologues to the night.

—But I need your help, Vincent added after a pause.

—That is why I came, said Gabriel.

—Thank you, said Vincent. His ideas spun around like a lighthouse. He turned to face Gabriel. They can't be left to destroy this city.

—In any case, they have mined it.

—In the literal sense?

—You mean, in the ground? In the ground too, but in the soul first. The literal sense, as you say, always comes after the image. This city is still intact, and yet...It carries in itself a sadness that is greater—and that is something other—than the sadness of its inhabitants.

—That's true. I thought I was finding my own worries there, that they were coming back to me as though reflected in a mirror, but it's something else.

—I have not been in this city for a long time, said Gabriel, but I have not yet heard its voice. It is as thought there were a timbre, a tone that lent the city its true meaning, its true place, and that now its anguish is that of mute woman who spends her nights trying to scream, again and again, and is never able to...

—You speak well, for an angel. Were you the one that was on guard at the Earthly Paradise, after the fall?

—No. That was someone else. He is still there, by the way. Are you still interested in that old story?

—Yes. I have a soft spot for the world's infancy...When we hadn't yet realized that everything would need to be started over again, perpetually...

In the garden, the statues were quivering. The farthest off ones were already skimming the bottoms of their feet against the night, to get to know it before plunging in. Others were attempting to walk onto the lawns. The muted sentinels were sheathing themselves in black.

—When we hadn't learned about this beautiful sadness, said Vincent's shadow, a statue made of sand among others.

—You were speaking about needing my help, said Gabriel. Is it this threat against your city that you are worried about?

—Not exactly. But, given the place I'm in right now, all the lines blur together. And since this city is what I love most in the world...

Gabriel felt the call of someone at wit's end rising toward him:

—What can I help you to do?

—To die, said Vincent.

<p style="text-align:center">✳</p>

They left the garden. The night was being pulled down to the edge of the rooftops. Beneath the arcades, fast-moving women, sentinels in straight lines, groups of soldiers. The besieged victors no longer dared to go out alone. The earth was shaking from underground machines. A car approached in silence, its headlights off. It hardly slowed down to pick up Gabriel and Vincent before immediately turning onto a street guarded by a golden rider. A tall boy with messy hair was driving.

—They'd better not stop us, said Vincent.

—We'll be done for, assured the driver with a laugh.

Inside himself, Gabriel was feeling the strong desire to defend them, to save them. He kept watch on the white gates, the motionless watchmen in the intersections, the flickering lanterns, anything that could have been a sign or a threat.

A call rang out from behind. With beaming lights and pulsating sirens, a powerful machine passed in front of them, blared, sped back up. They had enough time to recognize the red decorations of an officer. Vincent leaned forward, while the driver, with the same reflex, turned his head. For a moment, the two faces floated at the same height. They understood each other and smiled. Their car shuddered, settled into the shadow of the other one, and stretched out its headlights like antennas. A roadblock had been passed at full speed. The blowing whistles faded. Gabriel turned back. Shadows were moving about, ridiculously shortened by each passing second, returning to the spark-filled night. The city was coming alive, in a contained way, bringing together houses like a herd of half-asleep lions, Assyrian bulls burning victims, motionless figures with wings of stone that slowly metamorphosed into wings of flesh. The military car put on its brakes and swerved into a little square. They followed it. It seemed like the officers understood what this drive was about, that they were being drawn into something. All of this still eluded Gabriel. He felt only that this sparring involved much more than a battle of speed. To throw caution to the wind in this way, some unknown stakes had to be involved. Now there was a long avenue of mutilated trees. The two phosphorescent machines, like augers, sank deeper into the night. The sound of the engines grew shriller, sharpening into the howl of a tortured animal. Vincent shouted when they caught up with each other. The two drivers had the same closed-off expressions, lights shuddered in the dark city, tracer bullets. Slowly, the other car took off, regained some ground. Vincent was leaning over the back of the seat, entirely consumed by the drive, overtaken by a new beauty. Gabriel could no longer find those harsh lips that had spoken about Death. Another swerve, then the void: a wide boulevard surrounded by parks—the houses in retreat, frightened. The others kept winning. The crazy-haired driver grunted something, and Gabriel realized that, with all of their might, they were coming back. On this dizzying line sunken into the city, it was a fight between planets. The car shouted with its whole body. Gabriel could once again see the red

decorations, only backward this time, and soon after lost in the spectrum of the headlights. They kept up their momentum, with an empty road before them, then the driver threw them onto a side road, cut the headlights, and stopped next to the sidewalk. Somewhere behind them, a chase continued, crazy and aimless. Finally, a buzzing silence set in. Vincent began to laugh.

— They were good sports, said the driver. If they had gotten us, we would've done at least two years.

— Yes, but it was worth it, said Vincent.

The footsteps of a patrol emerged from the silence. They left. A few streets down, Vincent and Gabriel got out. See you later, said the driver. They smiled at secret things. The house weighed upon the silver-colored ground with all of its darkness. Up high, a string of blue light sliced through a window.

— My father, said Vincent. All night, he sits there at his table, his hands dangling.

— Is he thinking? asked Gabriel.

— Oh no, Vincent heartily responded, it's totally different. He's dreaming.

❋

— A new friend, Vincent said.

— Are you also conspiring? asked the Father.

— In my own way, said Gabriel. The old man was motionless, stiff in his armchair as if in a tomb. His hands were hanging, unclenched. Over the course of his hours spent alone, he would refuse movement, relying on the fervent lifeblood of his dreams to inflate the hollow shell of his existence. The only gesture that lent expression to his words was a half-shake of the head, permanently hinting toward negation. Above him, a beautiful etching depicting a tomb effigy surrounded by prayers. Gabriel stood there.

— That's exactly what I want for all of you, the Father said. Legs straight, fingers crossed—a good position for plunging into death.

— Are there many who have died, among your loved ones?

— Quite a few, said Vincent. But we aren't allowed to think about that.

— I know what you're thinking, said the Father, and he seemed to be contradicting himself by shaking his head. But we're not afraid of death anymore. Of dying, at most. After that...

— Are you a believer? Gabriel asked, disconcerted.

— No, said the Father.

A sound resonated through the house. There were footsteps, doors that closed. Beneath the blue veil of a shade, a single smudge of light encircled an open book. A flat bookmark covered in convoluted lines divided several columns of verse. A Bible, thought Gabriel.

— That must be Christel, said Vincent. Should I tell her to come up? The Father nodded. The footsteps grew closer. Vincent went out and called. Clocks rang onto the city.

Christel came in.

— Hello, she said to Gabriel. How goes it?

She quickly kissed the old man's forehead. His prominent dimples strangely blurred his northern warrior's face. The harshness of his eyes corresponded to Vincent's gaze. Gabriel tried to figure out which one was the other's mirror image.

— Any news? said Vincent.

— I know what they did to Phil. She shook her head and her curls splashed around. It's...terrible. They attached him to a shovel stuck into the ground by its handle, and they took turns flogging him with a bullwhip while the shovel's blade dug deeper into his back...

— That's a new method, said Vincent.

— Yes...They must have received a detailed memorandum explaining the whole thing...scientifically. There's little risk of blacking out and the fear...Do you understand how awful—a shovel...

— Did he talk?

— I don't know. Personally, I think that I would have.

She turned toward Gabriel, showing no defiance:

— And yet, I'm brave.

— In the face of horror, there isn't much that holds out, said the Father.

— Where is he now? asked Vincent.

She gave the name of a prison. The Father nodded. No one they knew had made it out of there. Beyond that was death, or maybe being sent away to icy lands, to do the work of the damned.

— Another one to forget, said Vincent.

And then his hand plucked Ode to Joy on the bass notes of the piano.

— I'm always waiting, he went on, speaking very quickly, for that moment in the *Ninth*. I wish that the conductor would turn toward the audience and shout: "And now, all together! And the people sing and sing...fine."

— We don't know how to take advantage of life, said Christel, raising her voice. There should be traveling salesmen who go door-to-door telling people that Joy exists, and the proof is that we've got music all around us. People always believe what's been printed.

— And, so that they notice, we'll deprive them of one sense for a while.

Vincent cast his words like an incantation. One would have thought that he was in a hurry, looking to prevent an absent voice from speaking out against them.

— For a month, they would be blind, or deaf, and the day of their healing, we would throw a big party, where we would show them everything beautiful that there is to see, or to hear...

— And they would've seen or heard such things, said the Father, that they would immediately ask to be made blind and deaf again.

The three of them laugh, and Christel, with no reservation, lets her head fall onto Vincent's shoulder. Strange community, thought Gabriel. He dared to speak the name of Phil. On his face, Vincent wore an absent smile.

— He was our best friend, said Christel.

As soon as the young people had left, Gabriel felt the power of this motionless world that the Father had made for himself. He was fighting with his own thought, and was slowly sinking deeper, in search of singular agreement. Through some

bizarre contradiction, his face came to life whenever he closed his eyes and, within him, sleep must have been the farthest image from death. Facing this suspended demise, with out-stretched arms, Gabriel perceived quite an unusual demand, and beneath this intellectual's mask, a peasant's rigor. In the street, there were still rhythmic footsteps. The Father opened his eyes and shook his head.

— Why do you hate them? said Gabriel.

— I don't think that I hate them...Nothing that invigorates life can leave me indifferent. It's not the loyalty within them or the persistence of a mythology that offends me...Quite the opposite. It's what they've betrayed.

— What have they betrayed?

— All of this...His hand finally rose and gestured vague-ly toward the walls embedded with books, etchings, casts of hands and of torsos. They didn't dare renounce this. I actually would have forgiven. It would have even been quite beautiful. Burning legends in order to make them live. Burning images in order to preserve even richer ones inside oneself. Breaking statues in order to sculpt a hero out of one's own flesh...But they didn't dare. They preferred to create false legends, crude images, clumsy statues. That is what I believe to be their sin against the spirit...He smiled: You see that I don't fall into the same traps...But those who pick fights with me don't know it. They think that they're fighting for the ideas of men. We are only fighting for...a kind of beauty.

— Or for God, said Gabriel.

— Beauty, is God...

His hands fell back down, dead. Once again, a shake of the head drew out his sentence, as if one had to look harder, and for something else. On the long black marble fireplace, the stone shapes rose up, victorious from men. Every work here appeared like a defeat granted by the living. Other creation was not like that, Gabriel thought, and he began to admire hu-man things.

— This is our only chance, you see, the old man went on, his voice sounding weaker. In our current loneliness, what do we still have rights to? To beauty, to suffering. To flesh, to blood...

You were speaking to me about God. For us, he begins with man, with Christ. The meaning of Incarnation is that God can enter into man, into each man...His voice regained some of its strength. That's what we're looking for, and...He looked toward the door through which Vincent and Christel had left. And what they're looking for, without really suspecting it... Obviously, by looking for God in ourselves like this, it's quite possible we'll end up stabbing ourselves in the chest, but...He leaned backward. The image of the tomb effigy appeared to be standing up.

— This one's found it, he said solemnly.

Silence surrounded him with a sacred inflexibility, like a suit of armor. Gabriel tried to find its flaw.

— If he was your son?

— I would envy him...

He had neither the comfort nor the fear with which old folks speak about death, but the calm resolution of a young man. Gabriel thought that a very strong bond must have connected him to his son, and that each one's life strove to improve the other's. The Father understood what he was thinking and denied it by shaking his head, intentionally this time. His mouth was shaking slightly.

— No...I would envy him just like any other tomb effigy. You see, I believe that between a father and a son there is an absence...a definitive one. Something insurmountable...Perhaps it's just the absence of desire, he added sharply. He reflected for a second. It's odd, but by many accounts, the space that separates me from Vincent is no wider than it would be if he were dead. That's what I meant. The question is not whether the image of him that I love is living or dead, but whether or not this image disappoints me...Communion with life, with his life, is forbidden to me. He reflected again. And if I wanted to be very...realistic, I think that I would find something rather disquieting in the image of Vincent having been killed. Something like the secret hope of finally getting to know him... Forbidden from being in communion with his life, but...perhaps allowed to be in communion with his death. His features had grown sharper. With a half-smile, all of that was erased:

You see how you can end up mysteriously desiring the death of a being that you love...more than anything else. Well...that explains to you why I don't think about death in the same way that you do.

— Oh, I am not involved, said Gabriel. It would be difficult for me to explain to you the extent to which I understand, but...I was thinking about them.

— Oh well, you see...They're very caught up in their action. For reasons entirely different from mine, obviously. But for Vincent, there's no question about it. He holds within him that kind of fatality that can only lead toward death—she does too. And they love each other. That's what's serious.

— Is she his fiancée? Gabriel had taken Christel to be Vincent's sister.

— His mistress, the Father plainly stated. They are in a very strange place, you know. Their love is an attempt to part with the world, you could even say to rebuild the world, because they have rejected it. The boundary is death. You see, everything's headed that way. As for me...

Gabriel saw himself backing down a dark road, holding the Father's hand. At the end of the road, a flashing light. This room. These masks. These books. Weighty residues of the past. And full presence, even stronger than God: Death. No shroud, no scythe, no second-hand store of human imaginings. Like a wild taste in one's mouth, and the strangeness of unknown fruits.

— As for me, the old man went on, I was born for this creation that "they" betrayed. There was talk about me, as a young writer...Don't go looking. Spoken, not written. Except for a few reviews. And I bought back every single copy of my only published work. After a while...a very short while, I decided to remain silent. It's the same mechanism, you see, if you look deep inside. At the furthest boundary of all expression, there's silence, just like at the furthest boundary of all love, death... He shut his eyes. And what's extraordinary...what's extraordinary is the power of the images that come to you when it's time. The world has womanly reactions. So long as you reject it, you won't be able to believe what gifts it holds...He smiles:

Don't think that I'm obsessed with death. But, if a kernel of wheat dies...

Gabriel was shaking. In front of this prophesying old man, he felt just as helpless as when he had believed he was protecting Vincent. I came too late, he thought. Or too early? This pride, this lonely search for a unique path, all of this eluded the grasp of his kingdom. What help could be brought to a species that only found strength in its own abandonment? He had come in response to the prayers of Vincent, who appeared to believe, and to have faith. But now he understood that he was being asked to act as a witness more than he was being asked to come to the rescue, and that this call into the lives of men was a most outstanding challenge.

Vincent and Christel returned. They had put on their jackets—and Christel a lazily tied blue scarf. Eagerness for their adventure lit them up, their young bodies were quivering like animals before a race.

— Are you coming? said Christel, her mouth half-open, her eyes half-closed. Gabriel thought that her face must have also looked that way while making love.

Vincent offered a quick smile to his father, then left. Christel, with a gesture that she would have laughed at if it had been somebody else's, chased after him to fix the collar of his jacket. Gabriel was the next to rise, a bit shaken up. What Vincent had said to him in the garden flashed on the walls, around this calm old man. He was on the verge of shouting out the truth. In spite of himself, his words transformed.

— And...in this this moment of abandonment, YOU can believe in their action?

He stood in front of the half-open door. Vincent and Christel were waiting for him downstairs.

The Father leaned over the open Bible and moved the bookmark that was covered in cruel lines. The light dug new wounds around his face of a weary god.

— *Whatsoever thy hand findeth to do, do it with thy might,* he read, *for there is no work, nor device, nor knowledge, nor wisdom, in the grave, whither thou goest.*

Gabriel stood beside the wall without moving. The Book.

The old man. The tomb effigy. A line connected all of them—and brought them into a tranquility filled with life to the point of infinite despair. All of this appeared distant to him, and was fleeing from him at a frightening pace, until he saw nothing other than a smooth dark wall. He realized that he had shut the door.

— But then there's everything else, said the Father in the empty room.

Through the white gates, soldiers were entering. At each entry, a swelling of light and laughter splashed through the street, then immediately died out. A single sentinel, numb, was swaying like a bear along the façade.

The cyclist passed by again, unhurried. His leather jacket glimmered in front of the sentinel, who did not move. Vincent and Christel, underneath a neighboring archway, appeared to be quite busy kissing each other. Gabriel, half invisible, observed the street. When the Top Boss would fall under the spell of this hurried light, the cyclist would pass by again, and... Actually, he had just stopped at the intersection, where he was busy with some kind of repair. Then, Vincent would hurl himself in front of the door, a large package in his hand. He would toss it. The cyclist would have time to flee. "Why him?" Gabriel had asked. Vincent had not responded. As for Christel... Christel? "The boundary is death." Perhaps they embodied the Father's intelligence. Or his will...Gabriel shuddered. In front of a man's power, he was afraid.

The voices inside the House went quiet. Then a woman's voice sang out. The sentinel turned around, like he was trying to see through the wall. Passersby stopped. It was a strange song. With a lively, military rhythm, lyrics that were proving wrong the shadows that filled them, a painting of a dead city, and the call for an impossible union...

> *Wie einst, Lily Marleen,*
> *Wie einst, Lily Marleen...*

The voice swelled up. Within it flowed all the winds of futile countrysides, of victories whose stakes had slipped away,

elusive conquests. Somewhere, lines of cavalrymen were breaking through Europe's borders, advancing upon burning cities. Others were keeping watch over the gold-studded night. And the same void spread out in front of them, like a flag. And one had to have hope. Then the voice was singing about a long-awaited day, the clouds evaporating from over the rivers, and a far-off light, so far off.

> *Wie einst, Lily Marleen,*
> *Wie einst, Lily Marleen!*

As a wave breaks by rumbling over pebbles, the song vanished into applause. And the people in the street, they remained motionless. Gabriel was discovering mankind. They had thoughts that cracked the old world, and songs that made angels tremble. It did not matter that this was contributing to their destruction. It was still affirming them. Their supreme defiance.

Vincent and Christel weren't moving. The song had petrified them as it passed by. In imitation of its desire. *Wie einst...*They were fully savoring one of their victories, a complete ownership that was indistinguishable from complete annihilation.

Someone came out of the House. He was wearing the insignia of the men-at-arms, but Gabriel recognized the driver from the unfathomable drive. As he was passing by Vincent, he spat out, "He's leaving," and quickly moved away. Once Vincent had passed by him, the cyclist slowly climbed onto the saddle of his bike and came back toward the gates. Vincent made Christel turn around, pretending to kiss her again, so that he could have a direct view of the door. Gabriel, glued to the wall, was sifting through his angel's sensibility for an emotion that could match this. The cyclist was still moving forward. Even as slowly as he was going, he was on the verge of moving past the sentinel. "He is going to miss them" thought Gabriel who, no sooner, was astonished to find such human reflexes within himself. He was no longer watching the door, and instead was looking in Vincent's face for the beauty of someone who is about to kill.

When Gabriel saw him abandon Christel and ready himself, with tortured arms, the joy of a crucified man in his eyes, he understood that the Top Boss had just stepped outside.

No. It was not possible. All of this was planned, rigged. A tremendous man, made even larger by his officer's tunic with its glittering decorations, in plain sight, awaiting death, motionless, the sentinel motionless, Vincent and the cyclist moving forward with a submarine's slowness. The man was not shouting, the sentinel was not shooting, the two executioners were moving closer. What was this slow-motion spectacle, this sacrifice that everyone was agreeing upon, in which everything had been anticipated and necessary for ages and ages, for generations and generations? The Big Boss of all the men-at-arms, the ones that throw flames and the ones that sink into the sea, the crew members and the ones that bear dark flags, the silent ones who wear metal necklaces, and the ones whose clothes are black with metal bones; this one was standing there in plain sight, a few steps away from his murderer...Gabriel did not realize that the scene's intensity had made him forget the pace of time. Christel's gaze, loving and wild, reminded him of it, and things became fast and blinding again. He had barely pieced back together the sight of the street when he was ripped up by a stippling of sneaking and cruel noises...The cyclist vanished, images came one after another without any connection, like swiftly flipping through a photo album. The Big Boss tilted into the light of ruined cities, his eyes glued to his badges. Then his body, stretched out across the door, with a substantial rumble emerging from behind him, and the sentinel's movement...Then abruptly, like a tremendous snowman, Vincent's movement in response...Then they plunged into fire, and all the winds swirled around them, chubby and winged as one sees them on maps, with a howling that could rip life to shreds. The shadows fell to pieces, whistles came, unfamiliar shouts, and behind everything else an incomprehensible rustling of fabric. Gabriel flew among the ruins. When he regained his appearance and his gait, Vincent and Christel, beside him standing upright, were coming back toward the explosion. At that moment he knew that everything had been carried out.

Vincent and Christel hurried, knowing that the getaway had lost them, while they assumed the appearance of onlookers coming to check out the news. And those who had seen Vincent act were dead…Near the twisted gates, in the crackling of darkness, people were running, people were improvising emergency services. Men-at-arms were showing up from every which way, blocking off the streets. A few steps away from the mangled wall, Vincent stopped. A black body at his feet. The body turned over and moaned. Metal badges gleamed. A combatant. Christel continued on, but Vincent knelt down.

The injured boy's face revealed itself in the light. It was a boy around Vincent's age. A bloody lock of hair was twisted under his upturned hat. Little skulls and crossbones shot up around his collar. Vincent propped him up in a Pietà gesture and tried to understand his words. Christel looked at him, not with hatred, but with a degree of revulsion. Gabriel could sense something still unknown behind this straightforward demeanor.

— Don't move, mate, said Vincent. In his voice there was a solemn softness, the kind that women never hear. The injured boy said a few words in a foreign language, then was taken over by a long shudder. Vincent lifted his gaze toward Gabriel.

— Anything we can do for him?

— Pray, said Gabriel.

Vincent shook his head and leaned forward. Blood was flowing over his hands. The injured boy looked at him. He had understood Gabriel's answer. "I am killed," he said, stammering.

— So you think, said Vincent. You're trying to make yourself interesting.

— Him, I understood him…He made an effort to see Gabriel who blended in with the wall.

— You shouldn't believe him. He's a big liar. We're gonna bolt on a wooden head for you, and then you'll feel better, right?

The injured boy smiled out of the corner of his mouth that had not yet been contorted by death. Wriggling his head, he nestled into the crease of Vincent's arm with the movement of a sick child. Vincent lifted the bloody lock of hair and kept his palm flat against the boy's burning forehead. His eyes had lost all of their harshness, and even more so now than at the

time of the struggle, he seemed to have recovered his true face. "That's it, sleep" he said, very gently. The injured boy started moaning and stammering again. Pointlessly, Vincent's arms sought a cradle-like movement, as if they were tapping the rustling rhythm of death that used to fill the Northern forests, back when war was still as pure and true as dawn. Quietly suffering, Vincent listened to the echo of his most intense voice, and recognized one syllable, always the same one. Why. Why.

— Pay no attention, he said. This is all beyond us. But you can let yourself go. I'm a friend. The injured boy grumbled. "You hear?" Vincent almost screamed, "friend, frehn-duh! I'm a friend!" The boy's hat slid to the ground, and his wounded forehead, under its own weight, turned his face back over. His features were peaceful now. Vincent was absurdly holding up this dead body. There was nothing left around them but silence.

— I think you can leave him...

An officer was standing near Vincent. In all likelihood he had heard their last words. In his stiff uniform, he appeared uneasy and moved. Vincent got up, then grimaced as he held his arm, which was numb from effort. Christel and Gabriel moved closer.

— You were...He was searching for the words. You were very...good to that man. I just want to say...thank you. He reached out his hand. Vincent shook it, mechanically, stunned. You can can go! The officer had resumed his natural tone. He gave an order to the soldiers to let them through. Whispers spread through the night. Several suspects had been arrested immediately. A woman was sniveling. Soldiers were insulting civilians under their breath. Hazy smoke fluttered around the hushed street. Vincent and Christel walked quickly, shaking from exasperation. It was all so absurd, thought Gabriel, and he thought that it was all over.

It was at that moment that an animal's prolonged scream ran along the roofs, igniting other screams along its way, and that the city felt its threat.

They ducked into the nearest shelter, a mighty archway of flaking glazed tile, of violently colorful images. The crowd, in

good spirits, laid low there. Jokes were exchanged. "When the bomb heads their way, this is what it looks like." A deeper and deeper whistling. "Then, once they realize they've made a mistake, the bomb starts to leave, like this." A higher and higher pitched whistling. People laugh. "Nothing's going to happen" someone said, "it's the commanding officer who wants to scare his little boy, because he didn't mind his manners at the dinner table." "There's no reason to worry," said a young man to his companion, "the chances of being shot are as slim as winning the lottery." "But," she said, "the thing is that I won the lottery." Little by little, the jokes became worn out. The oldest ones were recycled, as a last resort against silence. But the silence settled in anyway; slowly, it slid in among the groups, voices growing lower, as if in a church, the great cathedral of fear. Finally, they fell quiet. Then, one could hear, high up above, the buzzing of machines, and the first shots fired.

Gabriel had attempted to speak to Vincent again, about his young death. He had abruptly turned away, and Christel had looked at him anxiously. That is not hatred, thought Gabriel. It is beyond hatred. For a moment he had hoped that the power of mankind was not so new, that deep down it was just a new mask for the old instinct to fight. And then there's this profound brotherhood between the murderer and his victim… Christel appeared more intelligible, on that note. She did hate, deeply. Gabriel, in a kind of fever, looked back over the strange hours he had spent this evening. There was no question that Vincent would die. He had told him as much, in the deserted gardens, next to the river, when he was still just a confident boy with a harsh look. Everything was so different then…

Gabriel sensed that the most humiliating thing for Vincent was this true pity that had saved him, as though he had been tricked into it.

The shots grew closer. The ground shook slightly. The sound of engines ran through the archway, turned into a rusty mewing, then vanished, bursting into pieces. "Pedestrians can pass now," one man said, and people started to laugh again. A few other shots struck, far off, covered by the momentary pulse of rapid fire. Engines revved above the city.

Vincent ran his hand across his forehead, then moved away from the group. Gabriel and Christel respected his solitude. He stood at the entrance to the tunnel. His face looked very weary.

— Perhaps it is because he needs you...Gabriel whispered.

— I don't think so, said Christel. I don't know what he's going over there to look for, but...I get the sense that it's not me. She stared at Gabriel. For the very first time, just before, we didn't share the same feeling. That's what's serious, she said in the same tone as the Father, when he was speaking about their love.

The engines gathered, very far off, and set back on their way like a hunted animal.

Christel was speaking. Gabriel had understood that she was not speaking to him anymore—she was speaking to Vincent, who was motionless, who did not hear her.

— Until now, the closest beings to me were still incredibly distant—as for us...we both had to make each other suffer a lot to get where we are. It was through the harm that we brought each other that we saw ourselves in one another. She lowered her voice. Through the expanse of my pain, I fully realized all the joy that you would be able to bring me...

— You still share what matters, said Gabriel.

— What matters, said Christel, is that we share everything.

The engines, hunted beasts, came back. The noise swelled up, scratched the walls of the tunnel, tore up thoughts. For a few seconds, it was all that was there for the people in the tunnel. Then a deeper and deeper whistling came and wiped it out...They understood. Most of the men had already thrown themselves onto the ground, pulling women down with them. Vincent lifted his head. Christel had remained standing and was opening her mouth with a powerful muted cry...The impact was dark, flameless. The noises spread out, as did the colors. Once this puzzle settled back into place, the far end of the tunnel had finished caving in. A number of people were stuck under it, or had rolled closer, mutilated. Vincent had been knocked down with them. In one piece. Beautiful. Dead.

Gabriel knew it. That is how it had to be. And that was good. What he did not know was that Christel, now far from

him, drawn into the crowd, was throwing herself onto the first combatant to arrive, ripping his dagger from him, striking... Another combatant fired, haphazardly. The mob writhed like a wounded octopus. Fights broke out. The soldiers continued to gather near the way out. They were trampled. And this was a frightening scene. They carried Christel, folded up on herself with the gesture of a mummy, already taken with an unworldly pain. In a tense silence, blows were being thrown out at random. The mob suddenly began to calm down as though in a farandole dance, a few disorganized soldiers grabbed each other's arms, and whacked. No one was watching out for the final cry of the beast on the roofs, which was driving away the threat. The mob rippled, let out sighs of wild animals. Other men-at-arms came, sowing further dissent. They continued to fight for much longer, then grotesque and terrifying silhouettes fainted in a fog of weariness.

Gabriel remained alone by Vincent's body. He could no longer bear his weight in man. Through the opening in the tunnel came something unbelievable: men singing in the streets, men marching, calling out to each other...Muffled voices, then more songs...What to make of this community? thought Gabriel, then he stretched out Vincent's body, his legs straight, his arms crossed, like a tomb effigy.

May 1946.

February 1947 *And while we wait for a classless society? How to justify this use of the term "second classes" if there are no longer any firsts? Not only are we missing out on the opportunity to engage in a prefigurative experiment of ideal Democracy (the one where, as each of us knows, the elite is everyone), but still, by using this number Two, we are allowing who knows which phantom of heretoforeism to linger within the operation, a kind of emigration of the Firsts into an Abstraction from which they will one day make a big comeback so that they can toss the people beneath a blank slate, a ghost of privilege that haunts these underground corridors, the temporary silence of a defined space. Add to this the fact that the rare chosen ones who managed to find a seat among the Firsts (in Neuilly, in Passy, or on the Champs-Elysées), generally living at the start of the line, they continue to occupy the same positions for one peanut less, while the others keep hold of theirs at a doubled price, and you see the psychosis that can come as a result of speaking the language of the state. These are the facts that should be made known to the grandchildren of '47 and the great ancestors of '89: the Socialists are no longer the friends of the people. Acquaintances at best.*

But let's get back to serious matters. A train engineer very astutely demonstrated that the metro could, without doing damage to its operation, be free of charge. The absence of tickets, receipts, inspections, etc...would result in such a reduction of staff that the remaining expenses that are chargeable to taxpayers would be significantly lightened and so that a mere penny added to the City of Paris's budget would be enough to pay for it. The Company's unused staff would find jobs in the many businesses that are lacking accountants and labor.

And what a feeling of collective joy at the thought that we could take the metro as though it were a simple moving walkway. Which it is, actually. A gold star for the engineer.

January 1947 REGARDING EARTHLY PARADISE. "Read Eusebius' cold declaration, Praep. Ev. lib. I, p. 11," Laurel tells us, "which claims that since the coming of Christ there has been no more war, nor tyranny, nor cannibalism, nor pederasty, nor incest, nor savages eating their families, etc...I find this quotation in one of Volney's Meditations, dated 1792. And the old author adds: When one reads these early doctors of the Church, one never ceases to be astonished by their bad faith or by their blindness."

"And that's not the end, you see," Hardy chimes in, "No more adultery, no more prostitution, no more concubinage, no more perversion...What can I say, deep down, I find this rather encouraging," he concludes, putting back down **Pravda**.

January 1947 A LECTURE BY LOUIS ARAGON. We were told of a lecture about Mass Culture, so we came to the Sorbonne like we were going to school. Admittedly, we were not expecting such a delight, nor this multiplication of oneself that turns old man Proteus, Frégoli, and the mime Étienne Decroux into little boys at Mr. Aragon's side.

Father Aragon, of the Company of Jesus, is the first to step up to the pulpit. He is pure gentleness, pure unction. He quickly demonstrates the absurdity of the title that poorly informed intermediaries gave his sermon: no, he will not be speaking to us about mass culture, but about "something else entirely." And from there unfurls a very well-mannered sermon on the precision of language. Is it to illustrate the relevance of his talk that, from the gallery, with lapidary precision, falls this shout: "Shut it!" tossed down by the lewd voice of a drunken viper? The flock is dismayed by this, whereas Father Aragon is moved by having enlivened this snake and, without further ado, hands the pulpit over to Brother Aragon of the Holy Office who wages war against the spirit of evil. The tone of the new speaker is quite different: the ecclesiastical elegance of his gestures in no way interferes with the vigor of his remarks, and all the way down to the level of his language itself, one finds the harsh simplicity of Church fathers: unafraid of words, he violently condemns metaphysical whores, and a shudder runs through the crowd that is already

biased against respectful prostitutes. Why must our Inquisitor stir up a misunderstanding by quoting a long passage from the heretic Malraux? The heretics in the room immediately applaud their master, while the true believers applaud the way that he is going to use this quote—anyway, everyone is applauding, and the greatest disturbance is going to come out of this false communion. When, having already honestly advised us that "to be anything is to be fascist," Brother Aragon dissects this bundle for us, which, apart from Malraux, is comprised of Bernanos, Trotsky, Denis de Rougemont, Jaspers, Spengler, **Le Figaro**, Unesco, Man, Europe, and...metaphysics—the non-scientific individuals in the room, the ones that don't know that Error itself can prove useful, are violently opposed to this. And then comes the Apocalypse. People shout, "Long live Malraux," they hiss, they go, "booooo," while a voice—belonging without a doubt to a university professor—lets out: "Stay on topic," a relevant comment that is taken up by the whole room, chanting in unison. Then, since things seem to calm down a little, someone has the whimsical idea of shouting out, "Long live de Gaulle" (like the Fenouillard daughters shouting, "Hurray for Fumisty"). Because of that, now everyone is looking for something to shout. We hear, "Long live Joseph," but they're not talking about Stalin. Since Maurras is part of the discussion, a shrill voice cuts through the uproar: "Maurras is not a traitor." "Behold the face of contradiction," the speaker replies, since he knows the extent to which Maurrasians have their hearts set on defending Malraux and Bernanos. But at this point it is no longer the Inquisitor who is speaking. It's the Clarion: "Gentlemen, I wear my diplomas on my boutonniere." — "You're not the only one," howls the Gaullist. The commotion is at its height, but by now, to everyone's surprise, Aragon has transformed into Elvire Unesco, the dynamic star, and with the inimitable cadence that earned him his fame, succeeds in unleashing everything weighing on his heart, after which, using the same gesture that goes along with the grand aria from "La Traviata," he raises his glass to the good health of those howling in the gallery. For a short period of time, he poses as Father Ubu, as the King of Poland, and as Aragon, in order to draw conclusions from the debate, all while Stephen Spender,

who had congratulated Malraux on the occasion of his lecture, sinks deeper and deeper into his chair, and the bibliocrats in the audience walk out, incensed....

Let's stop joking now. All of this is extremely sad. Because it's sad that this heckled man was right about what he said, that he was right for saying it, and yet that he deserved his cabal. We are in perfect agreement regarding the threat that Unesco's current method poses for peace. We know perfectly well that Aragon's position with regard to Malraux is, at least on the level of action, the only viable one. We also know that one portion of the hecklers was more than happy to find pious reasons for collectively playing the Reaction game. It is no less regrettable that the constructive content of this presentation disappeared, drowned in commonplaces, false profundity, false simplicity, and little bouts of score-settling that were not interesting for anyone—that the tightening and the demanding nature of this position, in Aragon's mouth, were born from narrow-mindedness and indulgence—and finally, that it was **Homo communistus** himself that offered the most obviously generous excuses to an enemy from time immemorial, **Pithecanthropus reactio**. If I had a name in the Communist Party, I know well what fate I would hold in store for a display of this sort. When it comes to judging the spectacle itself, put on by this pale and well-dressed gentleman, vaticanning in the name of orthodoxy, one would at least need the hot-tempered flair, the wonderful intransigence of the Aragon from 1925. But that one is very dead, and how many others along with him, whose mad ghosts flail about in overcrowded places, and leave forgotten sites of candor and refusal desperately empty.

April 1947 IMAGINARY CURRENT EVENTS. The event of the month is of course the Soviet experiment using cosmic rays, which took place on Sakhalin Island. It is known that Russian scientists, having developed a ray that breaks down the ozone layer and sets free the destructive radiation absorbed by it, had decided to organize a demonstration of that weapon in the midst of a strong surge in

popularity: "And why should I not also have my Bikiki, my Bikini" was the most requested popular song on every radio wave. There was also an avid interest for the original conditions of the initiative: the Sakhalin penal colony, where a number of enemies of the regime can be found, had been seriously purged, some of the cases having been judged too notoriously incurable to serve the cause of progressivism, even passively. Then again, volunteers had turned up, happy to find such an opportunity for redemption. Out of the abundant applications, only two were successful: those from the former minister Liftistov, and the anarchist-leaning Outovlin. "I am a vile beast," declared the ex-comrade Outovlin to journalists, "a nefarious virus, a libidinous earthworm of the worst kind, absolutely unworthy of clemency from the state. May my example, at the very least, teach the younger generations about the abominations we expose ourselves to whenever we stray from the straight and narrow." In addition to the residents of Sakhalin and the two authorized volunteers, a dozen small children had been offered to the experimenters, drawn from marshal Stalin's personal ration.

While the preparations were drawing to a close, the global press was commenting on the affair from a wide variety of points of view: "The Sakhalin experiments," wrote *Pravda*, "have no other goal than to serve Peace, and to show the world of fascist agitators and arms dealers that the Russian people possess the means to destroy every last hell-raiser of war." "And what about us?" anxiously asked the *Times*, in which a biting editorial laid blame on the Labour government out of suspicion of feebleness and negligence, as a result of which British science had fallen behind the two other allied powers. The Pope reminded the world that whomever made use of cosmic rays would perish at the hands of cosmic rays, while the Antipope of Avignon (the layman Aragon, recently converted), more abreast of scientific matters, maintained that it is precisely through this gap in the firmament that the heavenly legions might fall. Finally, in the USA, the unofficial journal of the Jesuits, *Brain*, published a long article by its editor, Emmanuel Moonlight, who concluded as follows: "It is obvious that our

path is to be found in an increasingly keen awareness of our refusal of the event, which is tempered by concern for a true realism combined with a commitment to principles, with all of the reservations of a true idealism."

When the day comes, a carefully selected but very diverse audience—that included, alongside marshal Stalin's representatives, independent personalities such as Pierre Courtade and Monseigneur Spellmann—hurried onto rafts towed along the shore by boatmen called in for the occasion from Volga, to follow the experiment as it unfolded. Arthur Koestler, invited, had expressed his regrets. The shadow was nuptial, majestic, and ceremonious. No one knew where the machine generating the rays was hidden. One could only make out the outline of the island off in the distance, and through a telescope lens, those condemned to death searching their Marxist-Leninist souls with the help of printed questionnaires that had been handed out to them for this purpose. On a separate raft, the scientists responsible for the operation, lying flat on their stomachs, trembled with dread. This trait has already been reported on with regard to American scientists, attributable to commendable awareness of their responsibility. This awareness was heightened here by the presence, behind each scientist, of a civil servant armed with a Sivispachem-style Luger pistol who had been ordered to fire immediately if it turned out that, as a result of carelessness or sabotage, the experiment started behind schedule.

A loudspeaker mounted on a buoy counted the seconds as the fatal moment drew nearer. As soon as it said "Poom"—which, as each of us knows, means "Now" in Russian—clicking came from the skies; one could clearly hear the machine's radiation nibbling at the ozone layer, and one saw a beam of cosmic rays loudly hurtling through this open door, making a racket and horsing around like art school students.

A moment later, the earth was burning. But, as a result of who knows what mistake (some murmured with fear that it was a maneuver that had been premeditated for a long time), the other half of Sakhalin island, a former Japanese territory, was hit. From the ashes that were found, one learned that

lying in wait there, among the mountains of tinned sweet beans and bottles of Coca-Cola, were observers of an unknown nationality.

ETERNAL CURRENT EVENTS. We sometimes have the calming feeling that the real prevails over the imagination and uses its weapons to do so. Some sentences that we discover by chance while reading sound as though they were knowingly fabricated confessions.

For example, when you read, in Paul Valéry's **Rhumbs**: "The cause of the fall in birthrate is clear, it is presence of Spirit."

Or alternatively, on the walls of Paris, telling of three lectures by Mr. Winandy:

"The Secret of the Sepulcher."

"Who Killed Jesus?"

"The Supreme Pontiff."

What the surrealists quite fittingly call an "exquisite corpse."

The Separated

The snow that's demolished The beauty that's stolen
The blood that's still moving and the wood that goes mute
The gallows' towers and the doors' guillotine blade
burn upon the trestles in summer Saint John's Eve

The sun at six-o-clock horrifying the war
and making the earth free to the lovers' daydreams
We are walking dragging our heavy shields of glass
in the city where ice has the look of cement

We are inventing words for warding off their charms
Malguru Malguller And we are inventing
a language that holds up against the weapons' noise
in their waterless shots flowerless targetless

Listen we are walking listen here's where they kill
Here not exactly here but here deeper down
Here crisscrosses with time to create a statue
of wax of air of fire of noise of the noise made

by asp vipers of tin by syringes of frost
by injections of ice in the necks of the strong
by fists of black metal decorating the books
and degrading the hand clasped within their remit

Malguru Malguller People making stretchers
to take away from here Yesterday's burned body
have left marks drawn in chalk on the dividing wall
and we follow their steps down the iron bridges

Malguru Malguller Complaints are invented
Yesterday's the bull that's dragged along by the mules
Yesterday's the sick man brought to holy waters
Yesterday died of thirst its face in the pebbles

his mouth near the water though his mouth is still closed
his hands clasped yet his hands touching the keys of zinc
Yesterday died at dawn and in the number five
remaining his Urals his Nile his Crimea

Yesterday took hold of the last hearse in mid-flight
The dead have subway trains that are not to be missed
Not one went after it parce que the fogginess
hides droves of anarchists whose bombs are blowing up

There's droves of assassins that are surely russian
for throwing cannonballs into the daytime's paws
and burning with black fire the cities that surely
would have taken us in without the runaround

Malguru Malguller the earth's going faster
time's growing narrower the year's passing we know
how to spread onto bread the butter of cannons
and live within the walls that our death inhabits

The Scamander and Seine both have the same pastures
and finding a thousand bucks in three days takes luck
the horseshoes it appears come in different sizes
tastefully we have found in tears a salty taste

CHRIS MARKER

we're adapting you see to this time that is rigged
we are born with our hearts' outlines drawn in red lead
as the toughest tough nuts are stippling their necks
to announce their target and to pretend play man

the wrists have in advance a hollow for handcuffs
yet before the cock crow the mouth shalt deny me
the boats of desire chased away their pilots
and smashed open the hold and tore apart the jibs

On the ice floe soil a crowd is keeping us
from going to make love on the empty sidewalks
all while the subway trains push us their crevices
like pawns in a chess set of earthenware and steel

(Sheltered by metal gates saved from believing all
from a sky of white stone just as heavy as gel
from mixing our bodies with the city's cement
like haut-reliefs made out of asphalt and of salt)

and already metals circulate in our veins
our lips are made of lead our eyes of mercury
we're walking through the heart of this futile city
where old man Tomorrow comes to sell his balloons

June 23, 1949.

February 1947

THE SKINNY COWS. Algiers, 7:10 p.m. The arrival of B.'s train, a few hours late, obviously. A lot of people, not much light, a moon, four cops. The people and the light are sordid, the moon and the cops are imperial, the sordid and the imperial together are colonial. And the train unleashes the crowd by basketfuls, until some guy runs up to me, an Arab porter who walked his sordidness a bit too close to the cop's imperialism. It starts up again a bit farther away, with the blows of a billy club this time, while the first cop carefully wipes off his white glove. Nobody is paying attention to this, especially not the battered porters. As for me, I've already seen this gesture...Seen: China Express, *you know, that Soviet film where a crew of Chinese rebels fight and win their freedom. The whites defend themselves, fall back into the restaurant car, and I find the same problem again here: What to do to not be associated with the whites? On the China Express or in the Algeria Express, the dividing line is straightforward: white, color. The color that comes to offer its services to the white is looked down upon. The white who tries to associate himself with the color raises suspicion. And I wonder about this justification that all colonialists must give to themselves: Our place is on this side. And when I see socialist ministers or Christian military men standing together with the colonialists, I rediscover the same reflex, which deep down is a reflex of fascism. The young bourgeois who understands the class struggle tells himself: My place is on this side, anyhow I will not be welcomed on the other side, my pride wants me to fight, and he joins the French Socialist Party. May we no longer be surprised, then, to find some presumed revolutionary on this side of the China Express. Just like with fascism, it is still a question of rebellion: rebellion of the privileged.*

THE FAT COWS. Paris, 2 p.m., in front of the "Samaritaine," a kid, very badly dressed, flees, pursued by a cop, very well dressed. "Arrest him," the cop hollers, and it seems to me (joy!) that this call is enough for the crowd to make way for the pursued. But a gentleman comes alive with the voice of the cop (the voice of blood, as it were) and blocks the kid's pathway. The kid stumbles over the gentleman, the cop stumbles over the kid, the gentleman and the cop each grab one of the kid's arms, and they're on their way to see the goldfish.

The gentleman will go all the way to the police station, assuredly, where he will be warmly congratulated while they beat the kid up. For the moment, he casts victorious glances at the gallery. He is totally reassured, the brave man. He thinks of his kids, of himself, and of the good example of practical morals that this incident, with some embellishment (a knife between his teeth...in his hand, I mean), will bring to his dinner conversation. It will be an opportunity to work on his favorite maxims, such as "Crime does not pay for long when there is a cop nearby" or even: "He who takes from the rich lends to the Devil." And he is delighted to think that, this way, never will his children be of the kind that gets taken to the police station, that they will instead be among those who help to send them there.

THE MEDIUM COWS. A short prayer, dedicated to a friend from my military service who, recently arrested for a robbery, in turn, was robbed during the interrogation, and who wonders what fate can then await civil servants who exploit their office:

> *My God, who created cops, we are no longer in a position to be surprised by the curiosities of your Creation. But then give us the courage to refuse all complicity with them, and to love their victims. We forget every reproach of the dead. Make it so that the man who moves forward, his cheeks bleeding, tied to a fat vicious beast, be for us as though dead, and that his crime be returned to him. Make it so that the world over, every man, whatever his fault may be, who is in the hands of the police, touch our hearts, and that in some way it be we who are beaten. It will be one of the last forms of fraternity, while we wait for it to be the only one.* Amen.

May 1947 NEWSREEL. *The price of life.* 1. — Because she decisively could not find housing, a young married woman throws herself into the Scarpe river.

Do you have
AN ATOMIC FUTURE?

(Advertisement in *Écran Français*.)

To the east of the Philippines
on the island of Peleliu there is still
a group of Japanese soldiers
ignorant of the outcome of the war
who continue to resist the Americans

The price of life. 2. — Because she had made a false vow, a high-schooler from Sèvres throws herself into the Seine river.

> *"They are going to call us the moscowteers at the convent."*
> (Florimond Bonte.)

> *The production of goldfish in Japan has declined by 10% since the war.*

The price of life. 3. — Because he could not manage to fill out his income form, an ex-tax assessor hangs himself.

The King of Greece is dead from a thrombosis. He is replaced by his brother, the Diadochus.

"If I were king, I would be rad. soc."

(The Count of Paris.)

The price of life. 4. — During the Good Friday service, in Mexico City, two brothers stab the murderer of their brother on the steps of the altar and are lynched by the faithful, one of whom is killed.

The price of life. 5. — Because he did not like the way he was being looked at by him, A.B. cuts R.R.'s carotid artery.

> In a movie theatre in Turin, films of fascist propaganda mysteriously take the place of English documentaries.

> *"If General de Gaulle comes back, it will be you, Mr. Ramadier, who will have called him."*
>
> (J.L. Vigier.)

> Living separated
> the husband and wife,
> got back together
> to burglarize.
>
> (*Libé-Soir.*)

"The Resistance made way for Resistancialism."
(Alexandre Varenne.)

The price of life. 6. — Because they could not find seats for a boxing match, the people of Port-Saïd charge at the police, who defend themselves: 4 dead, 100 injured.

> Jean Cassou was arrested for being a scammer.
> The crook was
> of course
> someone else.

The state nationalized the Trémolin coal mines. Under this name, they discovered the outcrop that made it possible for a peasant to help out his neighbors who might be short on coal.

The price of life. 7. — Because...

Martine Carol...

> The radioactive smell of love.
> Magnetized and irradiated, this smell
> of love provokes, stabilizes, and contains
> sincere affection and attachment,
> even from a distance.
>
> (Advertisement in *Écran Français.*)

The price of life. 8. — In Greece...

CHRIS MARKER

May 1947 N.B.— *We could not help but take note, upon receiving the texts for this issue, that several of our collaborators were affected by the new fever that doctors are naming pernicious or treacherous americanitis. We preferred to group together the texts that were written under the influence of these fits. A recent statement from the Academy of Medicine reports that this fever, which has no relation to crypto-communitis, and which affects those with the most varied of temperaments, leads to a highly tonic effect for states of democratic languor and liberal euphoria.*

THE APOLITICIAN OF THE MONTH I. Moscow, April 1st

Things are not going so well for the Board of Directors of the World,[1] even in the eyes of the apolitician. The four main shareholders cannot come to an agreement, neither about the family quarrels that they insist on carrying over into the domain of business, nor about the precise purpose for their meeting, which is the right of certain peoples to manage others.

This, furthermore, brings about a new aspect of diplomatic duty: in the past, an international conference was a kind of enclosed field in which statesmen playacted as Horaces and Curiaces until a champion gained the advantage that roped in the nation. Now the role of the diplomat wavers between the liaison officer's uniform and the mailman's, and his exploits are those of the court bailiff. A minister hardly has any opportunities anymore to be genuinely plenipotentiary except for bearing his country's unconditional capitulation. Outside of that, he is the "broker"—as Bismarck already said—or even the manservant: "My master has instructed me to inform you, princess, that he is only pretending to leave with the army…" Farewell to the beautiful mastery of someone like Talleyrand, wagering France's fate on his audacity and his prestige. Today, we might view him like the others: tied down, ruled by a thousand binds that don't ever stop holding him back except to make him stumble as he tangles himself up. It's true that he,

1. To the attentive reader: "the World" does not refer to *Le Monde*, the newspaper of the same name—be careful!

in turn, has servants and assistants at his disposal that, after his failure, still spend a long time hitting each other with their arguments. When, after a certain number of these transfers of powers, the echo of great guiding principles begins to deform and to weaken, perhaps opening the door to an agreement, then a telephone call or another conference, working its way up the line, bringing things back into focus, once again clarifying the unshaken reasons for disagreement, and then we make an appointment for next month.

To be honest, we cannot quite see what exactly the agreement would be about. We wonder as a result of what enlightenment would the U.S.S.R. start to dream about a confederated Germany, or a France with an inviolable Ruhr—and through whatever judgment of Salomon such resolutely contradictory positions might actually be reconciled. We wonder what solution would be capable of satisfying the rivals whose point of view in this matter is so mixed up with ideologies that any concession would necessarily be taken as a sign of weakness. One could hope for an agreement through misunderstanding, but the forces that watch over misunderstandings do not act indiscriminately, and men are never more lucid than when they are defining that to which they are opposed.

Nothing is currently more criminal than shouting that war is imminent. But, come on, we cannot say that the Musk-Ox drill and the Bikini tests put us to sleep with a false sense of security, even if we are told that Admiral Byrd is off conquering the legendary metal whose singular purpose is to bring us closer to the delights of the Age of Uranium. In these conditions, and considering, in spite of all, the peril and the adventures of far too sophisticated warfare, we cannot contemplate, at best, anything other than the indefinite extension of the current state of things, the jealous conversation of conquered opinions and occupied territories...Anyway, the future of Europe might be nothing more than the begrudging homologation of the done deal—with, behind the scenes, a belligerence and an observation of every instant, funneling all of the forces that would have stepped, when faced with weapons, into a fight that is deaf to influences and to phynance.

For the absence of losers is not least among the paradoxes of this adventure. By virtue of their very weakening, and the availability that results from it, the countries of the European Axis, to the extent that they have a choice among their victors, find themselves being courted, as it were, and by the boundless belonging that they can offer to the most adept one, transforming their ruin into a kind of dowry. To such an extent that, when it comes to the final deal, they will hold more weight than some of the victors or their equivalents. And, in short, the Peace conference is no longer a diktat of the victors toward the losers, but a distribution of influence between the two sides, some of them now finding themselves in the same camp (such as the Balkan states with whom the U.S.S.R. signed separate treaties). The distinction between innocent peoples and the wrongdoings of their authoritarian governments plays a more-than-modest role in this process. To such an extent, it turns out, that the position of the partners does not concern the peace agreement of the war that has just ended, but that of a presumed next war which, just like in mathematics, exists for purposes of reasoning—the peace agreement of a next war that will not take place, of course, but whose unfolding everyone can imagine.

Is it not in accordance with this development that the United States, great victors in 1945, are now an uneasy, off-balance nation, as though paralyzed? In truth, it appears that their success in wartime Europe was due, above all, to the non-existence of that Europe, and to the need they felt to carry with themselves a kind of portable America in which problems resolved themselves like business as usual. Now, as Europe more or less resumes its own structures, the gap between two truly foreign conceptions of the world is becoming palpable. It is known that the width of the Atlantic grows by a few centimeters each year. The world of ideas goes hand in hand with the flight of continents—and surpasses it.

As proof, all that we need is President Truman's appalling declarations in *Collier's*, after he took power, in which, giving an overview of Europe—just as one gives a look around one's property—the first citizen of the United States shows himself to be incapable of measuring overseas realities except with

regard to America. And to be astonished that European countries can't achieve unity as easily as his states (since, in short, it would suffice to achieve unity of language, culture, myths, past, then politics would naturally be forced to follow suit...). And to cite Mazzini, Garibaldi, Victor Hugo and—above all!—Briand. And to cite Switzerland, as though an economic consortium could serve as a model for living nations.

It's true that Mr. Truman, in the same article, declares himself to be "profoundly convinced that the American form of government is the best in the world." If this conviction inspires a head of state to such childishness, one can conceive of certain potential anxieties regarding the spirit of global government that the most representative Americans lure us with the promise of—the lowest pole being represented by the primitive ramblings of Prof. Einstein, who atomically pacifies the world with the lovely assurance of scientists frolicking in the real (ramblings that, by the way, were merrily dissected by Sumner Welles in the January 1946 issue of *The Atlantic Monthly*)—and the highest pole by the reflections of Emery Reves in his wonderful book *The Anatomy of Peace*, in which, very aptly conceiving of the impossibility in which democracies find themselves, that of effectively making power reside in the hands of the people, he can still only find a solution in the delegation of this sovereignty to a world government, through either a sleight of hand or a mutual good will that would make this super-control almost useless, if one day it dared to exist.

We have no doubts about these men's disinterest. But is it not unknowingly so, because the United States, only having economic relations with Europe, are not interested in a properly political evolution of the continent, that they are so attached to an endorsement of stability that would ultimately only satisfy their selfishness? That would be the *Pax Americana*. These periods of peace that are too long and too self-satisfied are generally disturbed by a movement or a nation that recalls the facts of the human condition—and that satisfaction is always paid for with injustice. (A world pacified by the atomic police and the Beveridge Plan would obviously not be livable.) But this reminder seems inopportune and dangerous. Yet, it is

still being made: the victors never dare to follow Machiavelli's practical advice, which bids the prince to not let anyone from the enemy family live. So there still subsists an Antigone, a Christian, a sans-culotte, or a communist who can protest against the price of Order. And if this list looks like a step down, and if the nation that currently embodies this demand seems to some to be inappropriate for the role it is meant to play, that is because, at the end of the day, the purity of a cause depends upon what it is faced with.

When it comes to the U.S.S.R., the American conscience is moved and speaks about imperialism, expansionism, territorial ambitions, forgetting that it belongs to this period of history where the world seems to be conspiring against it. When Europe says, "Iron Curtain" (following an expression drawn verbatim from a speech by Dr. Goebbels), the U.S.S.R. can respond *"cordon sanitaire?"* Nothing can prevent Russia from gaining bases in the Mediterranean, nor from it having the right, in place of the bastions raised against it by the Europe of Versailles, from putting in place governments that conform precisely to its hopes—even if Mrs. Dragoycheva's regime is not idolized by the Bulgarians. With no hidden agenda, how much would Russia be able to trust these democracies that, successively, ostracized it from the civilized world, fought against it in all the territories of the Far East, let Germany rearm itself, Italy build its empire, Franco take power, and never ceased to reproach it for the maneuver through which, in 1939, it avoided following them into the ditch that they had themselves dug. In this, one can only see a powerlessness that is hardly reassuring—unless one were to accept as true the hypothesis of a vast anti-Soviet conspiracy that had been hatched since 1919, and toward which everything, even the hostilities, had been working.

Having reached this point, the Apolitician draws his conclusions, which are straightforward. They consist in three slogans, always the same ones, that he puts everywhere and that always stick: "There are no solutions," "No need to beat yourself up over it," "Things have their own way of happening." At the very least, can't we dream a little about the way things happen: wouldn't it be exciting, for example, if it was up to

little France to get the world's three big shareholders out of their vicious circle? Currently, France is standing back from the Board of Directors' table, having sold most of its shares in order to deal with painful due dates. France is tolerated, however, within reasonable limits, for the favors it did them, and sometimes, when the directors' stomachs are settled, they return the courtesy. The masters of the world would do well to remember France, when they discern the outlines of their future ruins. They would do well to remember, with their concern for not letting anything be lost, those old forgotten values of Christianity. They would do well to...But dreaming has its limits, and instead of searching for earthly paradise, they are contemplating the construction of the world of honor.

THE APOLITICIAN OF THE MONTH II. "In my campaign, I said that, fulfilling my role to the best of my ability, I would be a governor, not the distributor of political favors, the creator of a personal political machine...[After my election] I was approached with requests for favors, for approving applications to certain paid positions. I was told that I had been helped to become governor and that now I would be sent to the Senate of the United States. I responded that I had no political ambitions other than keeping my state as far as possible from social disorder, that I did not want to go to the Senate, that I did not even want to be reelected as governor, that all I wanted was to restore democratic order from a governmental problem that, with the greatest indulgence, they referred to as chaos... In the 24 days that immediately followed my taking office, the Georgia legislature broke every record having to do with emancipation..."

It is with these intentions that, in 1945, Ellis Arnall commented upon his own work as governor of Georgia. He would say shocking things, such as "The so-called question of race is an economic question, not a social one." "The ten million negro citizens of the South are no more a special and separate problem than they

are a special and separate resource...They have the right to be decently housed, decently dressed. They have the right to good schools, to economic freedom and to justice..." Fine.

The end of the story can be found in the February 17th issue of **Life**. The ideas of the new governor, the character of his administration, the ousting of politicians, all of this had the most moral outcome possible: when it came time for reelection, it was old man Talmadge, Ol'Gene, champion of white supremacy and friend of the Ku-Klux-Klan, who won. Since he was a sick old man, he was helped by an article of the constitution to have some votes be cast for him by his son, who then declared himself as a candidate to succeed his father, and who ultimately secured the position. I will refer curious readers to the report in **Life**, where through these images they can experience the fiddlings of the **Talmadgites**, in their triumphant procession after their victory, when they break down the doors of Arnall's office, when old Gene's bodyguard, John Nahara, lays into Arnall's desk, when Arnall is evicted from his home by the police who, until then, had served him, when Mrs. Talmadge ironically comments on the state in which Mrs. Arnall left the house, and so on. May this serve as a piece in the file on democracy, once we take democracy seriously.

July 1948 NEWSREEL. *Stranded in Ville d'Avray, June 1st at Dawn.* Will we be able to get out of the train? At regular intervals, the loudspeaker gives us world news, while, to kill the time, we fold and unfold Parisian newspapers. Time is only wounded. It does not stop. "THE EX-KING MICHEL IS STRIPPED OF ROMANIAN NATIONALITY" says the loudspeaker. Such misfortune will not befall Commodore Charles Drouilly, king of the hat, whose subjects are more obliging. This interesting character, *France-Dimanche* teaches us, has ushered in a heynight in Deauville, where he swings from streetlights and dons a blonde wig to entertain the ladies. To be noted, as in Prévert's *Attempt at a Description*, "Those who commodore." "THE STUDENT ORCHESTRA OF PARIS IS GOING AWAY FOR LACK OF MONEY." The Student Orchestra of

Paris would do well to play in Deauville for Commodore Charles Drouilly who urges on night club musicians "by means of 10,000 or 20,000 franc tips" imitated by his friend Spiro Catapolis, a famous Greek shipowner..."NEW EXECUTIONS IN GREECE"...a famous Greek shipowner, that is presented to us dancing the samba at 5 o'clock in the morning. The commodore is wearing a spencer. Miss America "who is very gay" is wearing a false beard. All the women are sporting the *nioulouque* and all the men are billionaires. "ROBERT GARRIGUE HAD KILLED FOR TWENTY FRANCS." Miss Joan Redder, special reporter for the *Daily Mirror*, having lost her evening dress, came to the opera in a nightgown. Nobody noticed. As for the Count Stanislas d'Herbemont, he changes his tie, suit jacket, or car every five minutes. *(Aux Écoutes.)* What an exaggeration! Here is how to fuel the class struggle..."A BRAZILIAN COMMUNIST GETS THE 1947 PERON PRIZE." We thought that Peron was fascist. And they tell you that things are getting better. The Stalin prize to François Mauriac, the Pulitzer to Jean Kanapa, and Pierre Boutang will come recite his poems at the *Lettres françaises*'s Saturday readings. Otherwise there's André Maurois, who *Life* tells us is currently reading his memoir at the home of the Duchess de la Rochefoucauld..."MATHÉ, FORMER VICHY MINISTER, ARRESTED BECAUSE HE WAS COURTING THE BUTCHER'S WIFE: HE IS REBUKED FOR A DECREE RELATING TO THE CASTRATION OF WORKHORSES." Inside a medallion, an old gentleman with delicate features, between two rather coarse women who are most likely invited writers heading to the coat check...There's a mix up, it's the maître d'hôtel who is giving information to a princess and countess. Jules Supervielle yawns, the duke of Strength made kinklies in his hair. Pierre Hervé distracts the miners from their duty and gets kicked out..."Ah, if one day we had

the coal of the Ruhr

then life would be beautiful..." says the loudspeaker. Oh yes, instead of depicting Mr. Frédéric Dupont as a German officer using photographic forgery..."MR. FRAISSINET IS CHARGED WITH 50,000 FRANCS IN DAMAGES AND INTEREST"...Mr. Fraissinet, through a similar forgery, could put the

head of Mr. Frédéric Dupont onto Tarzan's body and no one would say anything. "FOUR YEARS OF OCCUPATION BY SACHA GUITRY." The first nominee to be beatified of these four years has just been proposed in Rome: a Polish priest who had taken the place of one of his companions in the gas chamber. One finds ways to keep oneself busy. "WAR IN PALESTINE." "I saw the image of my mother again…I thought about the beings that are dear to me. I made the sign of the cross and I left for combat." That's Cerdan who's speaking, in *France-Soir*. And Gaston Bénac, in *Paris-Presse* "during a final round that appeared to us for a moment as though it should be the last one…" Thankfully that did not go on. "ARTHUR KOESTLER DECLARES…" He really needs to shut up. Bourvil sings "The Gay Yogi" on the Radio, and Raymond Raynal plays "The Police Chief is an Easy-Going Guy." What more does he want? We'll be able to get out of the train. Only, at the exit of the Saint-Lazare train station, unidentified people erased the sign that bore these words "BE-WARE OF MAINTENANCE CROCODILES." We still do not know what we are supposed to make of that…

Romancero of the Mountain

I
(Fragment)

That prowling night that speaks of victory
That nude singer in a seasonal dress
That glow of the reefs in the turf of dreams
That attracting night that speaks of return

Do not listen to it sentinel
Do not listen to it

If by chance you listen to it
take care not to understand
If despite yourself you understand
feign the inability to respond
If ever you respond to it
then be sure not to follow it
And if one day you follow it
do not come back among us

Go toward the enemy men
your torn-out heart in hand
Give them by your hand
like a fallen fruit your torn-out heart
Or throw it at them like a stone
your heart torn out of your hand
Or put it back in your wound
A rock on the road
tied to the neck of an abandoned dog

your heart will be so heavy on your weakness
that you will sink down with it
into a moist and somber pride

And the prowling night will sing your memory

Along the mountainside
fear climbs
dressed as a pauperess
It bleeds into the ravines
It gets caught up in the brambles
It moves forward with great difficulty
Far behind it
flocks of copper
run along the crepuscule
awoken by the warm breath
of this hour
that above the pools inflates
a thousand silver hot air balloons

At the bottom of the valley
sound the bells of stone
towers light up

Those who return home
ask each other
who is that woman
with the dress of dead leaves
crowned with wild roses
who steps through the stones
like an animal that's digging

It is the queen
It is the dead
It is lady saint Ursula
It is a masked insect

It is a brown frog
It is thirst
It is the moon
No one knows what it is

Sentinel sentinel
to whom then are you faithful
what is this dead beast
what is this complaint that brings
the evening cavalry

The procession gathers
in this coral corner of the sky
On taut skin
the funeral drums beat
The dragons of smoke
perched on the end of bamboo shoots
block the whole horizon
The horsemen
adorned with fog
raise hands gloved with black
toward the hurried angels on the balcony
that want to howl from fear
but only manage to form
the nightingale's song
The angels hurry into groups
at the grace of spears
Each one has on its throat
a handkerchief filled with blood

The evil of the night stretches out
like a mark of leprosy
It takes the whole body of the sky
that twists in its armor
where rust cuts up large stains
of ember and of silence

Do not listen to it sentinel
do not listen to it

Do you not have at the bottom of your helmet
the image of a lost garden
While this leprosy eats away at
the ashen face of the day
do you not have clasped in your hands
the shape of an encrusted flower
planted between marble swans
for the season of a girl
To this centuria of swarms
that roll over you rumbling
what name will you throw across
What branch will you shake
in front of these knights of frost
Do you not have at the bottom of your eyes
a garden with fruits of snow
enclosed in the golden ponds
like a liquid medallion

Do not listen to it sentinel
do not listen to it

Lean in lean in
Are you not curious
to know if this garden
still exists
if these levels of granite
do not lead down there as they bathe
in an icy spring
of sprawling flowers
in which a diver spreads out
clicking her wet ankles
under a skirt of water
while the spirits of the earth
strike tambourines in rhythm

You just have to lean in
You just need a single look
to know if you are hallucinating
if the fear is taking hold of you
or if between your lips
you will feel your name flow
like the only genuine fruit
that any being in the world can offer you

Let yourself guide sentinel
let yourself guide
and now open your eyes
and come closer
closer still

Along the mountainside
descends fear
dressed as a queen
lanterns of crystal
around her white bodice
her hands clasped over rings
Peaks of gold light up
beneath the lining of her eyes
She is rich
Soon sleep and rest
will ask to marry her
She clicks her heels
while passing over the ravines
with her finger the brambles part
She has two stones on her breasts
both similar to a man's eyes

The night lays down strange footsteps
on all the gardens of the earth

That prowling night that speaks of victory
that nude singer in a velvet dress
that glow of reefs in the turf of dreams
that attracting night that speaks of return

II
(Psalm for a dead comrade)

You do not hear me You do not see me
 – Comrade that I did not know
You donned this icy armor
 – to go down on the other road
They say that you are dead
 – but I belong for a time to the season of the dead
And it is your language that I speak
 – and you are my closest friend

Why this race at dawn
 – what a clamor had called you
Did you not see this great wall of crystal
 – that you hit head first
What meeting were you going to
 – Who was waving to you from the other side
For what harvest of paper flowers
 – did your hands grasp the grass?
On your lips they found
 – the red pulp of fruits of death
Your place is empty and the words that are thrown at you
 – are going to injure the passersby like stray bullets

I am a passerby
 – I received messages that were heading to you
I drank tears that were falling on you
 – I veiled you with my shadow
I held my body between a light that belonged to you
 – and the bottomless well of your absence

CHRIS MARKER

I separated your reign from mine
 – I confined this sea that you inhabit
By tearing you away from the lips of a living person
 – I gave you back your freedom
Then they took mine away
 – so that these things could be said
You lived here where I live
 – You followed these roads
The same desire burned before your eyes
 – like a pillar of flames before the army
You shuddered like a hunter
 – at this lost shout of trains in the valley
You found in the breeze of the hills
 – the same smell of untied hair
And the one who keeps watch in the depths of the night
 – could see our images joined
Walking at the same pace in silence
 – in a desert of cement built by the moon

Those steps that I heard passing my own upon each return
 – were these your steps
Was it you banging in the stone cistern
 – that they closed you into
Were you nailing down a bridge of hollow wood
 – over the inert fumes of the plains
Or were you knocking on the doors of nighttime houses
 – without finding anyone there?
Did you then come back from your voyage
 – Is the earth round
Even for children of the dead
 – and can they walk it from side to side?

Still I do not believe in you
 – The ones that come back are murderers
I do not even know if you fought
 – or if you existed
Only in these swollen eyes like unborn birds
 – that are hatched in a case of tears

I do not know where your body is mixed
* – with the earth of France or the sand of its dreams*
Whichever I know his burning legs
* – and the smell of milk from his mouth*
And dead body or image
* – you can do nothing but prowl like a poor man around*
* [my meal*
But you must not hate me
* – We took communion with the same blood*
And I do not hate anymore
* I look at my hate*
Like a rusty weapon from another war
* – like tarnished armor*
A souvenir of former campaigns
* – that I will never don again*
Those who defeated you
* – in their turn join the dead in weighty bunches*
And me at the boundary of the two reigns
* – I no longer have any enemies*

Those who died on the mountain
* – and others still in other snowfalls*
You fell down while shouting a name
* – that now I know*
Like a broken watch
* – that always shows the same time*
Those who laid down in the sea
* – and those who merge with the desert*
All of you that drag along our memory
* – like lifeboats that have been unmoored*
Still tied to our guard
* – but that we are no longer able to hear*

All of you horsemen of the dead
* – and you my comrade*
I watch you all disappear like a ship
* – that I did not have the strength to take*
I stay on my island

CHRIS MARKER

– among the yellow people
Those that you freed
 – and who did not follow you
Your light still flows on the earth
 – like a useless seed
There is no longer enough love
 – for a living woman and a dead man
But this living woman that you called
 – I also lost her
They surrounded me with a wall
 – and then can you get out?
I live in the house of the dead
 – for a time I am your companion in chains
Only you lost all the hours
 – and I do remember
My scream goes from tower to tower
 – it awakens the birds of fear
And each woman carries a dead man
 – who strikes and looks for the day.

You do not hear me You do not see me
 – It was perhaps worth it for you to die
For you to become this sign
 – this great indentation of iron in our sky
This weathervane for the breeze of our prayers
 – So that these things be said
So that we do not know victory
 – before having forgotten you.

July 1947.

February 1948 LES ENFANTS TERRIBLES. There's an electoral story that's well known in the French Union: in Black Africa, before a political gathering, the candidate for...(here, a blank, essentially standing in for the name of the party that the person telling you this story opposes)...places a coconut in the hand of a negro and tells him: "First to speak, let him talk. Second, chuck it straight into his kisser..." Then he steps up onto the platform. Unfortunately, the chairman of the session insists on saying a few introductory words, and so, the Machiavellian candidate, finding himself in second place, takes a coconut to the...as he said.

There's another story: Two young people, One and the Other, are listening to the radio. One, who purports to have a deep knowledge and love of music, holds his head up displaying every sign of being enraptured. The Other listens for a moment then asks him: "What's that playing?" One, sighing, and following a quick glance at his wristwatch, answers: "The prelude from **Tristan**." "Hey," says the other, "I never imagined it like that." With that the music stops and one hears: "That was Wal-Berg and his great jazz symphony. Now here's the Prelude from **Tristan and Isolde**, played by..." So, the Other simply says: "Your watch is fast..."

These two stories came to mind the other evening when, at the end of Radio-Luxembourg's game show, I heard the following dialogue:

— Who is the author of the **Discourse on Method**?

— Descartes.

— Very good. **The Anabasis**?

— Xenophon.

— Very good. **The Maharajah**?

— Montesquieu.

Then some noise, coughing, laughs. "It's a joke, you see... Coquatrix..." After that, they moved on to the next question:

— **The Spirit of Law**?

July 1947 IMAGINARY CURRENT EVENTS. General de Gaulle's welcome at the Académie Française, in the chair left behind by Philippe Pétain, had brought together every Tom, Dick, and Harry

in the area surrounding the quai Conti, per this phenomenon that's ever more common among the ruling classes that, in scholarly terms, we now call gallotropism. *Esprit*'s society columnist had a hell of a hard time getting into the noisy interior where, last week, hidden in a balaclava shaped like a pillowcase, he was able to catch the preparations for the ceremony. We remember that it is indeed at the very last moment, when winning the election seemed like a certain thing for Mr. Jean Rivain, the Pope's earl, that general de Gaulle abruptly put himself forward as a candidate and let his future colleagues know over the airwaves that, the same day, he would offer them a collective visit in order to, at the same time, conserve loyalty to usages and save himself time. A visit from a general can only be an inspection. Emotions ran high among the members of the academy who hurried to their positions by means of a firetruck that, thank heavens, was available, while one of their most recently elected members, Mr. Gustave Thibon, climbing up the big ladder, called for the meeting with a little tin trumpet. At the Académie itself, they began to scrub the floorboards and to whitewash the walls, after which, their shoes polished, each one stood in his place, motionless, his literary kitbag tidily ordered in front of him, while Mr. Georges Duhamel, permanent secretary, came and went nervously, counting and recounting the buttons on gaiters. Then the general entered, saluted, and quickly made his way through the rows with an impenetrable air about him. In front of Mr. François Mauriac, he stopped, "Where have I seen you, young man?" he said, casually pinching his ear. "The soup is good," he added, after a glance at the dictionary, quite purposefully arranged so that he could taste it. After that, the dress rehearsal for the ceremony took place, its final tune-up before being delivered to the public: what, in French theaters, is specifically referred to as a *générale*.

The welcome speech seemed to be legally due to Mr. Marcel Pagnol, author of *César*. However, it was judged that his far too recent immortality did not permit him to pronounce the profound position of the Académie with sufficient rigor regarding its new leader. And so it was asked of the oldest among them,

the venerable Mr. Peduncle, to define this position, which he did with as much good-heartedness as greatness:

> "Mind you, sir," he said, "that we are in no way welcoming you as a public figure, nor as the symbol of a Resistance whose echoes have hardly passed through these walls, but as the leader of a glorious army, the offspring of a good family, and even beyond all of that as the man who declared his withdrawal from the forum: indeed nothing could be in greater agreement with the meaning itself of our Company than that decision. To enter here is to renounce the world. We are the great retreaters of history. This asceticism that the Hindus granted to their local councilors when they reached the age, this right that they have to go off and live as hermits among the wild beasts—and the meager offerings of the people, France offers them to its most deserving sons, a republic calmed by its genius, where the all-consuming beasts make way for a lettered public, and the meager offerings for the generosity of the State...Thus, in this waiting room of Eternity, the member of the academy, turning his back to the tumult of the public square, devotes himself, through the intervention of the Dictionary, to this fair designation of things from which Plato made the supreme definition of Virtue. It should not come as any surprise at all, sir, to find here so many exhausted writers, so many canonical prelates, so many inoffensive thinkers, so many unreadable historians: our goal is to bring together personalities who are now sheltered from all temptation, that through the effects of age, of illness, or of a particularly debonair temperament, are as though anesthetized and, if I may say so, disarmed. And it is common sense itself: are we not a Museum? Are we not the living department of the Musée de l'Homme that runs the lengths of the same river, only a bit earlier than us? And would it not be of great recklessness, for example, to have a Museum of the Army in which the bombs were exhibited with their detonators, and the shells with their fuses?"

Rich (and wealthy) applause rewarded the orator who returned to his seat to listen, in turn, to General de Gaulle whose first task, a formidable one, was to be an accolade of his predecessor:

"The chair
of Philippe Pétain,
he began,
We shall not hide
that it has always
been
Our goal.
The very meaning of
Our
destiny
seemed to be
to make Us
sit down
in his place
as soon as he came
to leave it.
Whether it be about his
chair
at the Académie,
whether it be about
his seat
as head of State,
or about his position
as supreme
leader
of the army
or about this more
subtle
place that he held
in the consciences of
this country's
bourgeoisie,
to Us
and Us alone
belongs the task
of lifting it back up.
Some will even,
the general added,
smiling,
claim
that the place he
currently occupies
is already
reserved
for Us..."

A murmur ran through the assembly upon these words, which then resolved into applause, dominated by the voice of a lady: "No, never, we'd rather die!"

"That if,
the general continued
no one is surprised
by this kinship
after our struggles,
We will reply to them:
can we not be
near
in substance, and
irremediably
separated
like the two sides
of a
coin?
One of you,
Gentlemen,
at least
was not mistaken.
It is
Our eminent
colleague
Paul
Claudel
who celebrated us
both of us
success-
ively
and in almost
identical
terms."

Mr. Paul Claudel, who until then seemed to have been dozing off, sat back upright with a kind smile...

[Our typographer, out of breath and taken with a painful back-and-forth movement of her two pupils, asks us to continue the composition without any more rhythmic typography. Concerned with the well-being of all, we quite willingly grant her this.]

> "And we must not be mistaken," the General went on, extending his arms in a gesture that is familiar to him, and is the same one that is used by the priest announcing that Mass is over, "for if there exists a gap between us, if there exists a gap between the call for rebellion and the maintenance of Order, between the exaltation of the French people and the barracking of the masses, between the reign of money and the restoration of Christianity, this gap unites us more than it separates us, because it also measures well the distance between our principles and our deeds. It is the distance itself from Church to Community, from State to Nation. And this gap disappears in the realization, older than us, old as our faith, old as our earth, just as it is summarized in that beautiful French word *Contradiction*, which rings out loud and clear, and that wooly intellectuals working in the service of a foreign ideology have dishonored using the name Dialectic."

February 1947 CHRONICLE OF FASCISM (continued): Paris-Presse, *January 7. A big headline:* INTERVIEW WITH NGUYEN MANH HA: "Only a forthright French policy statement can put an end to this fratricidal war."

The hurried reader received the blow of a hammer to the back of his neck: he is inclined to read that an eminent Annamese personality advises us to bang our fists down on the table. You read the interview: beneath a skillfully toned-down text, Ho-Chi Minh's ex-minister straightforwardly reproaches the French for their variations and their contradictions.

Ce Soir, *January 9, two-column headline:* TWO SOLIDERS FROM ANDERS ATTACK A JEWLER. I would suggest the following headline for L'Aube: "HE ASSASINATED THE HEIRESS, HE HAD VOTED YES."

WE HAVE A PRESIDENT. It's neither **The Coronation** at the Louvre, nor is it the **Sacre du Printemps**. It's the **Bon Marché** election. While the lowest negro king, the day of his accession, dons his most beautiful fireman's helmet and cradles himself for three nights amid his people's hue and cry, while the most unworthy satrap on the evening of his victory is taken, if only for an instant, by a godawful dizziness and secludes himself for a moment in the company of the dead so they can make felt the weight of their legacy, while even father Ubu has horses slaughtered and organizes a treasure hunt the first day of his reign, while the next emperor of the Soong dynasty will most likely bring back to life all the rites of the Forbidden City, and while even on the far off day when marshal Stalin has a successor, there will likely be a commotion in the Red Square, while throughout the entire world, and since the depths of time, a nation has welcomed with joy and splendor this surprising phenomenon that is the birth of its Father, we have "chosen the bravest one" as someone dared to put it in print. After a few confabulations from guys in black and grey, the happy winner was pushed outside, like the little boys that are made to climb up on the platform during the prize giving ceremony, and like the little boys, the happy winner who was all choked up broke down in tears in the arms of uncle Léon. And then everyone left, and the country's other little boys had one day off, so that they might, at least, associate the election of the president with a pleasant memory through the well-known phenomenon of conditioned response. After that, the president and his people fell back into the same apathy, the same impotence. And we experienced neither that identification with power that each Englishman possesses and that makes it so that he feels as though each of his king's gestures is a personal matter, nor that reform of the sacred that the Americans invented whereby radio broadcasts,

kilos of shredded paper in the streets, and Coca-Cola orgies respectively take on the role of oracles, showers of roses, and libations. And that ugliness, that aggressive ugliness of politicians, that crushing proof that they couldn't do anything else, that no beauty could be familiar to them, that no temptation would find the flaw that turns them away from that absurd and degrading enterprise of governing. This defenestration of the sacred will come at a cost. And it is perhaps foresight of the bill that will incite their tears and their backslapping. It's not right, however, to overstate the dangers: for a very long time, the French people recognized itself in its kings, was delighted by their delights, was grieved by their pains. When it saw that, deep down, they weren't very interesting commies, it rubbed them out. As for Mr. Auriol, he fears nothing: he cannot disappoint us.

April 1947 *We've seen it, every person has a point of entry into the event that grants him his seat—and sincere men from the first row to the twelfth, if they haven't yet reached the point of hating each other, drift away from agreement. As for me, I admit that I can't possibly take sides: the argument about "Breton in* Le Figaro*" is worth as much as the one about "Tzara in the Pantheon." After all, the Sorbonne is just a university, not so different from those American universities where Breton apologized for speaking to young people, and it's hardly any more funny to see the Old Man of the Surrealist Mountain yield to the jeering of the illiterate folks of the Latin Quarter than it is hearing Dada recite its brand new catechism under the harsh and naive gaze of these young spiritual advisors. None of this was very serious, but as the feeble weight of these ghosts was still dwindling, the worn-out mask of Antonin Artaud was standing across from them at the back of the room, wearing on his face the mark of these years spent refusing the world that Breton dreams of—and that Tzara speaks of—transforming.*

On Jazz
Considered as a Prophecy

I WAS ALONE THE OTHER NIGHT, in the hall of the Conservatory, or almost alone...It was truly a pity. But the successive strains of an upsetting week, of unpredictable electrical supply, of generalized weariness, and of insufficient advertising having held back most of the event's listeners-in-the-making, it was in front of an almost untouched room that Boris Vian spoke to members of "Travail et Culture" about the positions, proposals, figures, and parables that have accumulated over jazz's fifty years of existence, including bebop's five or six years (see below, and don't worry).

The audience's desertion was unfortunate. Jazz is born from an animal heat, from a sort of mutual incubation period of listeners who must squeeze in, pile up, layer together, juxtapose themselves, interlock, mix around, until the shared egg cracks, producing a fowl chirping with trumpets and saxes. La Cave des Lorientais, nicknamed the Basin Street of the Latin Quarter, provides a good example of this.[1] As it happens, Claude Luter, bandleader at the Lorientais, was there and he demonstrated the definitions of the "old style" to a degree of perfection that, in Europe, perhaps only his orchestra possesses. Mastery that, by the way, entertains the mind more than it engages the feelings: it seems

[1]. N.B. Basin Street is a street in New Orleans where the first jazz orchestras played. The readers of *Esprit* would be mistaken if they thought that this was about the rue Bazin.

incredible that young boys, in 1947, are playing *naturally* just as they did in 1920. And we end up seeing them as some kind of society of antiquated jazz instruments (in which the banjo corresponds to the viola's layers, and the trombone, stunted by attacks from ragtime, to the high-pitched trumpet of Purcell or of Handel) capable of interesting, instructing, and soothing, but cut off from evolution, from development, from the very life of the music that it serves. This musical material, somewhat garish, somewhat grating—if we know how to tell it apart from all the fake jazz that exported its methods on the black market—still remains tied to images that are decidedly too out of date (the era of short skirts, of blackface, of the Charleston) to make it possible for us to approach it head on. It is nevertheless not a question of fashion (at the speed with which jazz progresses, the term "unfashionable" wouldn't make any sense: in no time, such a musical form, before becoming outdated, is already a style...) but of harmony, of "swinging"—such that we might be tempted to say: it is a question of a culture that either expresses us or refuses us. And that's why we feel better being in step with bebop (it's still below, so don't be impatient...)

None of this kept the event from being absolutely remarkable. And after Claude Luter and his Lorientais had broken the ice, Boris Vian stirred up the crowd in that familiar and somewhat eccentric style that makes his articles and translations so appealing. Boris Vian, for the savages, is a child prodigy discovered by the good shepherd Sartre and moved over to the lands of literature from the green pastures where he practiced the cornet. Boris Christopher Vian The Cornet has the casual and considered look of a Russian sighthound that might have read Kierkegaard, the indifferent lip of Louis xiv, and the sunken eye of Prince Trubetzkoy, a large and rather beaming forehead from which his hair flows back with admiration and, above all, a charm and a simplicity that are commendable for a young man who is already the stuff of legends. His kindness wrests the spectators from the comfortable impermeability of their armrests and puts them in the mood to discuss what's happening. In short, he's a good specimen of a bebop man (still further below, so behave yourselves).

Before telling us what jazz is, Vian listed some things and people that are not it at all. Because it's astounding to remark upon the confusion that reigns over some people's understanding of jazz, really nice folks—and good musicians to boot—who would faint at the thought of putting Beethoven and Vincent Scotto or Josquin des Prez and Léo Delibes on the same plane, and for whom "Jazz" is in this jumble: Duke Ellington, Glenn Miller, Jack Hylton, Stravinsky's Ragtime, Gershwin's Rhapsody in Blue, the Quintette du Hot Club de France, Peter Kreuder, Al Jolson, Bing Crosby, Louis Armstrong, Yvonne Blanc—and why not Chales Trenet too?—without saying a word about the theatre organ, about that musical incest that calls itself "symphonic jazz," nor about people who think that swing is a style of dress. All the way up to dear Roland-Manuel, a great preacher of initiation into music, who in a recent broadcast defined the Blues—a precise harmonic construction—as "jazz's adagio"! Quadruple the tempo of a blues, Roland-Manuel, and it will not stop being a blues and—since not everyone knows it—boogie-woogie is nothing more than the classic blues played over a new rhythm. Now put an adagio through the same treatment, and we'll see what you get! But I digress: after this enumeration together with a few rather biting definitions (such as Yvonne Blanc, who "never saw a piano except through fog"…), the advocate moved on to the flood, that is, to the trip to America through which the slave traders' ships, like so many Noah's arks, had sent the races of Africa and the music adjacent to them. Regarding these African origins of jazz, Vian adopts the theories of Hornbostel and Borneman who discovered, beneath the seemingly primitive and rudimentary exterior of the African drum and black songs, a complexity, a science that goes far beyond the simple rhythmic element to which European ears reduce them. It is in this way that, for Borneman, "the language of the West African drum is not some kind of primitive Morse code, it is a phonetic reproduction of the sound of words."[2] "Thus, language

2. Ernest Borneman, "Les racines de la musique américaine noire," *Jazz Hot*, December 1947.

and music are not strictly separated, and the average level of musical talent is extraordinarily high. Drum, song, and dance are practiced by all. Children learn to perceive the subtleties of rhythm, of melodies, and of local color like aspects of their language. Making music requires a little bit more competency, but is never considered as an art. The most competent musicians are warriors and sorcerers…" The survival of this music in America, its encounter with new conditions of life and new instruments, will lead to jazz. It is therefore a question of something entirely different than, as ninety-nine percent of the greatest minds believe, American popular music with who knows what ancestral wiggling from Africa as its only contribution. The little father Boris, for that matter, has his own idea about this (and if he didn't develop it in his lecture, I hope that I am not betraying him by reporting on it): if this African music, however complex it might be, at least seems to deny itself any acquisitions from the outside, if for us it appears to be indifferent to our own ideas of harmony and melody, that's because it doesn't need them. Short of any of its apparent limits, outside of the aspects described by Borneman—that we have a hard time analyzing, but that we perceive—there are others still that we don't even perceive, while a black person can hear them clearly. He will thus remain faithful to this falsely rudimentary form of music, which will give him just as much satisfaction and, to his ears, will sound like the most refined orchestrations do to ours. For a long time, we believed that fish were mute. Now we know that they communicate by ultrasound. And just as a blissful diver dispassionately regards the fish that shout way too loudly at him, the cultured European looks with pity upon the black man with his drum who is listening to the equivalent of a Brandenburg concerto, or to one of those "polyrhythmic twelve-part fugues" that Borneman speaks about, and that make you dream…(As an exception, there is no mention of bebop at the end of this paragraph, but be patient, it's on its way…)

The zero point of these jazz coordinates—Africa and America—can be approximatively situated in time, and confidently so in space: New Orleans, as Vian rightly points out,

was one of the main centers for the production of wind instruments and one of its red-light districts was particularly prosperous (it's worth mentioning) and hospitable, allowing a rare freedom for blacks. The abundance of cabarets, café-concerts, bordellos, and brothels necessitated the creation of many orchestras since, as everyone knows, music and morals are in direct correlation. And then they had to replace the phonograph, which hadn't yet come into existence. So it is in the shadow of parlor houses and young girls in flower that jazz came into the world. Some even state that the word "jazz," originally, referred to nothing other than the act usually fulfilled in the aforementioned shadow. And in this case, consider Mr. André Cœuroy, author of a mind-boggling book in which it is shown clearly as moonlight that jazz is hereditarily, consubstantially and indissolubly white—better: French...—and draws its etymology from the verb *jaser* (to chatter), I'll say it: what a good look for Mr. André Cœuroy. This red-light district was, incidentally, shut down and broken up after the war, following one of those moralizing and Marthe-Richard-ian winds that sometimes blows across a nation. After the flood, the exodus. And Vian recounted this saga to us: all of the musicians gathered in the streets, at the same time, playing and making the biggest racket all the way to the piers, each one towing his luggage, his furniture, and his women...You might get some remote idea of this legendary incident by watching the film *New Orleans*—which, by the way, is scandalous, since all of this is explained, softened, and corrected as is seen fit. An ingenious film, nevertheless, that shows, unbeknownst to itself, how the whites, having anticipated the wonderful future of jazz music, made it their task to dispossess the blacks of it, and to convert the vague hodgepodge of boom-boom and tra-la-la that they pulled from it into double-zoons (that's Vian dialect), even if that means distorting the very idea of jazz for an entire generation. And here's why: it took ten years for the first recordings, dating to 1921, to eventually, thanks to the founding of the Hot-Club, make their way into France. And this is how, in 1947, there is still confusion, and the majority of Europeans are just barely finding out about the classical jazz

age, even though it is the prolegomena to future music, along with bebop (it's coming, since we told you that it's coming...).

A few records illustrated this survey of the great eras of jazz. Those, and the Hubert Fol trio, also brought us the last word, the *dernier cri* (we couldn't put it better) of the genre: bebop (see, what did I tell you?). Bebop or re-bop, they're not set on it yet. American musicians use both terms, and up till now we have assumed that they're both the same thing, even though we must be careful and not underestimate the value of prefixes. (Can you imagine if we got to thinking Bolsheviks and Mensheviks, same difference?) I will not try to define bebop here. Instead, you should try listening to some, it's worth it. In fifty years, jazz music went back over the path of "classical" music, caught up to it and is in the process of surpassing it. The set-up of traditional jazz distinctly separated the rhythm section from the instrumental sections, and both of them— even if they willingly turned to odd sounds, to dissonance and to modified harmonies—were nevertheless based on classical methods in very conventional ways. We know about how contemporary music rediscovered medieval scales and a few other trinkets with mixed reviews. Yet, it does seem that on this ground, bebop leaves contemporary music far behind it, and that if there were a run-in between Gillespie and Leibowitz, the latter would walk away annihilated. The rhythm section is freeing itself from its supporting role and playing its own part. The double bass is awakening its class consciousness, and, instead of struggling in its corner, exploited by the bourgeoisie of the brass, is, in counterpoint, building a manifesto for double basses. The piano, which was falling asleep on the walking bass, now cuts up the action with biting chords laid down with two hands, or otherwise it is stringing together long and inspired phrases played in octaves. Harmony is also being set free, tending toward atonality (sorry, toward twelve-tone-ness, to please Davenson) which it sometimes is even able to attain. One such section of a Duke Ellington record from the prebebopic period irresistibly brought Alban Berg to mind. And finally, there are new themes, the touchstone of bebop, which expresses itself through the long and

unpredictable phrases that I spoke about earlier, snaking from one scale to another with a sort of sugar-coated purity, breaking the rhythm out of its structuring, slicing it, shredding it, and yet finding it back in one piece whenever it pleases—like the fakir who unveils, still in one piece, the woman that he just cut into pieces—and culminating in these loops, in these knots, in these returns onto itself that are the signature of its style, which are occasionally drawn to ensure its authenticity. Nothing is more impenetrable than this music. Even gentleness is, for it, a mental construction. Hence, it would seem, the reluctance of the American audience, against the insistent enthusiasm of bebop's practitioners. But, how well it matches its era: tough, smart, complex, like science, like poetry, like aesthetics, half-submerged in a cold light that hides one piece away from us and constructs a reverse hermeticism; no shadow protects it—it eludes us with its radiance. With it, we enter into this thin layer of the surreal, this asymptote to the demarcation line of the world where everything is leading us, the curve of athletic performances like that of atomic decay, the blurred sight of the impressionists, who are on the trail of the real, like the clear sight of the surrealists that breaks through to it, and that is precisely where the *beyond* begins...It is admittedly not by chance that the most memorable record of this memorable evening—a kind of catastrophe for seventeen instruments owed to Dizzy Gillespie, grand master of the Order of bebop—is called "Things to come"...And if the Trumpet of Judgement were to play a bebop phrase, that wouldn't come as such a surprise to me...

In this light, we can better understand why certain forms from our era—jazz, Bikini, abstract painting, fashion, Rita Hayworth—so badly get on the nerves of people who are comfortably settled in the world, or who would like to be. The next evening, seeing Jean Painlevé's *Freshwater Assassins* at the film society of "Travail et Culture" (the richness of whose programming is decidedly only equalled by its indifference to informing public opinion), I also understood why the ferocious miming and dancing of the film's insects was accompanied by jazz tunes...For all that fear and powerlessness bury in the

soil of consciousnesses, strange flowers take root there. To this harsh and fragile world—subjugated by all forces and prodigiously the master of its destruction—Art can no longer offer any response, except by denying itself, by making paintings with pasted paper, music from clashes, and poetry with letters. There is still science, chance; there is still jazz for expressing, with certainty, order, torn-up forms, color, and screams.

July 1948.

November 1947 SARTER NOSTER. During World War I, we would place little rats in cages ahead of the front lines in order to detect the approach of asphyxiating gasses. It seems that the committed writer, apart from the respect that I owe to him, has devolved into this heroic role, and that the meaning of his (voluntary) commitment is exactly to offer the sensibility and intuition, to which his writerly nature grants him the privilege, in the service of political action, faced with the rudimentary offices of experts and politicians. The fact remains that Jean-Paul Sartre was the first to violently and publicly (and also freely) react to these mixed scents of lavender and of mothballs that, since two Sundays ago, have been rising from the prairies of France.

Having paid tribute, we now can admit that this broadcast, which made so much noise, was quite weak. All the more so, for that matter, being that it might have changed nothing about anything: it has been for some time now that in our country of correctness, facts have no longer existed. Or, more precisely, they are drying up in the midst of a chorus of mirrors brandished at the end of a sickle, an arrow, a sword, or an aspergillum, and seeing themselves judged in this way, proved, denied, or justified by appearances, without anyone taking interest in their poor but honest existence as facts, they end up doubting their own reality, and in turn they vanish into the beyond from whence it is not certain that some uncommitted historian will one day extract them. To convince yourself of this, all you have to do is, for fifteen minutes prior to each meal, consider this foregone conclusion: if Sartre had begun his political broadcasts by attacking the communists, then the right-wing papers would have brandished the battle flag of total freedom of expression, and l'*Humanité* would have shouted scandal.

For the crux of the quarrel does not reside in the broadcast's actual content, where it was easy for Sartre to shut the trap of some unconvincing Gaullist, here incarnated by Chauffard: it even seems to have been fair game to give the adversary a little head start, and to sort him out more decisively after having bestowed him with a hint, while the character who had been manufactured for this purpose came across dumber than life—if

that's possible. But we see what gave rise to several hours of outrage for a bourgeois population drunken from its victory and from its seeming impunity: the comparison made by one of Sartre's collaborators, and that more or less any Parisian could have artlessly made, namely that, in his campaign posters, Mr. de Gaulle had the same mug as Hitler. There's no two ways about it. That same day, a newspaper seller (for *Le Monde*, besides), an out-and-out drunkard, a first-class pharmacist, and a distinguished economist said the same thing to me, without anything clearly indicating that they had planned this in advance. Anyway, how could you be surprised: in this field, there's a kind of obscure attraction that makes some posters bring back from the dead the ones that they fear the most. We remember the anti-American poster from the time of the occupation, where Fiorello La Guardia looked like Laval, and that Communist Party poster, one of the first in free Paris, that was traced onto a page from *Signal*. There, as anywhere else, the magic redeems itself and underhandedly produces these mysterious unions that are behind the RPF and the Freudian slip.

The scandal and entertainment therefore are to be found much less in the broadcast itself than in its sidelines: Bénouville and Henry Torrès who pit their "normal and sane" people's taste against Sartre; l'*Huma* that writes "Mr. Sartre attacks de Gaulle, only the naive will fall for it"; and *Paris-Presse* most of all. We know that newspapers, to stick with the metaphors of an elementary philosophy, are similar to Pavlov's dog: given the slightest sign, without there even being any need to offer them their food, they start to drool. But *Paris-Presse* outdoes itself:

> In the event that the broadcast had been produced *before the RPF's victory*, one would consider that Mr. Jean-Paul Sartre's diatribe was the result of an unhappy coincidence. Yesterday's listening would thus prove that *order no longer prevails at Radiodiffusion Française* [I added the emphasis, with good reason] since, over the course of the day, no supervisor realized that it would be *appropriate to postpone the broadcast*...If, on the contrary, the

Sartrian lampoon was designed, arranged, and recorded at some point on Monday, it is then easy to *establish that it was premeditated.*

You read correctly: in the event of an RPF "victory," an organization that is concerned with "order" has the duty to "postpone" any infringement on the winning person. The strange recognition of an attitude that usually wilts beneath the name of opportunism. About this, one might believe that *Paris-Presse* was taking responsibility, if other unambiguous signs didn't lead one to believe in the powerful motives that make this newspaper side with the powers that be—if I dare express myself in this way.

An indignant and clearly sartrifugal woman tells me: "He's so ugly that he needs to take it out on others." Given that, just the day before, I had seen the fake newsreel that the American firm Metro Goldwyn Mayer had fabricated out of a few harmless images and a huge excerpt from the Vincennes speech that was intended to contribute to propaganda for the general's campaign—and I still have the laughter of children in my ears, filled with emotion from the incredible ugliness of this man whose numerous chins seem to have been designed for the sole purpose of holding up his nose, like the bearings of a propeller shaft—initially, I too felt like laughing. Upon reflection, this sentence becomes clearer to me. I remember having read in a text by Montherlant that, when a female audience had been asked to choose the most handsome man in France, they picked Jean Bouin, who was deformed but who embodied the myth of the athlete. Doubtless, for many ladies de Gaulle embodies the male principle (a sort of response to the Holy Virgin for pious and simple souls) and, after all, a ballot isn't as complicated as adultery.

It remains to be seen what really comes out of this democratic counsel made from the weariness and guilty conscience that gave the RPF its majority. When Sartre passes judgement on it, and he does so sanely, it is in the name of a third power, of a refusal to accept the choice between the two blocs. But when it comes down to it, who accepts it keenly outside of a minority

from the two extremes? Do most voters, even including de Gaulle's, not precisely see in him a means to escape from the predicament of foreign influences, by taking refuge in France itself, in this real Country that we are just beginning to get to know? One of the benefits of Marxism is the proven certainty that, whatever we do, there are no three-way fights. Boy scouts from Ville-d'Avray, sons of businessmen from Neuilly, ladies from Oloron-Sainte-Marie don't take part in politics and deny this predicament, but they chime in as a chorus to vote for de Gaulle. Yet, it does indeed seem that there is a third power: the one that flows through each of us. Those who diverge from it: die-hard socialists, French neo-Labor supporters, members of the MRP who excel in their loyalty to nothingness, and underground fascists can all look for the third way and they will end up on one of the two national highways. Between this huge number of third powers and the dispersal in space of its former empire combined with the subtle intrusions that are being made on its territory, France is once again brilliantly showing that it remains the country of Pascal: its center is everywhere and its circumference is nowhere.

Yet, there's no longer a center. The one problem, despite all these attempts at confusion, is the match between socialism and capitalism. And every attempt to restyle this fight with a unifying and blessing hat or a kepi, in reality, only worsens the mess. This ends up artificially drawing together the factors linked to one of the involved forces, which are solicited by an illusion whose abandonment ruins them: this is how we saw some people who were looking to fascism for the death of capitalism and others who saw it as capitalism's best means for survival. We're starting to be enlightened about the worship of these two bicephalous gods; the trick of the Sacred Union, the trick of the French State, the trick of the *Rassemblement*, they've pulled it on us once, twice…For us, the jig is up. There will be enough remaining good families and brave hearts to march the next time they're asked: the guard is dying—and isn't facing up to reality.

I had a friend who was possessed by this passion for the *rassemblement*: one day, he wanted to bring together two electrical

wires, and he blew all the fuses. It's the thought of this darkness that guides my feelings toward neo-Gaullism, and leads me to grant its leader the rank that he really deserves, that of major general...

This thought, and this image—which quickly passed through the current of events—for me, sum up the whole RPF drama: Malraux, a dreamer, the alpha of this mob from Vincennes, at least half of whom were of the ilk that offered swords of honor to Francoist officers, while he was writing *Man's Hope*...

March 1947 TWO LITTLE NEGROES. We already saw it with Dakota, lost in the mountains. Just at the moment when society has been so saturated with horror that any sense of pity has been dulled, it discovers the great reserves of anxiety, for human beings. It so happens that just at the moment when millions of Greek, Hindu, and Palestinian children are living inside of death's kingdom itself, Labour MPs urgently ask for the pardon of two little American negroes who have been condemned to death by electrocution. This reminds me of something very specific: the boss who shakes the hand of one chosen worker on his name day, filling him with such great honor that, the next day, everyone can more happily get back to work.

March 1948 SCIENCE AND LIFE. There is a curious publication that is spreading through bookstores right now. Its title: **Le Da Costa encyclopédique**, fascicle VII, volume II, whose layout, my word, is quite encyclopedic, beginning abruptly at the top-left of the first page with "inexplicable festations," which leads one to imagine an infinite number of preliminary definitions, coming to an end with the description of Marieangela's mystical raptures—and the treats pertaining to it—by way of definitions for which we have been waiting in vain from science until these past few days, such as "**Hectoplasm**—Ectoplasm whose mass weighed in the void is exactly equal to that of one hundred cubic centimeters of distilled water," "**Et caetera**—What parents do not want to tell children," "**Exaggeration**—Nothing is exaggerated," reproducing, for the

first time that we are aware of, a facsimile of the "License to Live," whose inevitable promulgation we felt coming for some time now, and which is only issued for one year and is only valid if it bears the stamp of approval for the current month, whose absence or nullification will lead to capital punishment, increased for foreigners to include deportation...this publication, I would say (owed, let's admit it, to Patrick Wabberg, surrealist poet celebrated by Harold Kaplan in the **Partisan Review** for his struggles in Magnesia against the evil spirit Mala-Parth) appears, for people of right mind and stale sense, as a good joke—and, as such, attests to a strength and a **seriousness** that it would be in vain to search for elsewhere...

January 1952 *CATS ARE PEOPLE TOO. Not too long ago, Esprit made the same claim (though more adventurously so) concerning women. We would like to return to it as it concerns cats, and on the occasion of the Cat Fair that has just siphoned several thousands of tender-hearted Parisians onto rue Berryer. For the news media abounded, the line to get in tailing back beyond the front steps of the Hôtel de Rothschild, as though one big cat were housed there—and the parade through the galleries, the hushed voices, the down time, recalled viewings of dead sovereigns. Half dead as they were, the poor little mousers, as much heat as there was boredom as there were compliments. He who finds you looking awful makes you sick. He who treats you as a mummy turns you into a mummy. We don't have cats: cats have us. Cats are gods, the most widespread and accessible form of god—that's beyond question. But might we not better understand their discreetness, their duty to remain invisible, the unremitting effort they put toward taking an interest in mice, in balls of yarn, in other kitties too, as a way of making us respect their anonymity as gods? This exhibition and its pretensions come out looking to us like one gigantic blunder, like the disguised servant who said "Your Royal Highness" out loud to his disguised master. And these cats—in their stalls, thus discovered, condemned, petrified, wakeful sleepwalkers, interrupted magic spells—were giving us the dazed look of Louis XVI on the royal flight to Varennes. In fairy tales, once the identity was revealed of the prince disguised as a cat, he vanished. They were vanishing. By*

whatever means were still at their disposal in this prison: sleeping, hiding. One of them was sneaking away; they caught him (it was a white one; he was noticed on the dark flooring; he cursed his father). Another one scratched a distressed model (well done). Another one was hiding beneath the veil of his cage. They were, nevertheless, beautiful: Persians that were blue like the smoke of cigarettes, which were probably smoked by their siamese neighbors, whose noses and fingers were stained from nicotine—Abyssinians with short hair, like boy scouts—Russians with short hair, like Russians—and others still, with the mask of Fantômas, with the jabot of Robbespierre, with the nose of Cleopatra, and the Bolivian cat, of frog-ox type, in a display case. So what, women are beautiful too, but it is relatively ill regarded to lock them up in glass cages for three days to be admired by the masses. And even this admiration must be more carefully examined. Let's ignore the details of this matter having to do with marketing, snobs, and idiots. But there's still another problem, one that's been pretty much completely spirited away by our era, that has to do with our general attitude toward animals. I would be less harsh regarding the worship of cats—the massive cat King Karoun's private bedroom and its adjacent literature—if man's alienation from them was the only thing I could see there. The same goes for other, more serious forms of alienation too. But the animal also comes out alienated, and when that happens it's just not right. I'm not kidding: humanity has a duty for dialogue with creation. It works out just fine with regard to plants, elements, and the good Lord. But when it comes to animals, at every moment a deviation always lies in wait: no longer treating them as animals, but as substitutes for humans, in the name of some obligation for dialogue. The old girl and her parrot, the divorcee and her cat, Léautaud and his monkey, they all betray humanity, and they betray animality too. The unbearable slogan on our ashtrays, on our plates—"The more I see men, the more I love my dog"—contains the seeds of the amputation of a whole piece of the created world, this contempt by which I impoverish myself without enriching others. Who could get us out of there? Between the repression-animal, the furbaby-animal, the royal poodle, the jester monkey, the exhibition cat, and the haughty indifference to which the wild animal attests, there might be room for an intercession. Perhaps it might be the task for a new religious order. Perhaps it

might be desirable for this natural tendency to speak with the planets that seems to take hold of the Church at a high-up level in the hierarchy to devote itself, at a more humble level, to the perpetuation of simple and pure relations with the animal world—for us to have animal orders of monks, just as we have herbalist orders and musical orders...

Till the end of time

P AT CORMON SOLD HEAPS OF COLD THINGS in a shop that itself looked like a refrigerator. The morning after V-J day, when this rain began that would not stop until two days later, he went to his door to see the show.

People began to run or to head inside the houses. All at once the sky grew empty, like a playing field. Somewhere above Pat's head, a lit-up advertisement agitated and licked the building facades bathing them in big strokes of blue, swaying, swinging, inviting seasickness. Level with the sidewalk, a burst pipe sculpted gargoyles out of water. Little by little, a ghost of the inverted city hollowed out the road, and men and their doubles, like unfolded cutouts, flitted into the void.

Jerry appeared in the boutique just as the world was born out of chaos. The seven days of Creation, rolled into a ball in his fur-lined coat, fled through the chaos-room, in the perforated chaos-light of the chaos-rain, dropping off Jerry-Adam in his Navy uniform, the color of Earthly Paradise. The Eternal, by which I mean Pat, welcomed him rather grudgingly, but Jerry did not seem at all concerned by that.

— It's really over, that good old war, he said with satisfaction.

— We had the Law to ourselves, Pat solemnly responded.

— Sure, Jerry said. The Law's a good thing too. And so is the Bomb. Two good things for us—right, Pat? We're a big country.

— A soldier shouldn't joke about these things, said Pat.

— Sorry, said Jerry. I haven't had the time yet to learn how a soldier is supposed to behave around civilians. If you spend

enough time in foxholes, you become a fox yourself. I'm going to have to learn the language of the hens. That way I'll be able to hold a conversation with you without shocking you.

— You don't say, lousy son of a...

— Don't be vulgar, Pat. If the angels hear you, they'll repeat it to all the good people of this city, and they'll take away your clientele.

— I'm sorry that you've gone mad, said Pat.

— I'm delighted about it, said Jerry.

Night was falling. The suds of light endured, turbulent, increasingly nauseating.

— Nasty weather, said Jerry. I had a gig in the Park—now it's drowned. I'll go to the Flit Flat instead. You wanna come?

— Sure, said Pat, sure I'm gonna run out in weather like this to listen to some damned nasty negro drool into a trumpet.

— I see, said Jerry. You still have ideas about negroes. It's prejudice, if you know what that means. I met some of them on the other side of the sea who drank exactly as men do.

— If you want to know what I think, it's that you're a nasty guy, Jerry, said Pat. My boy, you've gotten to making jokes and rambling about things. You're good for nothing now, if you want to know my opinion.

— You're awful good like that, Pat, said Jerry. You gesticulate in front of the display windows, and the rain lights you up from every which way, just like the ape in that good old Sandburg thing, you know...

And Jerry planted himself in front of the door, in the suds of the light, gayly reciting:

There was a tree of stars sprang up on a vertical panel of the south
And a monkey of stars climbed up and down this tree of stars...

— There you go now with your damned poetry, Pat groaned, turning his back to Jerry.

Night had now completely fallen. A flood of streamers, tossed from a window the night before, had twisted itself around the arm of a lamppost above the boutique, and this illuminated branch, criss-crossed by the rain, appeared as

though powdered with the phosphorescent snow that they put on Christmas trees.

— It was only a dream, oh ho, yah yah, lou lou, only a dream, five, six, seven, five, six, seven, Jerry enthusiastically finished.

— There is not one grain of sense in anything that you're saying, Pat kindly observed.

— You'll never understand that there are words that topple the world, said Jerry very excitedly. Nothing stays put anymore, exactly as though the place that we're in all of a sudden set out on its way, you see, and started wandering about the entire city.

— Well my feet are firmly on the ground, said Pat angrily. And you could talk like this for weeks, and neither you nor I would have our feet any less firmly on the ground, and the same street wouldn't stop being in the same place, and the whole old dump surrounding it, till the end.

— Till the end, said Jerry. But that's the thing, the end, it'll eventually have to come. Right? What if the old dump gave in, right Pat?

Pat shrugged with exasperation. He hated Jerry, who always came around to tell half-dreamed-up stories, and you could never tell if he was serious or if he was making fun of you. I wonder if he finds all this in books or what. And what beats everything is that you can't take a soldier whose been decorated, wounded, all that, and send him packing. And this sort of malaise that went along with his visits, as if in his bouts of madness he had touched a sore spot somewhere inside of you, something hidden, something shameful, a dormant pain whose meaning had been lost, but that lived on, that lived on, like remorse. And just at the thought of it, the pain would awaken, a sort of shortness of breath, a sort of disgust, as if a woman seated beside you abruptly were to decompose. Fittingly, Pat saw a woman stepping out of the rain, and her face of death in the blue and purple dizziness of the rain. On the threshold now, then inside, and asking permission to take shelter during the shower. Pat grunted a vague assent, completely overcome with a nausea brought on by purple light and the end of the world. The water gargoyles got the hiccups. The branch of the

Christmas tree shining in the swaying light, vibrating beneath this dead glimmer, rippling, this sort of obscene, craven, stubborn stroking.

— You know what I thought about, Jerry went on more quietly. It's something you shouldn't really say, but with you, it's no matter, you won't believe it. You know what loads of us thought about, in the foxholes and elsewhere? The only thing that we brought back with us?

— I'm not listening to you, said Pat. He was devoting all his willpower to not sticking his fists in his mouth, to keeping them in his pockets.

— That's right, Pat, exactly. The end of the old dump. Don't take me for one those old nutcases who hollers that the world is gonna blow because we offended the Eternal. Not at all like an explosion or some heavenly wrath. Something, if you will, like... putrefaction. Cities in ashes, your legs and your hands and the table and the stones all muddled together, as one, like chains and the feet of prisoners. And a shop like yours, Pat, that dislocates itself and heads out crossing the streets all the way to the sea.

The woman looked on with surprise. She had the beautiful face of a Northern warrior, and a violent mouth, swollen, glistening from the rain. The upper part of her face was veiled by the shadow of the door. Her mouth remained in full light, strangely helpless and available. From the moment he had seen her, Pat felt his breath growing shorter.

Jerry seemed to have completely lost sight of the end of the world and his prophecies. Perched on a corner of the counter, he was imitating Frankie Boy Sinatra. Outside, the swaying lighting appeared more rapid, less forgiving, dragging the building façades along on its carousel ride, tugging on the city and trying to make it crack. Pat was looking at the woman's mouth, gleaming like a lantern. My Nancy, Jerry sang, his arms open in a gesture of admiration. Water gargoyles, the color of stained glass. On the woman's lips, the light poured into her purple, impure kiss. Pat was shaking. Jerry jumped up and down, wriggling into his fur-lined coat, still singing.

— ...You can't resist her, sorry for you, she doesn't have any sisters, not one...I'm off to the Flit Flat, it's too sad at your

place, Pat. I'm leaving you, so try your best to be decent with the girl. Farewell, little sis. See you later, Pat. He dove into the rain, the dead light, the flickering facades. Pat and the woman remained motionless for a long while, behind the display windows, in silence. And the movement of the shadows brushing past the woman's mouth, in a sinful light.

Here's something odd. Pat Cormon thought that he knew his street and his everyday landscape thoroughly. In this squarely built city, everything lined up, everything interlocked. Whenever you stood up, centered in front of his door, the door across the way fit perfectly inside of his door's smallest windowpane. In his hours of idleness, Pat had undertaken this experiment more than once, closing one eye then the other to see it pop from one side to the other. Had he always been wrong or was it still an effect of this damned light, you could've sworn that the door on the other side of the street was too big for the windowpane. Pat started closing one eye then the other, then realized that he must have seemed completely idiotic and stopped. Damned light.

— Your friend, he seemed restless, said the woman. Pat watched her mouth, with amazement, as if he was just discovering that she could also speak. She had a nice voice—smooth, dark, spirited—like her lips.

— I think that he was drunk, said Pat. He was talking about the end of the world.

— It's interesting, said the woman with a little laugh. That actually interests me a very great deal too. She pressed her forehead against the windowpane. The light climbed along her face. The flesh around her eyes was bit paler. When she lowered her eyelids, you might have said two freshly filled-in tombs. I had a friend who made plans to meet with me at the end of the world. Since then, I've been waiting.

"Well alright," thought Pat with hatred, "now there are secrets." And at the same time, he looked across the street. His eyes wrinkled. Damned light. The other door seemed to have moved again.

— You have a nice voice, said Pat. And he surprised himself by having said that.

— Yes...He would also tell me about my voice. He would say...that it existed outside of words, like music. And also, that the Angel of Death might call out to him with my voice.

— Is he dead? asked Pat, just to say something.

— Not even, said the women. She lifted her head. The shadow fell all the way to the level of her mouth, biting slightly into her upper lip. Pat was looking at her sideways, short of breath, and at the same time realized that, out of fear, he no longer dared to look at the other door.

— He wrote me: "Your voice remains within me, like an open wound. Like a wound that might call out to me with spirited lips, with your lips." Do you also write things like that?

Hearing her speak about her lips, Pat began to shudder like an animal in pain.

— No, I don't write things like that. I don't think them, I don't say them. More nonsense, he shouted, like the other guy with his end of the world.

— Yes, she said, you don't believe in it. And yet...Her voice had remained very calm. And yet the other side of the road isn't quite in the right place anymore. And you know it.

Pat turned back around, frightened.

— What are you saying?

— And you won't dare to look at it anymore.

She lowered her head. And, once again, the light climbed up to her pale hair, once again her eyes closed, fresh tombs, once again mauve and blue bite marks, like shadows, on her lips.

Pat felt that something in his head was growing harder and curling into a ball, while everything else was moving like crazy. He dared to look outside. The door across the way was now even with the right windowpane. It was clearly still drifting. Both sides of the road were sliding slowly, like two ships passing each other, side by side. Pat was suffocating from fear. He vaguely heard the woman pronounce a name, a movie theatre name, the name of a movie theatre that was situated a little farther away, on the left, on the other side of the street. He repeated it mechanically, then repeated it again, bordering on gibberish, when he saw the cinema itself, a sparkling mass,

square, arctic, projecting a large block of white light into the street's free-flowing decay.

— Are you afraid? said the woman.

Then Pat started to shake. From the depths of the night, the houses fell into place and rose up like pieces of a stage set. They are as rigid and as threatening as great Assyrian winged lions. There's a movement happening in the city. Demons load the building facades onto their backs to prepare the show. The nauseating carousel of the purple, mauve, blue light, leads all this along and guides the march. Like a heavy tray that's been rattled, the street is turning faster and faster. The mad windows are fox hunting around the bright lantern, around this woman's mouth. Pat is seized by his obsession with this mouth. The water gargoyles hiccup toward her, warriors dying at the feet of a desired woman. The light pulls on the houses, distorts and abandons the houses like lost children, and escapes from the houses to strike through this mouth like an enraged and impure licking, before disappearing. The Angel of Death calls out with Her voice. And from the depths of the foxholes, Jerry, and all the dead, gesture at the cities that pass by. They're hitchhiking for houses, but nobody stops. Pat can guess everything that is going to happen, the boutique down to the end of the road, and then the sea. And in front of the display windows, just as fixed, just as still as before, like passersby or cars, headlights bolted into the night, the clouded images of radio calls, seeking the aid of the stars, and ships silently sliding under the windows, in the mist, branded by their flames. And this mouth. Branded by this mouth. The great ships calling for help.

— The great ships calling for help...said the woman.

— Listen...said Pat. I don't know what you came here to do...

He was shuddering. The woman was close to him, her warm and helpless mouth, like a dead bird. He realized that he hadn't even perceived her body, lost in the shadow and muddled into the mixing lights, but from which something rose that was at once a promise and a threat. He didn't dare look at her eyes, but in her breath, which drew nearer and nearer, he

smelled a bodily scent wet with rain, with bitten fruit, and just like a taste of annihilation.

Suddenly, he threw himself backward.

— Get out, he said with rage, I don't know what you came here to do, but get out, before...before...

She remained for a moment without moving, facing him, without even feigning surprise. His hands banged on the counter without managing to settle down. Outside, you could see nothing more than the arm of the lamppost, similar to a Christmas tree branch, sparkling in the night beneath the scribble of the rain. Somewhere above their heads, a lit-up advertisement agitated and licked the building facades bathing them in big strokes of blue, impure, slow, stubborn kisses.

And the motionless mouth, in the shadows now, like a beast ready to pounce.

— Get out, Pat repeated.

She turned around, put on her hood, put her hand on the door. Pat closed his eyes, heard the sound of the door. He walked out next, followed her with his eyes. The street was in its place, the doors were properly aligned. He followed her with his eyes for a long time. She kept moving, taking little steps in the rain, with a very consistent, very distinct gait, her head lowered slightly beneath her hood. A passerby like any other.

Pat came back in, completely soaked. The rainfall was calmer, straighter. A ghost of the inverted city inhabited the street. The light was turning. Level with the sidewalk, a burst pipe sculpted gargoyles out of water. Pat shook his head, as though he were hunting them, with drops of rain, dead phantoms and the dregs of this ever so strange, ever so strange era.

October 1945.

Le temps n'est que blessé. Il ne s'arrête pas.

Mars 1947

LE MUSICIEN ERRANT. Maître Cortot, perché sur un arbre généalogique, tenait en son bec un fromage : la régence de la Musique, au sein de la Famille, à Vichy. À ce titre, il se fit un certain nombre d'ennemis parmi les musiciens évincés par ses soins, qui se jurèrent de lui garder un violon de leur viole. D'où une interdiction temporaire de paraître en public, à la Libération. Les temps étant venus, le voilà qui annonce des concerts. Mais point d'affaire : les musiciens le chahutent, et toutes les villes où il annonce sa venue lui font rebrousser chemin. Curieux spectacle d'un pianiste que chacun se renvoie, comme au billard Nicolas. Comme légalement il est blanchi, et que d'autre part un public impatient de le revoir conteste même son temps d'interdiction, une seule constatation s'impose : c'est que de part et d'autre, on s'accorde à considérer la Loi comme nulle, et les décisions officielles comme une plaisanterie. C'est peut-être dans ce secteur limité mais sûr qu'il convient de rechercher les fondements de l'Unité Française.

Juin 1947

POLES. Parce que dans nos esprits le « tour du monde » se faisait toujours plus ou moins parallèlement à l'Équateur, parce que les deux tropiques nous paraissaient les limites normales du passage clouté qui permet de traverser la Terre, parce que la Terre elle-même se tient debout comme une grande, et que pour l'étudier de plus près nos classes nous en donnaient une image plate et déformée, nous n'imaginions pas qu'un jour les chemins les plus courts pussent passer par le pôle Nord, ni que pour avoir une claire vision de certaine conjoncture géographique, il convînt de regarder notre globe par en haut. Il a donc fallu que les revues américaines nous désabusent en montrant par d'excellents croquis que les distances (à vol de bombes les plus réelles entre États-Unis et U.R.S.S.), se dessinent d'un bord à l'autre de l'océan Arctique et que l'exercice dit du Bœuf musqué (dont le thème, on s'en souvient, était « attaque venant du Nord ») nous bouleverse la carte des grandes invasions. Rêvons un peu là-dessus : est-il possible que le monde change de perspective, que les

planisphères futurs fassent tenir ensemble, dans leurs vrais rapports, les grandes nations ennemies, tandis que ce sera notre tour, vieille Europe, d'être étirée dans les coins comme l'est aujourd'hui le Groenland, ou la Sibérie? Est-il possible que ce rôle de chemin, de carrefour, de cratère d'une civilisation que le monde ancien avait dévolu à la Méditerranée, ce soit le pôle Nord qui l'assume désormais? Après le tiède creuset qui rejoignait la chrétienté à l'Islam, les nouveaux temps verraient marxisme et capitalisme s'affronter au-dessus de régions stériles et glacées? Avouons que la symbolique n'y perdrait pas.

Août 1947 *INFORMATION. Le vendredi 4 juillet 1947, tous les journaux ont publié un état récapitulatif du complot des cagoules (lequel, s'ajoutant au complot des soutanes et précédant de peu le complot des sandales, achève de dessiner à notre horizon la silhouette bien connue des Familiers du Saint Office). Chaque accusé faisait l'objet d'un petit paragraphe, où sa situation du moment était exposée et commentée avec cette précision dans la documentation et cette objectivité dans les conclusions dont s'honore à juste titre la presse française.*

Et voilà ce que ça donne, en ce qui concerne Max Vignon:

> FRANC-TIREUR. — « Il a été établi que le journaliste Max Vignon, appréhendé la veille, n'a aucun lien avec le journal clandestin *Le Réseau*. La police s'est en effet aperçue qu'elle avait pris un Vignon pour un autre. L'autre, c'est Pascal Vignon, ancien milicien, animateur du *Réseau*; c'est celui que l'on recherche. Max, lui, résistant depuis septembre 40 au réseau Georges-France, ex-directeur politique de *XXe siècle*, fondateur d'un journal clandestin sous l'occupation, a été rapidement remis en liberté par le juge. »

> L'HUMANITÉ. — « Les renseignements généraux ont interrogé Max Vignon. Et l'ancien collaborateur de

Radio-Paris a eu l'audace d'exhiber une attestation de ‹ résistance › signée du lieutenant-colonel Josset du service des Renseignements des Forces Françaises Combattantes. Décidement, certains officiers supérieurs de l'entourage de de Gaulle utilisent tous les moyens pour sauver leurs amis compromis dans le complot de la Cagoule... Toujours est-il que le juge d'instruction Lévy n'a pas hesité à le mettre en liberté provisoire. N'avait-il pas promis récemment pourtant que les cagoulards seraient châtiés ? »

L'ÉPOQUE. — «Apres avoir été entendu par M. Robert Lévy, juge d'instruction, M. Max Vignon, ex-directeur politique de l'hebdomadaire *XXᵉ siècle*, a été remis en liberté. ‹ Je n'ai, a-t-il dit, aucune déclaration à faire, en raison du caractère secret de l'instruction. Je puis toutefois préciser qu'une enquête minutieuse a établi qu'un individu s'était servi de mon nom dans une affaire délictueuse. › »

Comme disait notre grand camarade Pascal, tout le malheur des hommes vient de ce qu'ils ne peuvent se tenir à un journal.

Janvier 1951 CROIX DE BOIS ET CHEMIN DE FER. À Ploen (Schleswig-Holstein) je monte dans le train de Kiel. C'est la pluie balte, qui contient de la lavande, comme chacun sait, et juste assez de mélancolie pour vous faire des âmes de conquérants. *Die Haare, die Haare, sind grau von Baltikum...* Il est là, dans mon compartiment, le conquérant. C'est le contrôleur. Il appartient à cette génération, à peu près introuvable en Allemagne aujourd'hui, des gens qui ont eu vingt ans en 1940. À part cela, petit, les yeux très clairs, le teint très rose, la visière de la *Deutsche Reischsbahn* fendue comme celle des troupes de montagne — et cet air inimitable de bébé militaire — il est honteusement conventionnel. Dès qu'il a repéré mon accent, il s'assied en face de moi, m'offre une cigarette et déclare : « Je ne connais pas la France. »

C'est dommage, mais ça me fait plutôt plaisir. J'étais déjà résigné à subir le récit de ses garnisons à Bayonne ou à Deauville — le trentième depuis le début de mon voyage. À croire qu'ils s'imaginent que ça nous fait plaisir d'entendre parler du pays. Comme cet autre, à Lübeck : « Je suis arrivé à Paris en juillet 44, mais nous avons dû repartir tout de suite », et, me prenant à témoin : « Pas de chance ! »

Il ne connaît pas la France, mais c'est tout juste : Belgique, Hollande, Italie, Grèce, Ukraine, il a fait tout ça, de 40 à 45. Et mobilisé dès 38, prisonnier un an : en tout huit ans de guerre. Plus ses parents enterrés sous les morceaux de leur maison, sa province inaccessible, le chômage pendant deux ans, l'impossibilité de reprendre ses études, maintenant le chemin de fer. Une recrue de choix pour l'appel de Stockholm. Mais je n'ai pas besoin de lui en parler. Sans transition aucune, il entre dans le vif du sujet : « Le Russe, dit-il (en Allemagne, on dit *les* Américains, comme les moustiques, et *le* Russe — *der Russe, der Ivan* — comme *le* tonnerre. En Allemagne, tout ce qui compte, même dans l'ordre de la crainte, doit être abstrait), le Russe nous réduit en esclavage, dans la zone Est. Il attente à la dignité de l'homme… » Suivent cinq minutes consacrées à la liste des méfaits du Russe « et cela, nous y sommes formellement opposés ! »

Sur quoi le train entre en gare. Le contrôleur fonce sur le quai et se met à rugir des noms de stations sur le ton des adieux de Wotan, me laissant juste le temps de méditer sur la façon dont les anciens de la Wehrmacht s'opposent formellement à la dégradation de l'homme — et hop ! il est déjà revenu sur la banquette. « D'ailleurs, dit-il, Eisenhower est un imbécile. »

En voilà un qui n'est pas gentil pour son futur commandant en chef. Je lui demande des précisions. Il les apporte : « En 1945, les Américains étaient forts, l'armée allemande de l'Ouest était presque intacte, il fallait tout de suite tomber sur les Russes. Eisenhower a laissé passer l'occasion, et maintenant il est trop tard. »

On a beau avoir l'habitude, ce genre de déclarations vous coupe toujours le souffle. « En 1945, dis-je avec patience, les Américains *vous* faisaient la guerre. Et je ne crois pas que les

GIs qui venaient de découvrir les camps de concentration vous auraient facilement tolérés comme alliés. Il a fallu cinq ans pour leur faire oublier ça.

— *Ach*, toujours les camps de concentration, gémit-il. Il faut voir les deux côtés de la question, *wir müssen objektiv sein*. Vous êtes occupant, maintenant, vous devez comprendre. Si je faisais partie d'un mouvement de résistance contre les autorités d'occupation, vous me mettriez dans un camp de concentration, c'est forcé.

— Je ne crois pas que *moi*, je vous mettrais dans un camp de concentration, dis-je.

— Bah, vous avez des prisons, en France, c'est la même chose...

— Ce n'est pas la même chose. Chez nous, l'humiliation de l'homme n'est pas une industrie...

— ... et de toute façon, maintenant nous devons être de nouveau amis, il faut oublier tout ça.

— Il ne faut rien oublier du tout. Mon meilleur ami est mort dans un camp de concentration, et voilà cinq ans que je fais de l'éducation populaire en Allemagne — parce que je n'ai pas de haine pour le peuple allemand. Mais c'est justement en n'oubliant rien, en nous souvenant ensemble des camps de concentration, que nous arriverons peut-être à travailler ensemble à un monde sans camps de concentration. Je ne vous demande pas d'oublier les bombardements...» (Et je pense au double bombardement, de Mayence : une première vague, incendiaire — et une heure après, les maisons brûlant, les gens dans les rues, les équipes de secours au travail, une seconde vague...)

Il fait alors ce geste d'effacement que seuls les Allemands savent faire, en déplaçant l'avant-bras comme un essuie-glace devant le visage — geste magique, exorcisme par lequel la chose rejetée cesse d'être, cesse réellement d'être, d'avoir jamais été — geste qui donne son sens au «il faut oublier tout ça». Le même geste en 1945, et cinq ans de guerre à l'ouest étaient effacés, le gars était prêt à se battre contre les Russes au côté des ennemis du matin, sans arrière-pensée. «Les maisons, les morts...» dit-il, et il efface. «Mais l'âme, il y a l'âme... Nous devons défendre l'Europe chrétienne.»

Je jure que je n'invente pas. Il y a eu tout cela à la fois : le regret de n'avoir pas continué la guerre contre les Russes ; la défense des camps de concentration et l'Europe chrétienne. Tandis que le train roule lentement parmi la brume, matin semblable à tous les matins de guerre, avec le même bruit, le même givre sur les vitres, et des soldats anglo-norvégiens qui passent dans le couloir pour parachever le souvenir — j'essaie de lui répondre, ce qui, après une nuit blanche, en face de cette confusion, et en langue allemande, est déjà une performance. Je lui parle des dangers de la bonne conscience, de notre responsabilité du monde, de l'illusion de guérir un mal par le mal pire de la guerre et, prudemment (le Russe est à quelques kilomètres), de la révolution nécessaire. Il m'écoute sérieusement. « Les Américains peuvent bien bâtir un mur contre les Russes, ce mur sera bâti sur nos corps. » « Le communisme est fait de toutes les fautes des Chrétiens » ; ces formules lui plaisent, il acquiesce. Mais je n'ai pas la prétention de changer la *Weltanschauung* d'un contrôleur de la *Deutsche Reichsbahn* entre Ploen et Kiel, et quand nous nous quittons, très cordialement, sur le quai, je me demande encore dans quelle mesure il ne porte pas, enfouie sous toutes ses bonnes raisons contradictoires, la nostalgie de la conquête.

J'en verrai encore bien d'autres, avant mon retour : des professeurs à binocle sortis de l'Ange Bleu, des étudiants doués d'une insatiable curiosité comme l'enfant d'éléphant, des géants au teint d'endive qui me serreront les mains avec transport parce que si tous les hommes étaient frères, le monde irait mieux, des costauds aux nerfs de femmes qui pleurent de joie à l'annonce du plan Schuman et se convulsent quand on parle de Mao Tse Tung — pacifistes par lassitude, bellicistes par intuition, confusionnistes de naissance — bourrés de connaissances et vides de culture — gros enfants qu'il ne faut pas effrayer, doublés de simples d'esprit qu'il ne faut pas égarer, triplés de nègres qu'il ne faut pas offenser — complaisants, polis, hantés, sensibles, actifs, irritants, désarmants — si j'ose dire...

Juin 1947 LE PAIN ET LE CHIEN. Depuis quelque temps, je constate qu'Oxyde, le chien affectueux, honneur et délices de ma maison, se refuse obstinément à bouffer la moindre miette de pain. Avec le bel égoïsme de ma race, je m'en inquiète peu jusqu'à ce qu'un rappel involontaire m'enseigne que le chien Oxyde a cessé de toucher au pain du jour où celui-ci a subi certaines modifications exigées par le gouvernement. Cela ne laisse pas de m'émouvoir. Oxyde ne lit pas les journaux, ne sort jamais : l'observation n'a donc pu venir que de lui. Qu'entre-t-il donc en ce pain, Seigneur, qui dégoûte à ce point un animal moyennement raffiné ? Tous les jours, je tente l'expérience le cœur battant. Son refus persiste. Le voisinage s'y intéresse. Des paris sont engagés. Ingénieux gouvernement, qui nous donne le pain et les jeux tout à la fois, sous la même forme, et comme le magicien noir nous fait manger des énigmes...

Février 1957 IMPORTÉ D'AMÉRIQUE. Lorsque, dans l'obscurité de ce cinéma new-yorkais, notre Don Juan de Brooklyn frôla une fourrure veloutée et fleurant le musc, aussitôt imagina-t-il la tendre créature luxurieusement nippée par un homme d'affaires qui lui apporterait, d'une œillade, la paix du cœur et les douceurs de l'entretien. Et sans plus tarder dériva sa main soignée vers les doigts qu'une large expérience lui promettait revêtus de gemmes et lunés de sang. Quel ne fut donc pas son étonnement de rencontrer, au terme de la fourrure splendide, une griffe crochue quoique rognée, tapie dans les poils comme un piège à loup. Et quand son regard habitué aux ténèbres decouvrit, où il attendait voilette et rimmel, le museau courtois d'un fort bel ours, dare-dare s'en fut Don Juan protester auprès de la Direction contre l'admission des plantigrades dans les cinémas de Broadway. S'en vint alors la Direction, prudemment, auprès du second voisin de l'ours, et lui dit : « Monsieur, n'est-ce pas là votre ours ? — Si fait, répondit l'homme. — Comment donc, repartit la Direction, trouvez-vous raisonnable d'emmener un ours voir un film ? — J'ai peut-être eu tort, convint l'homme d'un ton penaud, mais quoi, il avait tant aimé le roman... »

Mars 1947 *LES TROIS PETITS COCHONS. C'est ainsi que je les désignerais si j'étais le Grand Méchant Loup. Qui? Attendez: peut-être, lorsque vous pensez à la guerre d'Espagne, avez-vous trois titres qui vous viennent à l'esprit, comme les plus belles expressions de ce drame: «Pour qui sonne le glas», «L'Espoir» et «Un Testament espagnol».*

C'est là que je vous arrête. Pour comprendre qu'Hemingway n'est «pas un homme de gauche», il suffit de lire «Pour qui sonne le glas»? Ce n'est pas moi qui le dis, c'est quelqu'un de beaucoup plus «dans la ligne». Et saviez-vous que Koestler, à la veille d'être arrêté par les franquistes, disait qu'il n'avait rien à craindre? (Courtade, dans Action*). Suspect, n'est-ce pas? Quant à Malraux, il serait de mauvais goût d'insister. Dommage tout de même, quand on y pense, que l'histoire héroïque du prolétariat (texte d'une annonce d'*Europe *pour «le Temps du Mépris» avant-guerre) soit écrite par des fascistes.*

Les vivants et les morts

par Chris Mayor

... car ce n'est pas à des anges
que Dieu a soumis le monde à venir...
Heb. 11:5.

DANS LA VOITURE luisante et bourdonnante comme un insecte, le conducteur ronronnait. Lorsqu'il s'arrêta le long des jardins et que le voyageur l'eût royalement récompensé, il attendit que le soleil fût plus bas, pour repartir dans une ville de corail. Cet instant permit au voyageur de revenir sur ses pas. Son chapeau blanc à larges bords, son manteau flottant avaient des reflets d'argent. Il vint à la voiture, ouvrit la portière, prit sur la banquette une étrange chose légère et lumineuse, toute ronde, qui vola un moment au-dessus de sa tête avant qu'il eût rabattu son chapeau et repartit d'une démarche impérieuse, un peu voûtée. C'est alors seulement que le conducteur reconnut l'archange Gabriel.

✳

Gabriel se hâtait maintenant par les jardins déserts du crépuscule. Un grand vent y apportait déjà de contrées perdues loin dans l'Est l'odeur et les images de l'hiver prochain. Le soleil s'y décomposait, et ses éclats de verre givrés, repris par le plomb du fleuve, faisaient un vitrail sombre sous l'ogive des

ponts. La ville repliait frileusement ses arbres dans les avenues. Saisie de peur à l'approche des géants muets de la saison glacée, elle allumait en désordre une constellation tremblante de feux et de lampes d'alarme. Le ciel droit comme un front d'enfant malade avait une roseur de fièvre. Gabriel écoutait distraitement la ville geindre et frémir comme un dormeur, et la cadence régulière de sa pulsation la plus profonde : le pas des hommes d'armes dans les rues éloignées. Dans ces jardins royaux, peuplés de statues tristes, l'armée ennemie n'entrait pas. Le monde froid de brume et de métal qu'elle apportait entre les taches vives et ses drapeaux s'arrêtait aux frontières de cette puissance morte. Les soldats eux-mêmes reculaient devant la saisissante douleur de ces sentinelles de pierre qui se souvenaient d'avoir été des hommes. Au-delà, c'était entre des chevaux cabrés l'ouverture d'une place rayonnante où se plantait, comme un manche de dague, une borne d'énigmes — puis l'avenue triomphale pleine d'images dansantes — puis, tout au fond, l'arc immobile et clair, le lourd aimant tirant la limaille étoilée des maisons et des brouillards. Les bruits s'étouffaient lentement, mer qui se retirait, laissant derrière elle comme des algues un entrelacs de rues désertes. Et Gabriel pensait à ce peuple nocturne qui attendait la marée.

Quelqu'un vint parmi les arbres. Gabriel reconnut le garçon qui lui avait demandé cet étrange rendez-vous, et fit quelques pas à sa rencontre. Il fut frappé de la dureté de son regard. La dureté froide qu'il avait vue dans les yeux de certains guerriers n'avait pas ce cerné lumineux et riche, cette secrète profondeur de domaine interdit.

— Je vous ai fait attendre, dit-il. Et sur le même ton uni : Je m'appelle Vincent.

— Vous avez raison, dit Gabriel.

— Je m'excuse de ce rendez-vous. Tout à l'heure, nous irons chez moi... mais je ne pouvais vraiment pas vous y attendre. Ce... ce n'est pas un endroit pour les anges. On... Il hésita et dit très vite : On n'y croit pas. Et puis...

— Vous cherchiez un endroit libre, acheva Gabriel.

Vincent rougit : Libre, c'est aussi votre avis, n'est-ce pas ?

C'est un endroit tellement extraordinaire. Ils n'y viennent pas. Son regard se durcit encore. Ne croyez surtout pas que j'aie peur... d'eux. Seulement, c'est comme pour parler des démons : il faut choisir un endroit qu'ils aient déserté. Cela ne vous fâche pas, que je parle des démons ?

— J'en connais beaucoup, dit sérieusement Gabriel.

— Évidemment... Vincent le regarda curieusement... Vous connaissez aussi l'Enfer ?

— Non. C'est peut-être le seul point, où vous soyez plus... avancés que nous. L'Enfer, c'est la séparation. Nous ne sommes jamais séparés.

— Il... Vincent se mit à rire. J'allais dire une chose bête... J'allais dire qu'il vous manque quelque chose.

— C'est vrai, dit Gabriel, il nous manque la réconciliation. Le soleil grésilla au ras des collines. D'un coup, les ombres s'allongèrent jusqu'à se confondre avec la brume. Et ce furent, par des teintes de plus en plus sombres, les prologues de la nuit.

— Mais c'est de votre aide que j'ai besoin, ajouta Vincent après un silence.

— C'est pour cela que je suis venu, dit Gabriel.

— Merci, dit Vincent. Ses idées tournèrent comme un phare. Il fit face à Gabriel. Il ne faudrait pas qu'ils détruisent cette ville.

— En tout cas, ils l'ont minée.

— Au sens propre ?

— Vous voulez dire : Par le sol ? Par le sol aussi. Mais par l'âme d'abord. Le sens propre, comme vous dites, vient toujours après l'image. Cette ville est encore intacte, et pourtant... Il y a en elle une tristesse qui est plus, et autre chose, que la tristesse de ses habitants.

— Cela, c'est exact. J'avais cru que c'était mon inquiétude que j'y retrouvais, qu'elle me la renvoyait comme un miroir, mais c'est autre chose.

— Je ne suis pas dans cette ville depuis longtemps, dit Gabriel, mais je n'ai pas encore entendu sa voix. On dirait qu'il y avait ici un timbre, un ton qui lui donnaient son vrai sens, sa vraie place, et que maintenant son angoisse est celle d'une femme muette qui passe sa nuit à essayer un cri, toujours le même, et jamais n'y arrive...

— Vous parlez bien, pour un ange. C'est vous qui étiez de garde au Paradis Terrestre, après la faute ?

— Non. C'est un autre. Il y est toujours, d'ailleurs. Toute cette vieille histoire vous intéresse encore ?

— Oui. J'ai une grande tendresse pour l'enfance du monde… Quand on ne s'était pas aperçu que tout était à recommencer, perpétuellement…

Dans le jardin, les statues frémissaient. Les plus lointaines effleuraient déjà la nuit du bout du pied, pour la connaître avant que d'y plonger. D'autres s'essayaient à marcher sur les pelouses. Les sentinelles sourdes se gantaient de noir.

— Quand on n'avait pas appris cette belle tristesse, dit l'ombre de Vincent, statue de sable parmi les autres.

— Vous parliez de mon aide, dit Gabriel. C'est cette menace contre votre ville qui vous inquiète ?

— Pas exactement. Mais, à la hauteur où je vis en ce moment, toutes les lignes se confondent. Et comme cette ville est ce que j'aime le plus au monde…

Gabriel sentit monter vers lui un appel d'enlisé :

— À quoi puis-je vous aider ?

— À mourir, dit Vincent.

<p style="text-align:center">✳</p>

Ils sortirent du jardin. La nuit était tirée au ras des toits. Sous les arcades, des femmes rapides, des sentinelles droites, des groupes de soldats. Les vainqueurs assiégés n'osaient plus sortir seuls. Le sol tremblait de machines souterraines. Une voiture approcha en silence, feux éteints. Elle ralentit à peine pour prendre Gabriel et Vincent, et tourna aussitôt dans une rue gardée par un cavalier d'or. Un grand garçon aux cheveux en désordre la conduisait.

— Il ne faudrait pas qu'ils nous arrêtent, dit Vincent.

— Nous serions bons, précisa en riant le conducteur.

Gabriel sentait en lui le grand désir de les défendre, de les sauver. Il épia les barrières blanches, les guetteurs immobiles aux carrefours, les lanternes dansantes, tout ce qui aurait pu être un signe ou une menace.

Un appel éclata derrière eux. Rayonnante de faisceaux, vibrante de sirènes, une puissante machine les dépassa, mugit, reprit de la vitesse. Ils eurent le temps d'y reconnaître les parements rouges d'un officier. Vincent se pencha en avant, tandis que le conducteur, du même réflexe, tournait la tête. Les deux visages flottèrent un moment à la même hauteur. Ils se comprirent et sourirent. La voiture frémit, s'allongea dans le sillage de l'autre, tendit ses phares comme des antennes. Un barrage fut franchi en pleine vitesse. Des coups de sifflets partirent. Gabriel se retourna. Des ombres gesticulaient, ridiculement rapetissées par chaque seconde, retournaient à la nuit pleine d'étincelles. La ville s'animait d'une vie contenue, rassemblait ses maisons comme un troupeau de lions à demi éveillés, des taureaux assyriens brûlant des victimes, des figures immobiles aux ailes de pierre lentement métamorphosées en ailes de chair. La voiture militaire vira au frein sur une petite place. Ils la suivirent. Il semblait que les officiers comprenaient le sens de cette course, qu'ils se piquaient au jeu. Tout cela échappait encore à Gabriel. Il sentait seulement que cette joute engageait beaucoup plus qu'une lutte de vitesse. Pour défier ainsi toute prudence, il fallait qu'un enjeu inconnu fût en cause. C'était maintenant une longue avenue d'arbres mutilés. Les deux machines phosphorescentes s'enfonçaient dans la nuit comme des foreuses. Le bruit des moteurs se faisait plus aigu, s'affinait en hurlement de bête torturée. Vincent cria quand ils se rejoignirent. Les deux conducteurs avaient la même expression fermée, les lumières vibraient dans la ville sombre, balles traçantes. Lentement, l'autre voiture décolla, regagna du terrain. Vincent était courbé sur le dossier, entièrement pris par la course, inondé d'une nouvelle beauté. Gabriel n'y retrouvait plus les lèvres dures qui avaient parlé de la Mort. Un nouveau virage, puis le vide, un boulevard large entre des parcs, les maisons reculées, apeurées. Les autres gagnaient toujours. Le conducteur aux cheveux fous grogna quelque chose, et Gabriel s'aperçut qu'ils revenaient de toutes leurs forces. Sur cette ligne vertigineuse enfoncé dans la ville, c'était une lutte de planètes. La voiture cria de tout son corps. Gabriel vit de nouveau des parements rouges, à reculons cette fois et bientôt

perdus dans l'éventail des phares. Ils coururent encore sur leur lancée, avec une route vide devant eux, puis le conducteur les jeta dans une rue de traverse, coupa ses lumières, et s'arrêta au bord du trottoir. Quelque part derrière eux, une course continua, folle et sans but. Enfin un silence bourdonnant s'installa. Vincent se mit à rire.

— Ils ont été sport, dit le conducteur. S'ils nous avaient eus, c'était au moins deux ans.

— Oui, mais ça valait la peine, dit Vincent.

Le pas d'une patrouille naquit du silence. Ils repartirent. Quelques rues plus loin, Vincent et Gabriel descendirent. À tout à l'heure, dit le conducteur. Ils sourirent à des choses secrètes. La maison pesait de toute son obscurité sur l'argent du sol. Très haut, un fil de lumière bleue découpait une fenêtre.

— Mon père, dit Vincent. Toute la nuit, il reste assis devant sa table, les mains tombantes.

— Il pense? dit Gabriel.

— Oh non, répondit vivement Vincent, c'est tout à fait différent. Il rêve.

<p style="text-align:center">❋</p>

— Un nouvel ami, avait dit Vincent.

— Vous conspirez aussi? demanda le Père.

— À ma manière, dit Gabriel. Le vieil homme était immobile, raidi dans son fauteuil comme dans un tombeau. Ses mains pendaient, ouvertes. Durant ses heures de solitude, il se refusait au mouvement, se fiant à la sève ardente de ses songes pour gonfler son écorce de vivant. Le seul geste qui donnât à ses mots une expression était un demi-hochement de tête, une perpétuelle ébauche de négation. Au-dessus de lui, une très belle eauforte figurait un gisant entouré de prières. Gabriel s'y arrêta.

— Voilà ce que je vous souhaite à tous, dit le Père. Les jambes droites, les mains croisées, la bonne position pour plonger dans la mort.

— Il y a beaucoup de morts, parmi les vôtres?

— Passablement, dit Vincent. Mais nous n'avons pas le droit d'y penser.

— Je le sais, ce que vous pensez, dit le Père, et il sembla se démentir en hochant la tête. Mais nous n'avons plus peur de la mort. De mourir, tout au plus. Après...

— Vous êtes croyant ? demanda Gabriel, troublé.

— Non, dit le Père.

Un timbre vibra dans la maison. Il y eut des pas, des portes fermées. Sous le voile bleu d'un abat-jour, une seule tache de lumière cernait un livre ouvert. Un signet plat aux lignes tourmentées divisait plusieurs colonnes de versets. Une Bible, pensa Gabriel.

— Ce doit être Christel, dit Vincent. Je lui dis de monter ? Le Père hocha la tête. Les pas se rapprochaient. Vincent sortit et appela. Des horloges sonnaient sur la ville.

Christel entra.

— Bonjour, dit-elle à Gabriel. Comment va ?

Elle embrassa rapidement le front du vieillard. Ses pommettes saillantes, troublaient curieusement son visage de guerrière du Nord. La dureté des yeux répondait au regard de Vincent. Gabriel chercha lequel était le reflet de l'autre.

— Des nouvelles ? dit Vincent.

— Je sais ce qu'ils ont fait de Phil. Elle secoua la tête et s'éclaboussa de boucles. C'est... atroce. Ils l'ont attaché à une pelle plantée par le manche, et ils l'ont flagellé à coup de nerf de bœuf, en se relayant, pendant que la lame de la pelle lui entrait dans le dos...

— C'est une nouvelle méthode, dit Vincent.

— Oui... Ils ont dû recevoir une circulaire détaillée, expliquant la chose... scientifiquement. Peu de risques d'évanouissement, et la peur... Tu comprends cette chose ignoble, une pelle...

— Il a parlé ?

— Je ne sais pas. Moi, je crois que j'aurais parlé. Elle se tourna vers Gabriel, sans défi :

— Et pourtant je suis courageuse.

— Contre l'horreur, il n'y a pas grand'chose qui tienne, dit le Père.

— Où est-il, maintenant ? demanda Vincent.

Elle prononça le nom d'une prison. Le Père hocha la tête.

On ne connaissait personne qui en fût sorti. Au-delà, c'était la mort, ou bien le départ pour des pays froids, dans des travaux de damnés.

— Encore un à oublier, dit Vincent.

Et il laissa sa main effeuiller sur les notes basses du piano le thème de l'Hymne à la Joie.

— J'attends toujours, dit-il encore, parlant très vite, ce moment-là dans la *Neuvième*. Je voudrais que le chef se tourne vers le public et crie : « Et maintenant, tous en chœur ! Et que les gens chantent, et chantent... bien. »

— On ne sait pas se servir de la vie, dit Christel à voix plus haute. Il devrait exister des commis-voyageurs pour annoncer dans les maisons que la Joie existe, et la preuve c'est qu'on a mis de la musique autour. Les gens croient toujours ce qui est imprimé.

— Et, pour qu'ils s'en aperçoivent, on les priverait d'un sens pendant quelque temps.

Vincent jetait ses mots comme une incantation. On eût dit qu'il se hâtait, pour empêcher un absent d'élever la voix contre eux.

— Pendant un mois, ils seraient aveugles, ou sourds, et le jour de leur guérison, on ferait une grande fête, où on leur montrerait tout ce qu'il y a de beau à voir, ou à entendre...

— Et ils auraient vu et entendu de telles choses, dit le Père, qu'ils demanderaient tout de suite à redevenir aveugles et sourds.

Ils rirent tous les trois, et Christel, sans abandon, laissa tomber sa tête sur l'épaule de Vincent. Étrange peuple, pensa Gabriel. Il osa prononcer le nom de Phil. Vincent avait sur le visage un sourire absent.

— C'était notre meilleur ami, dit Christel.

Dès que les jeunes gens furent sortis, Gabriel sentit la puissance de ce monde immobile que le Père s'était fait. Il luttait avec sa propre pensée, et lentement s'approfondissait, à la recherche d'un accord unique. Par une curieuse contradiction, son visage s'animait quand il fermait les yeux, et son sommeil devait être en lui l'image la plus éloignée de la mort. Devant

cette chute arrêtée, aux bras tendus, Gabriel devinait une exigence peu commune, et sous ce masque d'intellectuel, une rigueur de paysan. Dans la rue, il y eut encore des pas cadencés. Le Père ouvrit les yeux et hocha la tête.

— Pourquoi les haïssez-vous ? dit Gabriel.

— Je ne crois pas les haïr... Rien de ce qui exalte la vie ne peut me laisser indifférent. Ce n'est pas ce qui en eux est une fidélité ou la persistance d'une mythologie qui me choque... Au contraire. Mais ce qu'ils ont trahi.

— Ce qu'ils ont trahi ?

— Tout cela... Sa main enfin se leva et désigna vaguement les murs incrustés de livres, les eaux-fortes, les moulages de mains et de torses. Ils n'ont pas osé le nier. Moi, j'aurais pardonné. C'eût même été assez beau. Brûler les légendes pour les vivre. Brûler les images pour en garder de plus riches au fond de soi. Briser les statues pour sculpter un héros dans sa propre chair... Mais ils n'ont pas osé. Ils ont préféré créer de fausses légendes, des images grossières, des statues maladroites. Je crois que c'est cela, le péché contre l'esprit... Il sourit : Vous voyez que je ne tombe pas dans les mêmes pièges... Mais ceux qui combattent avec moi ne le savent pas. Ils croient combattre pour des idées d'hommes. On ne combat que pour... une certaine beauté.

— Ou pour Dieu, dit Gabriel.

— La beauté, c'est Dieu...

Les mains retombèrent, mortes. De nouveau, un hochement de tête prolongea la phrase, comme s'il fallait y chercher plus, et autre chose. Sur la longue cheminée de marbre noir, les formes de pierre se dressaient, victorieuses des hommes. Toute œuvre s'y montrait comme une défaite consentie par les vivants. L'autre création n'était pas cela, pensa Gabriel, et il se prit à admirer les choses humaines.

— C'est notre seule chance, vous comprenez, continuait le vieillard d'une voix plus faible. Dans cette solitude où nous sommes, sur quoi avons-nous encore des droits ? Sur la beauté, sur la souffrance. Sur la chair, sur le sang... Vous me parliez de Dieu. Pour nous, il commence à l'homme, à Christ. Le sens de l'Incarnation, c'est que Dieu peut entrer dans l'homme, dans chaque homme... Sa voix reprit de la force. C'est cela que nous

cherchons, et... Il désigna du regard la porte où étaient sortis Vincent et Christel. Et qu'ils cherchent, sans trop s'en douter... Évidemment, à chercher ainsi Dieu en nous, il se peut que nous arrivions à nous crever la poitrine, mais... Il se renversa en arrière. L'image du gisant lui apparaissait debout.

— Celui-ci a trouvé, dit-il gravement.

Le silence l'entoura d'une raideur sacrée, comme une armure. Gabriel en chercha le défaut.

— Si c'était votre fils?

— Je l'envierais...

Ce n'étaient ni la douceur, ni la crainte avec lesquelles les vieillards parlent de la mort. Mais une résolution calme de jeune homme. Gabriel pensa qu'un lien très fort devait l'unir à son fils, et que leurs deux vies travaillaient à s'enrichir. Le Père comprit sa pensée et la nia en hochant la tête, mais cette fois avec intention. Sa bouche tremblait légèrement.

— Non... Je l'envierais comme tout autre gisant. Voyez-vous, je crois qu'il y a entre un père et un fils une absence... définitive. Quelque chose d'infranchissable... C'est peut-être seulement l'absence de désir, ajouta-t-il nettement. Il réfléchit une seconde. C'est curieux, mais sous beaucoup de rapports, l'espace qui me sépare de Vincent n'est pas moins large que s'il était mort. C'est cela que je voulais dire. La question n'est pas que l'image que j'aime de lui soit vivante ou morte, mais que cette image ne me déçoive pas... La communion avec la vie, avec sa vie, cela m'est interdit. Il réfléchit encore. Et si je voulais être très... lucide, je crois que je trouverais quelque chose d'assez trouble dans l'image de Vincent tué. Quelque chose comme le secret espoir de le connaître enfin... Interdit de communier avec sa vie, mais... peut être permis de communier avec sa mort. Ses traits s'étaient accusés. D'un demi sourire, tout s'effaça: Voyez-vous, comme on en vient à désirer obscurément la mort d'un être qu'on aime... plus que toute chose. Enfin... cela vous explique pourquoi je n'envisage pas la mort comme vous.

— Oh, je ne suis pas en cause, dit Gabriel. Il me serait difficile de vous expliquer à quel point je vous comprends, mais... je pensais à eux.

— Eh bien, voyez-vous... ils sont très pris par leur action.

Pour des motifs tout à fait différents des miens, évidemment. Mais pour Vincent, la question ne se pose pas. Il y a en lui cette sorte de fatalité qui ne mène qu'à la mort, elle aussi. Et ils s'aiment. Cela, c'est grave.

— Elle est sa fiancée? Gabriel avait pris Christel pour la sœur de Vincent.

— Sa maîtresse, dit simplement le Père. Ils sont sur un plan très curieux, vous savez. Leur amour est une tentative de se séparer du monde, c'est même la reconstruction du monde, parce qu'ils l'ont nié. À la limite, c'est la mort. Vous voyez que tout y conduit. Moi...

Gabriel se voyait reculant sur une route obscure, tenant le Père par la main. Au bout de la route, une lumière clignotante. Cette pièce. Ces masques. Ces livres. De lourds alluvions du passé. Et une présence totale, plus forte que Dieu: la Mort. Sans linceul, sans faux, sans le décrochez-moi-ça des imaginations humaines. Comme un goût sauvage dans la bouche, et la curiosité de fruits inconnus.

— Moi, continuait le vieil homme, j'étais né pour cette création qu'«ils» ont trahie. On a parlé de moi, comme jeune écrivain... Ne cherchez pas. Parlé, pas écrit. À part quelques critiques. Et mon seul ouvrage publié, j'en ai racheté tous les exemplaires. Après un peu... très peu de temps, je me suis résolu au silence. Le mécanisme est le même, voyez-vous, pour peu qu'on cherche sa profondeur. À la limite de toutes les expressions, il y a le silence, comme à la limite de toutes les amours, la mort... Il ferma les yeux. Et l'extraordinaire... l'extraordinaire, c'est la puissance des images qui vous viennent alors. Le monde a des réactions de femme. On ne saurait croire ce que sont ses dons, pourvu qu'on le nie... Il sourit: Ne me prenez pas pour un maniaque de la mort. Mais si le grain ne meurt...

Gabriel tremblait. Devant ce vieillard prophétisant, il se sentait aussi démuni que lorsqu'il avait cru protéger Vincent. Je suis venu trop tard, pensa-t-il. Ou trop tôt? Cette fierté, cette recherche d'une route unique, dans la solitude, tout cela échappait à son royaume. Quelle aide apporter à une race qui ne trouvait de forces que dans son abandon même? Il était

venu à la suite d'une prière de Vincent, qui semblait croire, et se confier. Mais il comprenait maintenant qu'on lui demandait un témoignage plus qu'un secours, et que cet appel dans la vie des hommes était aux bornes du défi.

Vincent et Christel rentrèrent. Ils avaient mis leurs manteaux, et Christel un foulard bleu noué lâchement. L'impatience de l'aventure les illuminait, leurs jeunes corps frémissaient comme des animaux avant la course.

— Vous venez? dit Christel, la bouche entr'ouverte, les yeux mi-clos. Gabriel pensa qu'elle devait avoir ce visage dans l'amour.

Vincent adressa à son père un sourire rapide, et sortit. Christel, d'un geste dont elle eût ri chez une autre, le suivit pour relever le col de son manteau. Gabriel se leva à son tour, un peu bouleversé. Ce que Vincent lui avait dit au jardin flambait sur les murs, autour de ce vieillard calme. Il fut sur le point de lui crier la vérité. Malgré lui, ses mots se transformèrent.

— Et... dans cet abandon, VOUS pouvez croire en leur action?

Il se tenait devant la porte entr'ouverte. Vincent et Christel l'attendaient en bas.

Le Père se pencha sur la Bible ouverte et déplaça le signet aux lignes cruelles. La lumière creusait de nouvelles blessures autour de son visage de dieu lassé.

— *Tout ce que ta main trouve à faire avec ta force, fais-le, lut-il, car il n'y a ni œuvre, ni pensée, ni science, ni sagesse dans le séjour des morts, où tu vas.*

Gabriel resta immobile le long du mur. Le Livre. Le vieillard. Le gisant. Une ligne qui les joignait, et les menait dans une sérénité pleine de vie à l'infinie désolation. Tout cela lui apparut éloigné, et fuyant de lui à une vitesse effrayante, jusqu'à ce qu'il ne vît plus rien qu'un mur lisse et sombre. Il s'aperçut qu'il avait refermé la porte.

— Mais il y a tout le reste, dit le Père dans la pièce vide.

Entre les barrières blanches, des soldats entraient. À chaque entrée, une boursouflure de lumière et de rires éclaboussait la rue, et aussitôt se perdait. Une seule sentinelle, engourdie, se balançait comme un ours le long de la façade.

Le cycliste repassa sans se presser. Sa veste de cuir brilla devant la sentinelle, qui ne bougea pas. Vincent et Christel, sous un porche voisin, semblaient fort occupés à s'embrasser. Gabriel, à demi invisible, observait la rue. Quand le Grand Chef tomberait au pouvoir de cette lumière hâtive, le cycliste repasserait, et... Justement, il venait de s'arrêter au carrefour, et s'affairait à une vague réparation. Alors, Vincent se jetterait devant la porte, un lourd paquet à la main. Il le balancerait. Le cycliste aurait le temps de s'enfuir. «Pourquoi lui?» avait demandé Gabriel. Vincent n'avait pas répondu. Quant à Christel... Christel? «À la limite, c'est la mort». Peut-être incarnaient-ils l'intelligence du Père. Ou sa volonté... Gabriel frissonna. Devant la puissance d'un homme, il eut peur.

Les voix se turent à l'intérieur du Foyer. Puis ce fut un chant de femme. La sentinelle se retourna, comme pour voir à travers le mur. Des passants s'arrêtèrent. C'était une étrange chanson. Sur une cadence militaire et vivante, des paroles pleines d'ombre qui la démentaient, un tableau de ville morte, et l'appel d'une impossible union...

Wie einst, Lily Marleen,
Wie einst, Lily Marleen...

La voix s'enflait. Il y passait tout le vent des campagnes vaines, des victoires dont l'enjeu s'échappait, des conquêtes insaisissables. Quelque part, des lignes de cavaliers franchissaient les frontières de l'Europe, avançaient sur des villes enflammées. D'autres montaient dans les brouillards de l'aube. D'autres veillaient sur la nuit cloutée d'or. Et le même vide se déployait devant eux, comme un drapeau. Et il fallait un espoir. Alors la voix chantait un jour attendu, les nuages s'évanouissant sur les fleuves, et une lointaine, si lointaine lumière.

Wie einst, Lily Marleen,
Wie einst, Lily Marleen...

Comme une vague se brise en roulement de galets, la chanson se fondit dans les applaudissements. Les gens de la rue,

eux, demeurèrent immobiles. Gabriel découvrait les hommes. Ils avaient des pensées qui lézardaient le vieux monde, et des chants qui faisaient trembler les anges. Peu importait que cela concourût à leur destruction. C'était encore leur affirmation. Leur suprême défi.

Vincent et Christel ne bougeaient plus. La chanson, en passant sur eux, les avait pétrifiés. À l'image de son désir. *Wie einst...* Ils goûtaient pleinement une de leurs victoires, une possession totale qui ne se distinguait pas du total anéantissement.

Quelqu'un sortit du Foyer. Il portait l'insigne des hommes d'armes, mais Gabriel reconnut le conducteur de l'incompréhensible course. En passant à la hauteur de Vincent, il jeta : « Il sort » et s'éloigna rapidement. Quand il eût dépassé le cycliste, celui-ci remonta lentement en selle et revint vers les barrières. Vincent fit tourner Christel en simulant un nouveau baiser, afin de voir la porte de face. Gabriel, collé au mur, cherchait dans sa sensibilité d'ange une émotion qui fût égale à cela. Le cycliste avançait toujours. Si lentement qu'il allât, il était sur le point de dépasser la sentinelle. « Il va le manquer » pensa Gabriel, qui aussitôt s'étonna de trouver en lui des réflexes d'homme. Il ne regardait plus la porte, mais cherchait sur le visage de Vincent la beauté de celui qui va tuer. C'est quand il le vit abandonner Christel et se dresser, les bras suppliciés, une joie de crucifié dans les yeux, qu'il comprit que le Grand Chef venait de sortir.

Non. Ce n'était pas possible. Tout cela était concerté, truqué. Un homme immense, grandi par une tunique d'officier aux parements éclatants, en pleine lumière, attendant la mort, immobile, la sentinelle immobile, Vincent et le cycliste avançant avec une lenteur sous-marine. L'homme ne criait pas, la sentinelle ne tirait pas, les deux exécuteurs s'approchaient. Qu'était-ce que ce spectacle au ralenti, ce sacrifice où chacun consentait, où tout était prévu et nécessaire depuis les siècles des siècles et les générations des générations ? Le Grand Chef de tous les hommes d'armes, ceux qui jettent des flammes et ceux qui s'enfoncent dans la mer, les volants et ceux qui portent de sombres étendards, les muets qui ont un collier de

fer et ceux dont le vêtement est noir avec des ossements de métal, celui-là s'arrêtait en pleine lumière, à quelques pas de son meurtrier... Gabriel ne s'apercevait pas que l'intensité de la scène lui avait fait oublier le rythme du temps. Le regard de Christel, amoureux et sauvage, le lui rappela, et les choses redevinrent rapides et aveuglantes. À peine avait-il reconstitué le tableau de la rue, qu'il fut déchiré par un pointillé de bruits furtifs et cruels... Le cycliste disparaissait, les images se succédaient sans lien, comme un album vivement feuilleté. C'était le Grand Chef incliné dans la clarté des villes détruites, le visage collé à ses insignes. Puis son corps étendu en travers de la porte, avec une grande rumeur naissant derrière lui, et le geste de la sentinelle... Et brusquement, immense comme une statue de neige, le geste de Vincent qui lui répondait... Alors ils plongèrent dans le feu, et tous les vents tournèrent autour d'eux, joufflus et ailés comme on les voit sur les cartes, hurlant à déchirer la vie. Des ombres se disloquèrent, il vint des sifflets, des cris étrangers, et tout au fond un incompréhensible froissement d'étoffe. Gabriel volait parmi les ruines. Quand il reprit son apparence et sa démarche, Vincent et Christel, debout à côté de lui, revenaient vers l'explosion. Alors il sut que tout était accompli.

Vincent et Christel se hâtaient, sachant que la fuite les eût perdus, tandis qu'ils prenaient l'aspect de curieux venant aux nouvelles. Et ceux qui avaient vu agir Vincent étaient morts... Près des barrières tordues, dans un grésillement de ténèbres, on courait, on improvisait des secours. Des hommes d'armes surgissaient de tous côtés, barraient les rues. À quelques pas du mur déchiqueté, Vincent s'arrêta. Un corps noir à ses pieds. Le corps se retourna et gémit. Des insignes de métal brillèrent. Un guerrier. Christel repartait, mais Vincent s'agenouilla.

Le visage du blessé apparut dans la lumière. C'était un garçon de l'âge de Vincent. Sous le bonnet rejeté en arrière, une mèche ensanglantée se tordait. À son col flambaient les petites têtes de mort. Vincent le soutenait avec un geste de Pietà et cherchait à comprendre ses paroles. Christel le regardait sans haine, mais avec un peu de répulsion. Gabriel devinait quelque chose d'encore inconnu derrière ces attitudes simples.

— Bouge pas, vieux, dit Vincent. Il y avait dans sa voix une grave tendresse, celle que les femmes n'entendent jamais. Le blessé dit quelques mots en langue étrangère, et fut pris d'un long tremblement. Vincent leva les yeux vers Gabriel.

— On peut quelque chose pour lui ?

— Prier, dit Gabriel.

Vincent secoua la tête et se pencha en avant. Le sang coulait sur ses mains. Le blessé le regarda. Il avait compris la réponse de Gabriel. « Je suis tué », dit-il en bafouillant.

— Penses-tu, dit Vincent. Tu essaies de te rendre intéressant.

— Je l'ai compris, lui... Il tentait de voir Gabriel confondu au mur.

— Faut pas le croire. C'est un gros menteur. On va te visser une tête de bois, et tu te sentiras mieux, non ?

Le blessé sourit du coin de sa bouche non encore crispé par la mort. En remuant la tête, il se blottit dans la pliure du bras de Vincent avec un geste d'enfant malade. Vincent releva la mèche de sang et maintint sa paume à plat contre le front brûlant. Ses yeux avaient perdu toute leur dureté, et maintenant plus qu'au moment du combat, il semblait avoir repris son vrai visage. « C'est ça, dors » dit-il très doucement. Le blessé se remit à gémir et à balbutier. Inutilement, les bras de Vincent tentaient un mouvement de berceuse, comme pour marquer le rythme de ce murmure de mort qui avait été celui des forêts du Nord, lorsque la guerre était encore pure et vraie comme l'aube. Vincent écoutait avec une détresse calme l'écho de sa voix la plus profonde, et reconnaissait deux syllabes, toujours les mêmes. Pourquoi. Pourquoi.

— T'occupes pas, dit-il. Tout ça nous dépasse. Mais tu peux te laisser aller. Je suis un camarade. Le blessé râlait. « Tu entends, cria presque Vincent, camarade ; Ca-marade ! Je suis un ca-marade ! » Le bonnet glissa à terre, et le front meurtri, de son poids, retourna le visage. Les traits, maintenant, étaient calmes. Vincent soutenait absurdement ce corps mort. Il n'y avait plus autour d'eux que le silence.

— Je crois vous pouvez laisser...

Un officier était debout près de Vincent. Sans doute avait-il entendu leurs dernières paroles. Dans son uniforme

raide, il semblait guindé et ému. Vincent se leva, et grimaça en tenant son bras engourdi par l'effort. Christel et Gabriel s'approchèrent.

— Vous étiez... Il cherchait ses mots. Vous avez été très... bon pour cet homme. Je veux seulement vous dire... merci. Il tendit la main. Vincent la serra machinalement, stupéfait. Vous pouvez aller! L'officier avait repris son ton naturel. Il donna l'ordre aux soldats de laisser passer. On chuchotait dans la nuit. Plusieurs suspects avaient été immédiatement arrêtés. Une femme pleurnichait. Les soldats insultaient les civils à voix basse. De vagues fumées dansaient dans la rue éteinte. Vincent et Christel marchaient vite, tremblants d'énervement. Tout cela est si absurde, pensa Gabriel, et il crut que tout était fini.

C'est à ce moment qu'un long cri de bête courut au ras des toits, alluma d'autres cris sur son passage, et que la ville connut sa menace.

Ils étaient descendus au plus proche abri, une voûte puisante écaillée de faïence, bariolée d'images aux couleurs violentes. La foule s'y allongeait avec bonne humeur. On échangeait des plaisanteries. «La bombe, quand elle arrive, elle fait comme ça.» Sifflement de plus en plus grave. «Alors, quand ils se sont trompés, elle repart, comme ça.» Sifflement de plus en plus aigu. On riait. «Il ne se passera rien» disait quelqu'un, «c'est le Commandant qui veut faire peur à son petit garçon, parce qu'il s'est mal tenu à table». «Cela ne doit pas vous inquiéter», disait un jeune homme à sa compagne, «il y a aussi peu de chances d'être touché que de gagner à la Loterie». «Mais... disait-elle, c'est que j'ai gagné à la Loterie.» Peu à peu, les plaisanteries s'usaient. Les plus vieilles ressortaient, dernier recours contre le silence. Mais le silence venait quand même ; lentement, il se glissait entre les groupes, les voix se faisaient basses, comme dans une église, la grande cathédrale de la peur. Enfin, elles se taisaient. Alors, on entendait, très haut, le bourdonnement des machines, et les premiers appels de canon.

Gabriel avait tenté de reparler à Vincent de son jeune mort. Il s'était détourné brusquement, et Christel l'avait regardé

avec inquiétude. Ce n'est pas la haine, pensait Gabriel. C'est au-delà de la haine. Il avait espéré un moment que la puissance des hommes n'était pas aussi nouvelle, que ce n'était au fond qu'un nouveau masque sur le vieil instinct de combat. Et puis cette fraternité profonde du meurtrier et de sa victime... Christel semblait moins obscure, sur ce point. Elle haïssait, elle, fortement. Gabriel revoyait avec une sorte de fièvre les heures de cette étrange soirée. Vincent était sûr de mourir. Il le lui avait dit, dans les jardins déserts, au bord du fleuve, quand il n'était encore qu'un garçon confiant au regard dur. Et tout était si différent...

Gabriel devinait que le plus humiliant pour Vincent était cette pitié vraie qui l'avait sauvé comme une ruse.

Les coups se firent plus proches. Le sol trembla légèrement. Un bruit de moteurs courut depuis le fond des voûtes, devint un miaulement rouillé, et disparut dans un éclatement de pièces. « Maintenant, passez les piétons », dit un homme, et l'on se remit à rire. D'autres coups frappèrent, très loin, couverts par la cadence, brève des armes rapides. Les moteurs tournaient au-dessus de la ville.

Vincent passa la main sur son front, et s'éloigna. Gabriel et Christel respectèrent sa solitude. Il se tenait à l'entrée du tunnel. Son visage était très las.

— Peut-être a-t-il besoin de vous... murmura Gabriel.

— Je ne crois pas, dit Christel. Je ne sais pas ce qu'il va chercher là-bas, mais... j'ai l'impression que ce n'est pas moi. Elle regarda fixement Gabriel. Pour la première fois, tout à l'heure, nous n'avons pas eu une émotion qui nous soit commune. C'est grave, dit-elle sur le ton même du Père, lorsqu'il parlait de leur amour.

Les moteurs se groupaient, très loin, amorçaient un retour d'animaux traqués.

Christel parlait. Gabriel avait compris qu'elle ne s'adressait plus à lui, mais à Vincent, immobile, qui ne l'entendait pas.

— Jusqu'ici, les êtres les plus proches que j'aie connus étaient encore à des distances incroyables, et nous... Il a fallu que nous souffrions beaucoup l'un par l'autre pour parvenir à cela. C'est au mal que nous nous faisions que nous nous

sommes reconnus. Elle baissa la voix. C'est à l'étendue de ma douleur que j'ai mesuré toute la joie que tu serais capable de me donner...

— L'essentiel vous reste en commun, dit Gabriel.

— L'essentiel, dit Christel, c'est que tout nous soit en commun.

Les moteurs revinrent, bêtes chassées. Le bruit se gonfla, érailla les parois, déchira les pensées. Pendant quelques secondes, il fut l'unique élément des gens du tunnel. Puis un sifflement vint le rayer, de plus en plus grave... Ils comprirent. Déjà, la plupart des hommes s'étaient jetés à terre, entraînant des femmes. Vincent leva la tête. Christel était restée debout, et ouvrait la bouche dans un grand appel muet... Le choc fut sombre, sans flamme. Les bruits se séparèrent, avec les couleurs. Quand ce puzzle reprit sa place, l'extrémité du tunnel achevait de s'effondrer. Plusieurs personnes y restaient prises, ou avaient roulé plus près, mutilées. Vincent était renversé parmi elles. Intact. Beau. Mort.

Gabriel le savait. Cela devait être. Et cela était bien. Ce qu'il ne savait pas, c'était que Christel, loin de lui maintenant, prise par la foule, se jetait sur le premier guerrier venu, lui arrachait son poignard, frappait... Un autre guerrier tira, au petit bonheur. La foule s'agita comme un poulpe blessé. Des rixes éclatèrent. Les soldats tentaient de se grouper près de la sortie. On les piétina. Et ce fut une effrayante pantomime. On emmenait Christel, repliée sur elle-même dans le geste des momies, déjà pris par une douleur d'un autre monde. Dans un silence crispé, les coups jaillissaient au hasard. La foule se détendait soudain comme une farandole, enlaçait quelques soldats désordonnés, et cognait. Personne ne prit garde au dernier cri de bête sur les toits, qui éloignait la menace. La foule ondulait, poussait des soupirs de fauve. D'autres hommes d'armes vinrent, qui la divisèrent. On se battit encore longtemps, et les silhouettes grotesques ou terribles s'évanouirent dans un brouillard de fatigue.

Gabriel resta seul devant le corps de Vincent. Il ne pouvait plus supporter son poids d'homme. Par la brèche du tunnel vint une chose incroyable: des hommes chantaient

dans la rue, des hommes marchaient, s'appelaient... Des voix
confuses, puis encore des chants... Quel est donc ce peuple ?
pensa Gabriel, et il étendit Vincent, les jambes droites, les
mains croisées, en gisant.

Mai 1946.

Février 1947 *En attendant la société sans classes? Comment justifier cet emploi du terme «secondes classes» s'il n'y a plus de premières? Non seulement on laisse passer l'occasion de faire une expérience préfigurative de la Démocratie idéale (celle où, comme chacun sait, l'élite c'est tout le monde), mais encore, par l'emploi de ce chiffre Deux, on laisse planer sur l'opération je ne sais quel spectre de ci-devantisme, une sorte d'émigration des Premières dans une Abstraction d'où elles reviendront un jour en force pour rejeter le peuple sous les pieds de la table rase, un fantôme de privilèges qui hante ces couloirs souterrains, le silence temporaire d'un espace défini. Ajoutez à cela le fait que les rares élus qui parvenaient à trouver place assise dans les Premières (à Neuilly, à Passy ou aux Champs-Élysées) habitant généralement aux têtes de lignes, ils continuent d'occuper les mêmes places pour un haricot de moins, tandis que les autres conservent les leurs à double prix et vous voyez, pour parler le langage de l'État, la psychose qui s'en peut suivre. Tels sont les faits qui font dire aux petits-fils de 47 des grands aïeux de 89: les Socialistes ne sont plus les amis du peuple. Tout au plus des relations.*

Mais revenons au sérieux. Un ingénieur du métro a très astucieusement démontré que le métro pourrait être, sans dommages pour son exploitation, gratuit. L'absence de billets, de recettes, de contrôles, etc..., aurait pour conséquence une telle réduction de personnel que les dépenses restant à la charge des contribuables seraient beaucoup moins lourdes et qu'un simple centime additionnel du budget de la Ville de Paris suffirait. Le personnel inutilisé par la Compagnie trouverait des emplois dans tant d'entreprises qui manquent de comptables et de main-d'œuvre.

Et quel sentiment de joie collective à la pensée que nous emprunterions le métro comme un simple trottoir roulant. Ce qu'il est, en fait. Un bon point à l'ingénieur.

150 ETERNAL CURRENT EVENTS

Janvier 1947 À PROPOS DE PARADIS TERRESTRE. «Lisez la froide déclaration d'Eusèbe, Praep. Ev. lib. I, p. 11, nous dit Laurel, qui prétend que depuis que le Christ est venu il n'y a plus eu ni guerres ni tyrans, ni anthropophages, ni pédérastes, ni incestueux, ni sauvages mangeant leurs parents, etc... Je trouve cette citation dans une Méditation de M. Volney, datant de 1792. Et le vieil auteur ajoute: ‹Quand on lit ces premiers docteurs de l'Église, on ne cesse de s'étonner de leur mauvaise foi ou de leur aveuglement.›»

«Et cela continue, voyez, enchaîna Hardy. Plus d'adultère, plus de prostitution, plus d'union libre, plus de perversion... Que voulez-vous, au fond, je trouve cela plutôt encourageant» conclut-il, en reposant la **Pravda**.

Janvier 1947 UNE CONFÉRENCE DE LOUIS ARAGON. On nous avait annoncé une conférence sur la Culture des Masses, et nous venions à la Sorbonne comme on va à l'école. Certes, nous ne nous attendions pas à ce régal, ni à cette multiplication de soi-même qui fait du vieillard Protée, de Frégoli et du mime Étienne Decroux, de tout petits garçons à côté de M. Aragon.

C'est le Père Aragon, de la Compagnie de Jésus, qui monte en chaire le premier. Il est toute douceur, toute onction. Il démontre rapidement l'absurdité du titre que des intermédiaires mal informés ont donné à son prêche: non, il ne nous parlera pas de la culture des masses, mais de «tout autre chose». Et là-dessus roule un sermon de fort bonne tenue sur la précision du langage. Est-ce pour en illustrer la pertinence que tombe des tribunes ce cri d'une précision lapidaire: «Ta gueule!», jeté par la voix lubrique d'une vipère avinée? Les ouailles s'en consternent, tandis que d'avoir réchauffé ce serpent au sein de son discours, le Père Aragon s'émeut, et sans plus attendre, passe la parole au Frère Aragon, du Saint Office, qui part en guerre contre l'esprit du mal. Bien différent est le ton du nouvel orateur: l'élégance ecclésiastique du geste ne gêne point la vigueur de son propos, et jusque dans son langage on retrouve la rude simplicité des pères de l'Église: sans avoir peur des mots,

il dénonce violemment les grues métaphysiques, et le peuple déjà prévenu contre les putains respectueuses est parcouru de frémissements. Pourquoi faut-il que notre Inquisiteur crée un malentendu en citant un long passage de l'hérétique Malraux? Les hérétiques de la salle applaudissent immédiatement leur maître, tandis que les vrais croyants, applaudissent l'emploi qui va être fait de cette citation, bref, tout le monde applaudit, et de cette fausse communion va sortir le plus grand désordre. Quand après nous avoir prévenus honnêtement que «être n'importe quoi, c'est être fasciste», le Frère Aragon nous dissèque ledit faisceau composé, outre Malraux, de Bernanos, Trotzky, Denis de Rougemont, Jaspers, Spengler, **le Figaro**, l'Unesco, l'Homme, l'Europe et les... métaphysiques — les éléments non-scientifiques de la salle, ceux qui ignorent que l'Erreur même peut servir, protestent violemment. Et c'est l'Apocalypse. On crie : «Vive Malraux», on siffle, on fait : «hou, hou» tandis qu'une voix — celle d'un professeur de Faculté sans aucun doute — laisse tomber : «Traitez le sujet», remarque pertinente reprise par la salle sur l'air des lampions. Puis, comme ça a l'air de s'apaiser un peu, quelqu'un a l'idée saugrenue de crier : «Vive de Gaulle» (comme les filles Fenouillard criant : «Hurrah pour Fumisty»). Du coup, chacun va rechercher ce qu'il pourrait bien crier. On entend un : «Vive Joseph», mais il ne s'agit pas de Staline. Comme il est question de Maurras, une voix flûtée perce le tumulte : «Maurras n'a pas trahi.» «Voilà le visage de la contradiction», réplique l'orateur, qui sait à quel point les maurrassiens ont à cœur de défendre Malraux et Bernanos. Mais déjà ce n'est plus l'Inquisiteur qui parle. C'est le Clairon : «Mes titres, messieurs, je les porte à ma boutonnière.» — «Y a pas que vous», hurle le gaulliste. Le chahut est à son comble, mais déjà, à la surprise générale, Aragon s'est transformé en Elvire Unesco, la dynamique vedette, et sur le rythme inimitable qui lui a assuré sa gloire, achève de déverser ce qu'il a sur le cœur, après quoi, du geste même qui accompagne le grand air de « la Traviata », il lève sa coupe à la santé des tribunes hurlantes. Il reste un court laps de temps au Père Ubu, roi de Pologne et d'Aragon, pour tirer les conclusions du débat, tandis que Stephen Spender, qui a congratulé Malraux lors de sa conférence, s'enfonce à chaque

phrase un peu plus loin dans son fauteuil, et que les bibliocrates de l'assistance s'en vont indignés...

Arrêtons là la plaisanterie. Tout cela est infiniment triste. Parce qu'il est triste que cet homme chahuté ait eu raison dans ce qu'il disait, ait eu raison de le dire, et que pourtant il ait mérité sa cabale. Nous sommes parfaitement d'accord sur le danger que la formule actuelle de l'Unesco fait courir à la Paix. Nous savons parfaitement que la position d'Aragon en face de Malraux est, dans l'ordre de l'action du moins, la seule viable. Nous savons aussi qu'une partie des chahuteurs était trop heureuse de trouver de pieux prétextes pour jouer par la bande le jeu de la Réaction. Il n'en est que plus lamentable que le contenu constructif de cet exposé ait disparu, noyé dans les lieux communs, les fausses profondeurs, les fausses simplicités et de petits règlements de comptes qui n'intéressaient personne — que le resserrement et l'exigence de cette position soient apparus, dans la bouche d'Aragon, de l'étroitesse et de la galerie — qu'enfin ce soit l'**homo communistus** lui-même qui fournisse ses prétextes les plus apparemment généreux à son ennemi du fond des âges, le **pithechanthropus reactio**. Si j'étais quelque chose au Parti Communiste, je sais bien le sort que je réserverais au héros d'une semblable exhibition. Quant à juger le spectacle lui-même, de ce monsieur pâle et bien vêtu vaticinant au nom d'une orthodoxie, il y faudrait au moins la verve rageuse, la belle intransigeance de l'Aragon de 1925. Mais celui-là est bien mort, et combien d'autres avec lui, dont les fantômes fous s'agitent aux lieux encombrés, et laissent désespérément vides les places oubliées de la franchise et du refus.

ACTUALITÉS IMAGINAIRES. L'événe-
Avril 1947 ment du mois, c'est évidemment l'expérience soviétique d'utilisation des rayons cosmiques, qui s'est déroulée à l'île Sakhaline. On sait que les savants russes, ayant mis au point un rayon qui dissocie la couche d'ozone et libère les radiations destructives absorbées par la dite, avaient décidé d'en faire la démonstration, au milieu d'un grand courant de popularité: «Et pourquoi que j'aurais pas aussi mon Bikiki,

mon Bikini» fut la chanson la plus demandée sur toutes les ondes. On se passionnait aussi pour les conditions originales de l'entreprise: le bagne de Sakhaline, où se trouvent un certain nombre d'ennemis du régime, avait été sérieusement épuré, certains cas ayant été jugés trop notoirement incorrigibles pour servir, fût-ce passivement, la cause du progressisme. Par contre, des volontaires s'étaient présentés, heureux de trouver une telle occasion de rachat. Parmi les nombreuses candidatures, deux seulement furent retenues: celles de l'ancien ministre Gochistov, et du trotskyste anarchisant Padanlaline. «Je suis une bête immonde, déclara l'ex-camarade Padanlaline aux journalistes, un virus malfaisant, un lombric libidineux de la pire espèce, absolument indigne de la clémence de l'État. Puisse tout au moins mon exemple apprendre aux jeunes générations à quelles abominations on s'expose en s'écartant de la voie droite.» En plus des résidents de Sakhaline et des deux volontaires agréés, étaient offerts aux expérimentateurs une douzaine de petits enfants, prélevés sur la ration personnelle du maréchal Staline.

Tandis que s'achevaient les préparatifs, la presse mondiale commentait la chose avec une grande variété de points de vue: «Les expériences de Sakhaline, écrivait la *Pravda*, n'ont d'autre but que de servir la Paix, et de montrer au monde des provocateurs fascistes et des marchands de canons que le peuple russe dispose des moyens de détruire les fauteurs de guerre jusqu'au dernier.» «Et nous alors?» demandait anxieusement le *Times*, dont un éditorial acéré laissait peser sur le gouvernement travailliste un soupçon de mollesse et de négligence, dont le résultat était un retard de la science britannique sur les deux autres alliées. Le pape rappelait au monde que qui se servait des rayons cosmiques périrait par les rayons cosmiques, tandis que l'antipape d'Avignon (le laïc Aragon, récemment converti), plus au fait des choses scientifiques, affirmait que c'est précisément par cette brèche du firmament que descendraient les légions célestes. Enfin, aux U.S.A., la revue officieuse des jésuites, *Brain*, publiait un long article de son directeur, Emmanuel Moonlight, qui concluait ainsi: «Il est évident que c'est dans la conscience de plus en plus aiguë

de notre refus de l'événement, que tempère le souci d'un vrai réalisme, joint à une adhésion de principes, avec toutes les réserves d'un idéalisme vrai que se trouve notre voie.»

Le jour venu, une assistance soigneusement sélectionnée mais très diverse, qui comprenait à côté des représentants du maréchal Staline des personnalités indépendantes telles que Pierre Courtade ou Mgr. Spellmann, se pressait sur des radeaux halés du rivage par un corps de bateliers appelés spécialement de la Volga, pour suivre le déroulement de l'expérience. Arthur Koestler, invité, s'était excusé. L'ombre était nuptiale, auguste et solennelle. Nul ne savait où se cachait la machine génératrice de rayons. On distinguait seulement au loin les contours de l'île, et à la lorgnette les condamnés à mort faisant leur examen de conscience marxiste-léniniste sur des questionnaires imprimés qui leur avaient été distribués à cet effet. Sur un radeau à part, les savants responsables de l'opération, couchés à plat ventre, tremblaient de terreur. On a déjà rapporté à propos des savants américains ce trait, imputable à une louable conscience des responsabilités. La dite conscience était renforcée ici par la présence derrière chaque savant d'un fonctionnaire armé d'un parabellum du type Sivispachem, qui avait ordre de tirer sans attendre, s'il s'avérait que, négligence ou sabotage, l'expérience commençait en retard.

Un haut-parleur monté sur une bouée comptait les secondes à mesure que l'instant fatal approchait. Lorsqu'il prononça «Poum», ce qui comme chacun sait signifie en russe «Maintenant», un déclic se fit dans les cieux, on entendit nettement les radiations de la machine grignoter la couche d'ozone, et par cette porte ouverte on vit se ruer à grand bruit une bande de rayons cosmiques, chahutant et caracolant comme des étudiants, des quat'z'arts.

L'instant d'après, la terre brûlait. Mais par on ne sait quelle erreur (certains murmurent avec crainte qu'il s'agissait d'une manœuvre longuement préméditée), c'était l'autre moitié de l'île Sakhaline, ancienne possession japonaise, qui était touchée. Aux cendres qu'on y trouva, on sut que s'étaient embusqués là, parmi des montagnes de boîtes de haricots sucrés et de bouteilles de coca-cola, des observateurs de nationalité inconnue.

ACTUALITÉS ÉTERNELLES. On a quelquefois cette impression apaisante que le réel bat l'imagination avec ses propres armes. Certaines phrases qu'on découvre au hasard d'une lecture sonnent comme des aveux fabriqués tout exprès.

Par exemple, quand on lit dans les **Rhumbs** de Paul Valéry: « La cause de la dénatalité est claire, c'est la présence d'Esprit. »

Ou bien, sur les murs de Paris, annonçant trois conférences de M. Winandy:

« Le Secret du Sépulcre. »

« Qui a tué Jésus ? »

« Le Souverain Pontife. »

Ce que les surréalistes appellent fort justement un « cadavre exquis ».

Les Séparés

La neige qu'on détruit La belle qu'on emporte
Le sang qui bouge encore et le bois qui se tait
Les tours de l'échafaud Le couperet des portes
brûlent sur les tréteaux de la Saint-Jean d'Été

Le soleil de six-heure épouvante la guerre
et fait la terre libre au songe des amants
Nous marchons en traînant des boucliers de verre
dans la ville où la glace a des airs de ciment

Nous inventons des mots pour conjurer les charmes
Malgourou Malgouleur Et nous nous inventons
un langage qui tient contre le bruit des armes
dans les tirs sans jet d'eau sans fleurs et sans cartons

Écoute nous marchons écoute ici l'on tue
Ici non pas ici mais ici plus profond
Ici se croise au temps pour fondre une statue
de cire d'air de feu de bruit du bruit que font

les aspics de fer-blanc les seringues de givre
les piqûres de glace à la nuque des forts
les poings de métal noir qui décorent les livres
et dégradent la main prise dans leur ressort

Malgourou Malgouleur Les gens qui font des claies
pour emporter d'ici le corps brûlé d'Hier
ont laissé sur les murs des marques à la craie
et nous suivons leurs pas le long des ponts de fer

Malgourou Malgouleur On invente des plaintes
Hier est le taureau traîné par les mulets
Hier est le mourant porté jusqu'aux eaux saintes
Hier est mort de faim le front sur les galets

bouche proche de l'eau pourtant bouche fermée
mains closes quoique mains touchant les clefs de zinc
Hier est mort à l'aube et dans le chiffre cinq
demeurent son Oural son Nil et sa Crimée

Hier a pris au vol le dernier corbillard
Les morts ont des métros qu'il ne faut pas qu'ils ratent
Pas un ne l'a suivi because le brouillard
qui cache tant d'anars dont les bombes éclatent

Il est tant d'assassins qui sûrement sont russes
pour jeter des boulets dans les pattes du jour
et brûler d'un feu noir les villes qui nous eussent
sûrement accueillis sans en faire le tour

Malgourou Malgouleur la terre va plus vite
le temps se rétrécit l'an passe nous savons
étendre sur le pain le beurre des canons
et vivre dans les murs où notre mort habite

Le Scamandre et la Seine ont la même pâture
et trouver mille-balle en trois jours c'est calé
les fers ont paraît-il différentes pointures
on trouve avec du goût aux pleurs un goût salé

on s'adapte vois-tu à ce temps qui se truque
on naît avec le cœur dessiné au minium
comme les durs de durs se pointillent la nuque
pour annoncer la cible et pour jouer à l'homme

les poignets ont d'avance un creux pour les menottes
la bouche a fait d'avance un parjure sans coq
les bateaux du désir ont chassé leurs pilotes
et défoncé la cale et déchiré les focs

Sur la banquise terre une foule nous garde
d'aller faire l'amour sur les trottoirs déserts
tandis que le métro nous pousse ses lézardes
comme des pions d'échecs de faïence et de fer

(Délivrés de tout croire abrités par les grilles
d'un ciel de pierre blanche aussi lourd que le gel
et de mêler nos corps au ciment de la ville
comme des haut-reliefs de bitume et de sel)

et déjà les métaux circulent dans nos veines
nos yeux sont de mercure et nos lèvres de plomb
nous marchons dans le cœur de cette ville vaine
où le vieillard Demain vient vendre ses ballons

23 juin 1949.

Février 1947

LES VACHES MAIGRES. Alger, 19 h 10. Arrivée du train de B., avec quelques heures de retard, évidemment. Beaucoup de monde, peu de lumière, une lune, quatre flics. Le monde et la lumière sont sordides, la lune et les flics sont impériaux, le sordide et l'impérial ensemble sont coloniaux. Et le train déverse la foule à pleins paniers, jusqu'à ce qu'un bonhomme roule à mes pieds, porteur arabe qui a promené sa sordidité un peu trop près de l'impérialisme du flic. Ça recommence un peu plus loin, à coups de matraque cette fois, tandis que le premier flic essuie soigneusement son gant blanc. Personne n'y fait attention, surtout pas les porteurs cabossés. Moi, j'ai déjà vu ce geste... Vu : le Train mongol, *vous savez, ce film soviétique où un équipage de révoltés chinois combat et gagne sa liberté. Les blancs se défendent, se replient dans le wagon-restaurant, et je retrouve ici le même problème : Comment faire pour n'être pas lié aux blancs ? Sur le train mongol ou dans le train algérien, la démarcation est simple : blanc, couleur. La couleur qui vient se mettre au service du blanc est méprisée. Le blanc qui essaie de se lier à la couleur, on s'en méfie. Et je songe à cette justification que doivent se donner tous les colonialistes : Notre place est de ce côté. Et quand je vois des ministres socialistes ou des chrétiens militaires faire bloc avec les colonialistes, je retrouve le même réflexe, qui est au fond un réflexe de fascisme. Le jeune bourgeois qui comprend la lutte des classes se dit : Ma place est de ce côté, de toute façon je ne serai pas accueilli de l'autre, ma fierté veut que je combatte, et il entre au P.S.F. Qu'on ne s'étonne plus alors de trouver tel présumé révolutionnaire de ce côté-ci du train mongol. Comme pour le fascisme, il s'agit quand même d'une révolte : la révolte des privilégiés.*

LES VACHES GRASSES. Paris, 14 heures, devant la « Samaritaine », un gosse, fort mal vêtu, s'enfuit, poursuivi par un flic, fort bien vêtu. « Arrêtez-le », gueule le flic, et il me semble (joie !) qu'il suffit de cet appel pour que la foule s'entr'ouvre devant le pourchassé. Mais un monsieur s'anime à la voix du flic (la voix du sang, pour ainsi dire) et barre le passage au gosse. Le gosse bute sur le monsieur, le flic bute sur le gosse, le monsieur et le flic attrapent chacun un bras du gosse, et en route pour voir les poissons rouges. Le monsieur ira

jusqu'au commissariat, c'est certain, où il sera chaudement félicité, pendant qu'on tabassera le gosse. Pour le moment, il jette des regards victorieux à la galerie. Il est tout rasséréné, le brave homme. Il pense à ses gosses, à lui, et au bon exemple de morale pratique que cet épisode, un peu enjolivé (couteau entre les dents... à la main, veux-je dire) donnera à ses propos du dîner. Ce sera l'occasion de développer ses maximes favorites, telles que «Bien mal acquis ne profite pas longtemps quand il y a un flic à proximité», ou bien: «Qui prend aux riches prête au Diable.» Et il se réjouit de penser qu'ainsi jamais ses enfants ne seront de ceux qu'on emmène au commissariat, qu'ils seront plutôt de ceux qui aident à y conduire.

LES VACHES MOYENNES. Courte prière, dédiée au copain de régiment récemment arrêté pour un casse, un peu cassé à son tour pendant l'interrogatoire, et qui se demande quel sort on peut bien réserver alors aux fonctionnaires qui trafiquent de leur charge:

> *Mon Dieu, qui avez créé les flics, nous n'en sommes plus à nous étonner des curiosités de votre Création. Mais alors donnez-nous le courage de refuser toute complicité avec eux, et d'aimer leurs victimes. On oublie tout reproche auprès des morts. Faites que l'homme qui avance, les joues saignantes, attaché à une grosse bête brutale, soit pour nous comme un mort, et que son crime lui soit remis. Faites que dans le monde entier, tout homme, quelle que soit sa faute, qui est aux mains de la police, nous touche au cœur, et que ce soit un peu nous qu'on frappe. Ce sera une des dernières formes de la fraternité, en attendant que ce soit la seule. Amen.*

NEWSREEL. *Le prix de la vie.* 1. — Parce
Mai 1947
qu'elle ne trouvait décidément pas de logement, une jeune mariée se jette dans la Scarpe.

Avez-vous
UN AVENIR ATOMIQUE?

(Annonce de l'*Écran Français*.)

Il reste encore dans l'île de Peloliu
à l'est des Philippines
un groupe de soldats japonais
ignorants de l'issue de la guerre
qui continuent de résister aux Américains

Le prix de la vie. 2. — Parce qu'elle avait fait un faux serment, une lycéenne de Sèvres se jette dans la Seine.

« On va nous appeler les moscoutaires au couvent. »
(Florimond Bonte.)

La production des poissons rouges au Japon a baissé de 10 % depuis la guerre.

Le prix de la vie. 3. — Parce qu'il n'arrivait pas à remplir sa feuille d'impôts, un ancien contrôleur des contributions se pend.

Le Roi de Grèce est mort d'une thrombose. Il est remplacé par son frère, le diadoque.

« Si j'étais roi, je serais rad. soc. »
(Le Comte de Paris.)

Le prix de la vie. 4. — Pendant l'office du Vendredi-Saint, à Mexico, deux frères poignardent le meurtrier de leur frère sur les marches de l'autel, et sont lynchés par les fidèles, dont l'un est tué.

Le prix de la vie. 5. — Parce que son regard ne lui plaisait pas, A.B. tranche la carotide de R.R.

Dans un cinéma de Turin, des bandes de propagande fasciste sont mystérieusement substituées à des documentaires anglais.

> « Si le général de Gaulle revient, ce sera vous,
> monsieur Ramadier, qui l'aurez appelé. »
>
> (J.L. Vigier.)

> Vivants séparés
> le mari et la femme
> se retrouvaient
> pour cambrioler.
>
> (*Libé-Soir.*)

> « *La Résistance a fait place au Résistantialisme.* »
> (Alexandre Varenne.)

Le prix de la vie. 6. — Parce qu'ils ne trouvaient pas de place pour assister à un match de boxe, les gens de Port-Said chargent la police, qui se défend : 4 morts, 100 blessés.

> Jean Cassou a été arrêté comme escroc.
> Il s'agit
> bien entendu
> d'un autre.

L'État a nationalisé les houillères de Trémolin. Sous ce nom, on a découvert l'affleurement qui permettait à un paysan de dépanner ses voisins en charbon.

Le prix de la vie. 7. — Parce que...

> Martine Carol...
>
> Parfum d'amour radio-actif.
> Magnétisé et irradié, ce parfum
> d'amour provoque, fixe et retient
> affection et attachement sincère,
> même à distance.
>
> (Annonce de l'*Écran Français.*)

Le prix de la vie. 8. — En Grèce...

Mai 1947 N.B. — *Nous avons dû constater, en recevant les textes de ce journal, que plusieurs de nos collaborateurs étaient atteints de la fièvre nouvelle que les médecins nomment l'américanite pernicieuse ou perfidieuse. Nous avons préféré grouper les textes qu'ils ont écrits sous l'influence de leur crise. Une récente communication à l'Académie de Médecine signale que cette fièvre, sans rapports avec la crypto-communite, et qui atteint les tempéraments les plus divers, produit un effet très tonique dans les états de langueur démocratique et d'euphorie libérale.*

L'APOLITIQUE DU MOIS I. Moscou, 1er avril

Tout ne va pas très bien au Conseil d'Administration du Monde[1], même à des yeux apolitiques. Les quatre principaux actionnaires n'arrivent à s'accorder, ni sur les querelles de familles qu'ils tiennent à transporter avec eux dans le domaine des affaires, ni sur l'objet précis de leur rencontre, qui est le droit des peuples à disposer des autres.

Cela entraîne d'ailleurs un nouvel aspect de la fonction diplomatique : autrefois, une conférence internationale était une sorte de champ clos, ou des hommes d'État jouaient aux Horaces et aux Curiaces jusqu'à ce qu'un champion remportât l'avantage qui engageait sa nation. Maintenant, le rôle du diplomate oscille entre les uniformes de l'agent de liaison et du facteur, et ses exploits sont ceux de l'huissier. Un ministre n'a plus guère l'occasion d'être véritablement plénipotentiaire que pour apporter la capitulation sans conditions de son pays. Sorti de là, c'est le « courtier » — comme disait déjà Bismarck — ou bien le valet de comédie : « Mon maître me charge de vous dire, princesse, qu'il feint de partir avec l'armée... » Adieu la belle maîtrise d'un Talleyrand jouant le destin de la France sur son audace et son prestige. On le verrait maintenant comme les autres ligoté, gouverné par mille liens qui ne cessent de le retenir en arrière que pour le faire trébucher en s'emmêlant. Il est vrai qu'il dispose à son tour de serviteurs et d'auxiliaires

1. Argus, il ne s'agit pas du journal du même nom, attention !

qui, après son échec, s'assènent encore longtemps leurs arguments. Lorsque, après un certain nombre de ces délégations de pouvoirs, l'écho des grands principes directeurs commence de se déformer et de s'affaiblir, ouvrant peut-être la porte à une entente, un coup de téléphone ou une nouvelle conférence, remontant la file, remet les choses au point, précise à nouveau les motifs inébranlés de discorde, et on se donne rendez-vous au mois prochain.

À vrai dire, on ne voit pas très bien sur quoi porterait l'entente. On se demande par quelle illumination l'U.R.S.S. se mettrait à rêver d'une Allemagne confédérée, ou la France d'une Ruhr inviolable — et par quel jugement de Salomon des positions aussi résolument contradictoires pourraient bien être conciliées. On se demande quelle solution saurait satisfaire des concurrents dont le point de vue en cette affaire est si mêlé aux idéologies, que toute concession serait nécessairement prise pour un signe de faiblesse. On pourrait espérer un accord par malentendu, mais les forces qui président aux malentendus n'agissent pas sans discernement, et les hommes ne sont jamais aussi lucides que pour définir ce par quoi ils s'opposent.

Rien n'est plus criminel actuellement que de crier à la guerre imminente. Mais enfin, on ne peut pas dire que l'exercice *Musk-Ox* et les expériences de Bikini nous endorment dans une sécurité trompeuse, même si l'on nous affirme que l'amiral Byrd s'en va conquérir le fabuleux métal à seule fin de nous approcher des délices de l'Âge d'Uranium. Dans ces conditions, et considérant malgré tout le péril et les aventures d'une guerre par trop perfectionnée, on ne peut envisager, au mieux, que la prolongation indéterminée de l'état actuel des choses, la conservation jalouse des positions conquises et des territoires occupés... Bref, l'avenir de l'Europe ne serait plus que l'homologation à contre-cœur du fait accompli, avec dans la coulisse une hargne et une observation de tous les instants, versant dans une lutte sourde d'influences et de phynances toutes les forces qui auraient reculé devant les armes.

Car un des moindres paradoxes de cette aventure n'est pas l'absence de vaincus. De par leur affaiblissement même, et la disponibilité qui en résulte, les pays de l'Axe européens, dans

la mesure où ils ont le choix entre leurs vainqueurs, se voient pour ainsi dire courtisés, et par l'appartenance sans limite qu'ils peuvent offrir au plus habile, font de leur ruine une sorte de dot. Si bien que dans le règlement final, il leur reste peut-être plus de poids qu'à certains vainqueurs ou assimilés. Et en somme la conférence de la Paix n'est plus un diktat des vainqueurs aux vaincus, mais un partage d'influence entre les uns et les autres, certains se trouvant maintenant dans le même camp (tels les États balkaniques avec lesquels l'U.R.S.S. a signé des traités séparés). Le distinguo des peuples innocents des fautes de leurs gouvernements autoritaires n'aide pas médiocrement cette manœuvre. Si bien enfin que la position des partenaires autour de cette paix n'est pas celle de la guerre qui vient de s'achever, mais celle d'une guerre supposée, comme en mathématiques, pour la commodité du raisonnement — celle de la prochaine guerre, celle qui n'aura pas lieu, bien sûr, mais dont chacun peut imaginer le déroulement.

N'est-ce pas en vertu de cette évolution que les États-Unis, grands vainqueurs en 1945, sont aujourd'hui une nation inquiète, déroutée et comme paralysée? En vérité, il apparaît que leurs succès auprès de l'Europe du temps de guerre étaient dus surtout à l'inexistence de cette Europe, et à la nécessité où ils étaient de transporter avec eux une sorte d'Amérique portative où les problèmes se résolvaient à leur façon habituelle. Maintenant, l'Europe reprenant plus ou moins ses structures propres, l'écart se fait sensible entre deux conceptions du monde réellement étrangères. On sait que la largeur de l'Atlantique s'augmente de quelques centimètres chaque année. Le monde des idées accompagne la fuite des continents, et la dépasse.

Nous n'en voulons pour preuve que les ahurissantes déclarations du président Truman dans *Collier's*, après sa prise de pouvoir, où, faisant le tour d'horizon européen — comme on fait le tour du propriétaire — le premier citoyen des États-Unis se montre incapable de mesurer les réalités d'*overseas* autrement qu'à l'aune américaine. Et de s'étonner que les pays d'Europe ne réalisent pas l'union aussi facilement que ses États (puisqu'en somme il suffirait de réaliser l'unité de

langage, de culture, de mythes, de passé, et la politique serait bien forcée de suivre...). Et de citer Mazzini, Garibaldi, Victor Hugo et — le comble! — Briand. Et de citer la Suisse, comme si un consortium économique pouvait servir de modèle à des nations vivantes.

Il est vrai que M. Truman se déclare dans le même article «profondément convaincu que la forme de gouvernement américaine est la meilleure au monde». Si cette conviction inspire à un chef d'État de semblables puérilités, on en conçoit certaines inquiétudes quant à l'esprit du gouvernement mondial que nous font miroiter les plus représentatifs des États-Uniens — le pôle le plus bas étant représenté par les divagations primaires du Prof. Einstein, qui pacifie atomiquement le monde avec la belle assurance des hommes de science batifolant dans le réel (divagations d'ailleurs allégrement disséquées par Sumner Welles dans l'*Atlantic Monthly* de janvier 1946) — et le pôle le plus haut par les réflexions d'Emery Reves dans son beau livre *Anatomie de la paix*[2], où, concevant très pertinemment l'impossibilité où sont les démocraties de faire résider effectivement le pouvoir entre les mains du peuple, il ne peut pourtant trouver de solution que dans la délégation de cette souveraineté à un gouvernement du monde, par un tour de passe-passe ou une bonne volonté mutuelle qui rendrait presque inutile ce super-contrôle, si un jour elle s'avisait d'exister.

Nous ne doutons pas du désintéressement de ces hommes. Mais n'est-ce pas à leur insu, parce que les États-Unis n'ayant que des relations économiques avec l'Europe ne sont pas intéressés à une évolution proprement politique du continent, qu'ils s'attachent tellement à une consécration de la stabilité qui ne satisferait en fin de compte que leur égoïsme? Ce serait la *Pax Americana*. Ces paix trop longues et trop satisfaites d'elles-mêmes sont généralement inquiétées par un mouvement ou une nation qui rappelle les données de la condition humaine, et que la satisfaction se paye toujours par l'injustice. (Un monde pacifié par la police atomique et le Plan Beveridge ne serait évidemment pas habitable.) Mais ce rappel semble

2. Éditeur, Taillandier.

inopportun et dangereux. Pourtant, il se fait toujours : les vainqueurs n'osent jamais suivre le conseil pratique de Machiavel, qui enjoint au prince de ne laisser en vie personne de la famille ennemie. Alors il subsiste toujours une Antigone, un chrétien, un sans-culotte ou un communiste pour protester contre le prix de l'Ordre. Et si cette liste a l'air d'une dégression, et si la nation qui incarne aujourd'hui cette revendication semble à certains mal venue pour jouer son rôle, c'est qu'en fin de compte la pureté d'une cause dépend de ce qu'elle trouve en face d'elle.

Lorsqu'il s'agit de l'U.R.S.S., la conscience américaine s'émeut et parle d'impérialisme, d'expansionnisme, de visées territoriales, oublieuse qu'elle est de cette période de l'histoire où le monde a semblé se liguer contre elle. Lorsque l'Europe dit « Rideau de-Fer » (d'après une expression tirée textuellement d'un discours du Dr. Goebbels), l'U.R.S.S. peut répondre « Cordon sanitaire ? ». Rien ne peut empêcher que la Russie ait gagné ses bases en Méditerranée, ni qu'elle ait le droit, à la place des bastions dressés contre elle par l'Europe de Versailles, de mettre des gouvernements plus conformes à ses espoirs, même si le régime de Dragoicheva n'est pas idolâtré des Bulgares. Comment la Russie se fierait-elle sans arrière-pensée à ces démocraties qui successivement l'ont mise au ban du monde civilisé, l'ont combattue sur tous les terrains en Extrême-Orient, ont laissé l'Allemagne se réarmer, l'Italie bâtir son empire, Franco prendre le pouvoir, et n'ont pas fini de lui reprocher la manœuvre par laquelle, en 1939, elle a évité de les suivre dans la fossé qu'elles avaient elles-mêmes creusée. On ne peut que voir là une impuissance peu rassurante — à moins que l'on n'admette l'hypothèse d'une vaste conspiration antisoviétique ourdie dès 1919, et pour laquelle tout, même les antagonismes, a servi.

Parvenu à ce point, l'Apolitique tire ses conclusions, qui sont simples. Elles tiennent en trois formules, toujours les mêmes, qu'il place partout et qui collent toujours : « Il n'y a pas de solutions », « Faut pas se mordre le front », « Les choses ont une manière à elles d'arriver ». Tout au plus pouvons-nous rêver un peu sur la manière des choses : ne serait-il pas piquant, par exemple, que ce soit à cette petite France qu'il appartienne

de sortir les trois grands actionnaires du monde de leur cercle vicieux ? Actuellement, elle tient un peu en retrait au Conseil d'Administration, ayant dû vendre la plupart de ses actions pour faire face à de douloureuses échéances. On la tolère cependant dans de justes limites, en raison de services rendus, et quelquefois, quand la digestion a été bonne, on lui fait des politesses. Il faudrait que les maîtres du monde se souviennent d'elle, quand ils distingueront le contour de leurs futures ruines. Il faudrait qu'ils retrouvent, dans leur souci de ne rien laisser perdre, ces vieilles valeurs oubliées qui furent celles de la chrétienté. Il faudrait... Mais il y a des limites au rêve, car il faudrait que tout change, jusqu'à leurs chimères, et qu'au lieu de chercher le paradis terrestre, ils songent à bâtir le monde de l'honneur.

L'APOLITIQUE DU MOIS II. « Dans ma campagne électorale, j'ai dit qu'au mieux de mon activité je serais un gouverneur, et non le distributeur d'avantages politiques, le créateur d'une machine politique personnelle... (Après mon élection) on est venu à moi avec des demandes de faveurs, d'acceptation de candidatures pour certains postes rétribués. On m'a dit qu'on m'avait aidé à être gouverneur et que maintenant on m'enverrait au Sénat des États-Unis. J'ai répondu que je n'avais pas d'autre ambition politique ; que de laisser mon État aussi loin que possible de son désordre social ; que je ne voulais pas aller au Sénat ; que je ne voulais même pas me succéder comme gouverneur ; que tout ce que je voulais était restaurer l'ordre. démocratique dans un trouble gouvernemental qu'on appelait, avec la plus grande indulgence, chaos... Dans les 24 jours qui survirent immédiatement ma prise de pouvoir, la législature de Georgie battit tous les records d'émancipation... »

C'est avec ces intentions qu'Ellis Arnall, en 1945, commentait son travail de gouverneur de la Georgie. Il disait des choses choquantes, telles que « La question dite des races est une question

économique, pas sociale». «Les dix millions de citoyens nègres du Sud ne sont pas plus un problème spécial et séparé qu'ils ne sont une ressource spéciale et séparée... Ils ont droit à être décemment logés, décemment vêtus, ils ont droit à de bonnes écoles, à la liberté économique et à la justice...» Bon.

La fin de l'histoire, on la trouve dans **Life** du 17 février. Les idées du nouveau gouverneur, le caractère de son administration, l'évincement des politiciens, tout cela eut la conséquence la plus morale qui soit: au moment de la réélection, ce fut Talmadge père, Ol'Gene, champion de la suprématie des blancs et ami du Ku-Klux-Klan, qui gagna. Comme c'était un vieillard malade, on s'aida d'un article de la constitution pour faire passer un certain nombre de votes au nom de son fils, lequel se présenta ensuite pour recueillir la succession, et finalement l'obtint. Je renvoie donc les lecteurs curieux au reportage de **Life**, pour assister par l'image aux tripotages des **Talmadgites**, à leur procession triomphale après la victoire, quand ils enfoncent les portes du bureau d'Arnall, quand le garde du corps du vieux Gene, John Nahara, tombe à bras raccourcis sur le secrétaire d'Arnall, quand celui-ci est expulsé de son domicile par la police qui jusqu'alors le servait, quand Talmadge commente ironiquement l'état dans lequel Arnall a laissé la maison, etc. Que ceci serve de pièce au dossier des progrès de la démocratie, quand on la prend au sérieux.

Juillet 1948 NEWSREEL. *En rade de Ville d'Avray, le 1ᵉʳ juin à l'aube*. Pourrons-nous débarquer? Le haut-parleur nous donne à intervalles réguliers des nouvelles du monde, tandis que pour tuer le temps nous plions et déplions la presse parisienne. Le temps n'est que blessé. Il ne s'arrête pas. « L'EX-ROI MICHEL EST DÉCHU DE LA NATIONALITÉ ROUMAINE » dit le haut-parleur. Pareille mésaventure n'arrivera pas au Commodore Charles Drouilly, roi du chapeau, dont les sujets sont plus conciliants. Cet intéressant personnage, nous apprend *France-Dimanche*, fait les beaux soirs de Deauville, où il se balance aux reverbères et se coiffe d'une perruque blonde pour amuser les dames. À retenir pour

Prévert « Ceux qui commodorent ». « L'ORCHESTRE DES ÉTU-
DIANTS DE PARIS VA DISPARAÎTRE FAUTE D'ARGENT. » L'Or-
chestre des Étudiants de Paris ferait mieux de jouer à Deau-
ville pour le commodore Charles Drouilly qui stimule les
musiciens des boîtes de nuit « à coups de pourboires de 10.000
et 20.000 francs » imité par son ami Spiro Catapolis, célèbre
armateur grec... « NOUVELLES EXÉCUTIONS EN GRÈCE »... cé-
lèbre armateur grec, qu'on nous présente dansant la samba à
5 heures du matin. Le commodore est en spencer, Miss Amé-
rique « qui est très gaie » porte une fausse barbe, toutes les
femmes ont le nioulouque et tous les hommes sont milliar-
daires. « ROBERT GARRIGUE AVAIT TUÉ POUR VINGT FRANCS. »
Miss Joan Redder, envoyée spéciale du *Daily Mirror*, ayant per-
du sa robe du soir, est venue à l'Opéra en chemise de nuit. Per-
sonne ne s'en est aperçu. Le comte Stanislas d'Herbemont, lui,
change toutes les cinq minutes de cravate, de veston ou de voi-
ture. (*Aux Écoutes.*) Quelle exagération ! Voilà comment on ali-
mente la lutte des classes... « UN COMMUNISTE BRÉSILEN OB-
TIENT LE PRIX PERON 1947. » On croyait que Peron était
fachiste. Quand on vous dit que ça s'améliore. Le prix Staline
à François Mauriac, le Politzer à Jean Kanapa, et Pierre Bou-
tang viendra réciter des poèmes aux samedis des Lettres Fran-
çaises. Ou bien André Maurois, que voici dans *Life*, en train de
lire ses mémoires chez la Duchesse de la Rochefoucauld...
« MATHÉ, ANCIEN MINISTRE DE VICHY, ARRÊTÉ PARCE QU'IL
FAISAIT LA COUR À SA BOUCHÈRE. ON LUI REPROCHE UN DÉ-
CRET RELATIF À LA CASTRATION DES CHEVAUX DE TRAIT. »
Dans un médaillon, un vieux monsieur aux traits fins, entre
deux dames assez vulgaires, sans doute un des écrivains invi-
tés se rendant au vestiaire... Il y a gourance, c'est le maître
d'hôtel qui renseigne une princesse et une comtesse. Jules Su-
pervielle bâille, le duc de la Force s'est fait des frisoulis dans le
cheveu. Pierre Hervé détourne les mineurs de leur devoir, il se
fait expulser... « Ah, si nous avions un jour
 le charbon de la Ruhr
 que la vie serait belle... » dit le haut-parleur. Hé
oui, au lieu de représenter M. Frédéric Dupont en officier alle-
mand par un truquage photographique... « M. FRAISSINET EST

CONDAMNÉ À 50.000 FRANCS DE DOMMAGES ET INTÉRÊTS »...
M. Fraissinet, par un truquage similaire, mettrait la tête de M.
Frédéric Dupont sur le corps de Tarzan, et personne ne dirait
rien. « QUATRE ANS D'OCCUPATIONS PAR SACHA GUITRY. » Le
premier béatifié de ces quatre ans vient d'être proposé à Rome :
Un prêtre polonais qui avait pris la place d'un de ses compa-
gnons dans la chambre à gaz. On s'occupe comme on peut.
« GUERRE EN PALESTINE. » « Je revis l'image de ma mère... Je
pensai aux êtres qui me sont chers. Je fis un signe de croix et je
partis au combat. » C'est Cerdan qui parle, dans *France-Soir*. Et
Gaston Bénac, dans *Paris-Presse* « au cours d'un ultime round,
qui nous apparut un moment comme devant être le dernier... »
Heureusement que ça n'a pas duré. « ARTHUR KOESTLER DÉ-
CLARE... » Qu'il se taise, Koestler. Bourvil chante à la Radio
« Le Yogi gai », et Raymond Raynal joue « Le Commissaire est
bon enfant ». Qu'est-ce qu'il veut de plus ? Nous pourrons dé-
barquer. Simplement, à la sortie de Saint-Lazare, des inconnus
ont nettoyé la pancarte qui porte ces mots « ATTENTION AUX
CROCODILES D'ENTRETIEN ». On ne sait encore ce qu'il faut
entendre par là...

Romancero de la montagne

I
(Fragment)

Cette rôdeuse nuit qui parle de victoire
Cette chanteuse nue en robe de saison
Cet éclat des écueils dans la tourbe des rêves
Cette frôleuse nuit qui parle de retour

Ne l'écoute pas sentinelle
Ne l'écoute pas

Si par hasard tu l'écoutais
prends garde de ne pas comprendre
Si malgré toi tu comprenais
feins de ne pas pouvoir répondre
Si jamais tu lui répondais
alors garde-toi de la suivre
Et si un jour tu la suivais
ne reviens jamais parmi nous

Va vers les hommes ennemis
ton cœur arraché dans la main
Donne-leur comme un fruit tombé
ton cœur arraché par ta main

Ou lance-leur comme une pierre
ton cœur arraché de ta main
Ou remets-le dans ta blessure
Caillou de la route
lié au cou d'un chien abandonné
ton cœur sera si lourd à ta faiblesse
que tu t'enfonceras avec lui
dans une moite et sombre gloire

Et la rôdeuse nuit chantera ta mémoire

Au fil de la montagne
la peur monte
vêtue de pauvresse
Elle saigne dans les ravines
Elle se prend aux ronces
Elle avance à grand'peine
Loin derrière elle
des troupeaux de cuivre
courent le long du crépuscule
réveillés par l'haleine chaude
de cette heure
qui gonfle au-dessus des bassins
mille montgolfières d'argent

Au fond de la vallée
sonnent les cloches de pierre
des tours s'allument

Ceux qui rentrent
s'entre-demandent
qui est cette femme
à la robe de feuilles mortes
couronnée de roses sauvages
dont le pas dans les cailloux
est comme un animal qui fouille

C'est la reine
C'est la mort
C'est madame sainte Ursule
C'est un insecte masqué
C'est une grenouille brune
C'est la soif
C'est la lune
On ne sait pas ce que c'est

Sentinelle sentinelle
à qui donc es-tu fidèle
quelle est cette bête morte
quelle est cette plainte qu'apporte
la cavalerie du soir

Le cortège s'assemble
dans ce coin de ciel en corail
Sur la peau tendue
battent des tambours funèbres
Les dragons de fumée
perchés au bout des bambous
encombrent tout l'horizon
Les cavaliers
empanachés de brouillard
lèvent des mains gantées de noir
vers les anges pressés au balcon
qui veulent hurler de peur
et ne parviennent à former
que le chant du rossignol
Les anges se pressent en grappes
à la grâce des lances
Chacun a sur la gorge
un mouchoir plein de sang

Le mal de la nuit s'étend
comme une marque de lèpre
Il prend tout le corps du ciel
qui se tord dans son armure
où la rouille découpe de grandes taches
de braise et de silence

Ne l'écoute pas sentinelle
Ne l'écoute pas

N'as-tu pas au fond de ton casque
L'image d'un jardin perdu
Tandis que cette lèpre ronge
le visage blêmi du jour
n'as-tu pas dans tes mains jointes
la forme d'une fleur incrustée
plantée entre les cygnes de marbre
pour la saison d'une fille
À cette centurie de nuées
qui roule sur toi en grondant
quel nom jetteras-tu en face
Quelle branche agiteras-tu
devant ces chevaliers de givre
N'as-tu pas au fond des yeux
un jardin aux fruits de neige
enclos dans les vasques dorées
comme une médaillon liquide

Ne l'écoute pas sentinelle
ne l'écoute pas

Penche-toi penche-toi
N'es-tu pas curieux
de savoir si ce jardin
existe encore
si ces degrés de granit
n'y descendent pas en baignant
dans une source glacée

aux fleurs étendues
où se déploie une plongeuse
claquant ses chevilles humides
sous une jupe d'eau
tandis que les esprits de la terre
frappent des tambourins en cadence

Il suffit que tu te penches
Il suffit d'un seul regard
pour savoir si tu délires
si c'est la peur qui te prend
ou si entre tes lèvres
tu sentiras couler ton nom
comme le seul fruit véritable
qu'un être au monde puisse t'offrir

Laisse-toi guider sentinelle
laisse-toi guider
et maintenant ouvre les yeux
et viens plus près
plus près encore

Au fil de la montagne
descend la peur
vêtue en reine
des lanternes de cristal
autour de son corsage blanc
les mains jointes sur des bagues
Des pointes d'or s'allument
sous la doublure de ses yeux
Elle est riche
Bientôt le sommeil et le repos
la demanderont en mariage
Elle claque des talons
en passant sur les ravines
à son doigt s'écartent les ronces

Elle a deux pierres sur les seins
toutes semblables à des yeux d'homme

La nuit pose des pas étranges
sur tous les jardins de la terre

Cette rôdeuse nuit qui parle de victoire
cette chanteuse nue en robe de velours
cet éclat des écueils dans la tourbe des rêves
cette frôleuse nuit qui parle de retour

II
(Psaume pour un camarade mort)

Toi qui ne m'entends pas Toi qui ne me vois pas
 – Camarade que je n'ai point connu
Toi qui as revêtu cette armure glacée
 – pour descendre sur l'autre route
Ils disent que tu es mort
 – mais j'appartiens pour un temps à la saison des morts
Et c'est ta langue que je parle
 – et c'est toi mon plus proche ami

Pourquoi cette course dans l'aube
 – quelle clameur t'avait appelé
Ne voyais-tu pas ce grand mur de cristal
 – où tu es venu donner de la tête
À quelle rencontre allais-tu
 – Qui te faisait signe de l'autre côté
Pour quelle moisson de fleurs en papier
 – tes mains se sont-elles refermées sur l'herbe?
On a retrouvé sur tes lèvres
 – la pulpe rouge des fruits de la mort
Ta place est vide et les mots qu'on te lance
 – vont blesser les passants comme des balles perdues

Je suis un passant
 – J'ai reçu des mots qui allaient à toi
J'ai bu des larmes qui tombaient sur toi
 – Je t'ai voilé de mon ombre
J'ai tendu mon corps entre une lumière qui t'appartenait
 – et le puits sans fond de ton absence
J'ai séparé ton règne du mien
 – J'ai borné cette mer que tu habites
En t'arrachant aux lèvres d'une vivante
 – je t'ai rendu ta liberté
Alors ils m'ont pris la mienne
 – pour que ces choses soient dites
Tu as vécu là où je vis
 – Tu as suivi ces routes
Le même désir a brûlé devant tes yeux
 – comme une colonne de flammes devant l'armée
Tu as frissonné comme un chasseur
 – à ce cri perdu des trains dans la vallée
Tu as trouvé dans le souffle des collines
 – la même odeur de cheveux dénoués
Et celui qui veille au fond de la nuit
 – pourrait voir nos images rejointes
Marcher du même pas en silence
 – dans un désert de ciment construit par la lune

Ce pas que j'entendais doubler le mien à chaque retour
 – était-ce là ton pas
Étaient-ce tes coups dans la citerne de pierre
 – qu'ils ont refermée sur toi
Clouais-tu un pont de bois creux
 – par-dessus les fumées inertes de la plaine
Ou frappais-tu à la porte des maisons de la nuit
 – sans y trouver personne ?
Es-tu donc revenu de ton voyage
 – La terre est-elle ronde
Aussi pour les enfants des morts
 – et peuvent-ils en faire le tour ?

Pourtant je ne crois pas en toi
 – Ce sont les meurtriers qui reviennent
Je ne sais même pas si tu as combattu
 – ou si tu n'as existé
Que dans ces yeux gonflés comme des oiseaux à naître
 – qui s'ouvrent dans un écrin de larmes
Je ne sais où ton corps est mêlé
 – à la terre de France ou au sable de ses rêves
Qu'importe Je connais ses jambes brûlantes
 – et l'odeur de lait de sa bouche
Et cadavre ou image
 – tu ne peux que rôder comme un pauvre autour de
 [mon repas
Mais tu ne dois pas me haïr
 – Nous avons communié au même sang
Et moi je ne hais plus
 – Je regarde ma haine
Comme l'arme rouillée d'une autre guerre
 – comme la cuirasse ternie
Souvenir d'anciennes campagnes
 – que je ne me revêtirai jamais plus
Ceux qui t'ont vaincu
 – se joignent à leur tour aux morts en lourdes grappes
Et moi à la limite des deux règnes
 – je ne me reconnais plus d'ennemis

Ceux qui sont morts dans la montagne
 – et les autres dans d'autres neiges
Toi qui es tombé en criant un nom
 – que maintenant je sais
Comme une montre brisée
 – qui marque pour toujours la même heure
Ceux qui se sont couchés dans la mer
 – et ceux qui se confonde au désert
Vous tous que nous tirons au bout de la mémoire
 – comme des chaloupes démarrées
Encore liés à notre garde
 – mais que nous ne pouvons plus entendre

Vous tous cavalerie des morts
 – et toi mon camarade
Je vous regarde disparaître comme un vaisseau
 – que je n'ai pas eu la force de prendre
Je reste dans mon île
 – parmi le peuple jaune
De ceux que vous avez délivrés
 – et qui ne vous ont pas suivis
Votre lumière coule encore sur la terre
 – comme une semence inutile
Il n'y a plus assez d'amour
 – pour une vivante et pour un mort

Mais cette vivante que tu appelais
 – moi aussi je l'ai perdue
Ils m'ont entouré d'un mur
 – et toi peux-tu donc sortir?
J'habite la maison des morts
 – pour un temps je suis ton compagnon de chaîne
Seulement tu as perdu toutes les heures
 – et moi je me souviens
Mon cri va de tour en tour
 – il réveille les oiseaux de la peur
Et chaque femme porte un mort
 – qui frappe et recherche le jour.

Toi qui ne m'entends pas Toi qui ne me vois pas
 – Il valait peut-être que tu meures
Que tu deviennes ce signe
 – cette grande découpure de fer sur notre ciel
Cette girouette au souffle de nos prières
 – Pour que ces choses fussent dites
Pour que nous ne connaissions pas de victoire
 – avant de t'avoir oublié.

Juillet 1947.

Février 1948 LES ENFANTS TERRIBLES. Il y a une histoire électorale très connue dans l'Union Française: En Afrique noire, avant un meeting politique, le candidat du... (ici un blanc, rempli genéralement par le nom du parti adverse de qui vous raconte l'histoire)... dépose une noix de coco dans la main d'un nègre, et lui dit: Premier qui parle, laisse causer. Deuxième, fous-y sur la gueule... Puis il monte à la tribune. Malheureusement, le président de la séance tient à dire quelques mots d'introduction, et, c'est le candidat machiavélique qui, se trouvant en deuxième position, récupère sa noix de coco sur la... comme il a dit.

Il y a une autre histoire: Deux jeunes personnes, l'Une et l'Autre, écoutent la radio. L'Une, qui affecte une grande Érudition et un grand amour de la musique, se tient le front avec tous les signes de l'extase, l'Autre écoute un moment, puis lui demande: «Qu'est-ce que c'est qu'y jouent?» L'Une, en soupirant, et après un discret coup d'œil à son bracelet-montre, répond: «Le prélude de **Tristan**. — Tiens, dit l'Autre, je ne me l'imaginais pas comme ça.» Sur quoi la musique cesse et l'on entend: «C'était Wal-Berg et son grand jazz symphonique. Voici maintenant le Prélude de **Tristan et Isolde**, joué par...» Alors l'Autre dit simplement: «Ta montre avance...»

Ces deux histoires me sont revenues à l'esprit l'autre soir, en entendant à la finale des jeux de Radio-Luxembourg le dialogue suivant:

— De qui est le **Discours de la méthode**?

— Descartes.

— Très bien. **L'Anabase**?

— Xénophon.

— Très bien. **Le Maharadjah**?

— Montesquieu.

Ici un certain bruit, des toux, des rires. «C'est une plaisanterie, voyons... Coquatrix...» Puis on passa à la question suivante:

— **L'Esprit des lois**?

186 ETERNAL CURRENT EVENTS

Juillet 1947 ACTUALITÉS IMAGINAIRES. La récep-
tion du général de Gaulle à l'Académie
Française, dans le fauteuil laissé par Philippe Pétain, avait ras-
semblé force pékins aux alentours du quai Conti, par ce phé-
nomène de plus en plus courant parmi les classes dirigeantes,
qu'en termes d'école on nomme maintenant le gallotropisme.
Le chroniqueur mondain d'*Esprit* eut toutes les peines du
monde à pénétrer dans l'enceinte bruyante où la semaine pré-
cédente, caché dans une cagoule en forme de housse, il avait
pu surprendre les préparatifs de la cérémonie. On se souvient
en effet que c'est au tout dernier moment, alors que l'élection
semblait assurée pour M. Jean Rivain, comte du Pape, que le
général de Gaulle fit brusquement acte de candidature, et pré-
vint par la voix des ondes ses futurs collègues qu'il leur adres-
sait le même jour une visite collective afin de préserver tout à
la fois la fidélité aux usages et l'économie de son temps. Une
visite de général ne saurait être qu'une inspection. Aussi l'émo-
tion fut-elle grande parmi les académiciens, qui coururent à
leur poste au moyen d'une voiture de pompiers bienheureuse-
ment disponible, tandis que l'un des derniers élus, M. Gustave
Thibon, grimpant à la grande échelle, sonnait le rassemble-
ment sur une petite trompette de fer-blanc. À l'Académie elle-
même, ils entreprirent de savonner le plancher et de passer les
murs à la chaux, après quoi, les chaussures cirées, chacun se
tint immobile à sa place, son paquetage littéraire bien en ordre
devant lui, tandis que M. Georges Duhamel, secrétaire perpé-
tuel, allait et venait nerveusement, comptant et recomptant les
boutons de guêtres. Puis le général entra, salua, et passa rapi-
dement entre les rangs d'un air impénétrable. Devant M.
François Mauriac, il s'arrêta « Où t'ai-je vu, toi ? » dit-il en lui
pinçant familièrement l'oreille. « La soupe est bonne » ajouta-
t-il après un coup d'œil au dictionnaire, disposé, tout exprès
pour qu'il pût y goûter. Après quoi eut lieu la répétition de la
cérémonie, sa mise au point avant que de la livrer au public : ce
qu'au théâtre on nomme précisément une générale.

Le discours de bienvenue semblait revenir de droit à M.
Marcel Pagnol, auteur de *César*. Toutefois, on jugea que son
immortalité trop récente ne lui permettrait pas de dégager

avec suffisamment de rigueur la position profonde de l'Académie vis-à-vis du nouvel élu. Et l'on demanda au doyen d'âge, Me Pédoncule, de définir cette position, ce qu'il fit avec autant de bonhomie que de brillant :

> « Souvenez-vous, monsieur, dit-il, que nous n'accueillons point en vous l'homme public, non plus que le symbole d'une Résistance dont les échos n'ont guère traversé ces murs, mais le chef d'une armée glorieuse, le rejeton d'une bonne famille, et plus encore que tout cela l'homme qui a déclaré se retirer du forum : rien en effet ne pouvait s'accorder mieux au sens même de notre Compagnie, que cette décision. Entrer ici, c'est renoncer au monde. Nous sommes les grands retraités de l'histoire. Cette ascèse que les Hindous accordent à leurs édiles, l'âge venu, ce droit qu'ils ont de s'en aller vivre en ermites parmi les bêtes sauvages et les oboles du peuple, la France en offre à ses fils les plus méritoires, une république adoucie par son génie, où les bêtes dévorantes cèdent la place au public lettré, et les oboles incertaines à la libéralité de l'État... Ainsi, dans cette salle d'attente de l'Éternité, l'académicien, tournant le dos au tumulte de la place publique, se consacre, par le truchement du Dictionnaire, à cette juste désignation des choses dont Platon faisait la suprême définition de la Vertu. Ne vous étonnez donc point, monsieur, de trouver ici tant d'écrivains épuisés, tant de prélats canoniques, tant de penseurs inoffensifs, tant d'historiens illisibles : c'est que notre but est de réunir des personnalités désormais à l'abri de toute tentation, qui sous l'effet de l'âge, de la maladie ou d'un tempérament particulièrement débonnaire, sont comme anesthésiées et, si je puis dire, désamorcées. Et c'est le bon sens même : ne sommes-nous pas un Musée ? Ne sommes-nous pas la section vivante de ce Musée de l'Homme que baigne le même fleuve un peu plus tôt que nous ? Et ne serait-ce pas une grande imprudence, par exemple, qu'un Musée de l'Armée où les bombes seraient exposées avec leurs détonateurs, et les obus avec leurs fusées ? »

Des applaudissements nourris (bien nourris) récompen-
sèrent l'orateur, qui rentra dans le rang pour écouter à son tour
le général de Gaulle, dont la première tâche, redoutable, allait
être l'éloge de son prédécesseur :

« Le fauteuil	quitter.	bourgeoises
de Philippe Pétain,	Qu'il s'agisse de son	de ce pays,
commença-t-il,	fauteuil	c'est à Nous
Nous ne cacherons	à l'Académie,	et à Nous seul
point qu'il a toujours	qu'il s'agisse	qu'il appartient
été	de son siège	de le relever.
Notre but.	au char de l'État,	Certains même,
Le sens même de	de son poste	*ajouta en souriant le*
Notre	de chef	*général,*
destinée	suprême	prétendent
semble être	des armées	que la place qu'il
de Nous	ou de cette place plus	occupe actuellement
faire asseoir	subtile	Nous est
à sa place	qu'il occupa	d'ores et déjà
dès qu'il vient de la	dans les consciences	réservée… »

Un murmure courut dans l'assemblée à ces paroles, qui se
résolut en applaudissements, dominés par la voix d'une dame :
« Non, jamais, plutôt mourir ! »

« Que si,	séparés,	collègue
poursuivit le général	comme les deux faces	Paul
d'aucuns s'étonnent	d'une	Claudel,
de cette parenté	médaille ?	qui nous a célébrés
après nos luttes,	L'un de vous,	l'un et l'autre
Nous leur répondrons :	Messieurs,	succes-
ne pouvons-nous être	au moins	sivement
proches	ne s'y est pas trompé.	et dans des termes
par la substance, et	C'est Notre	presque
irrémédiablement	éminent	identiques. »

M. Paul Claudel, qui jusqu'alors avait semblé sommeiller,
se redressa avec un sourire aimable…

[Notre typographe, haletant et pris d'un douloureux va-et-vient des deux pupilles, nous demande de poursuivre sa composition sans plus de typographie rythmique. Soucieux de rassemblement, nous l'y autorisons bien volontiers.]

« Et il ne fallait pas s'y tromper, » reprit le général en étendant les bras d'un geste qui lui est familier, et qui est celui-là même du prêtre annonçant que la Messe est dite, « car s'il existe un écart entre nous, s'il existe un écart entre l'appel à la revolte et le maintien de l'Ordre, entre l'exaltation du peuple français et l'encasernement des masses, entre le règne de l'argent et le rétablissement de la chrétienté, cet écart nous unit plus qu'il ne nous sépare, puisqu'il mesure aussi bien la distance entre nos principes et nos actes. C'est la distance même de l'Église à la Communauté, de l'État à la Nation. Et cet écart se résout dans une prise de conscience plus vieille que nous, vieille comme notre foi, vieille comme notre terre, telle qu'elle se résume en ce beau mot français de Contradiction, qui sonne haut et clair, et que des intellectuels fumeux au service d'une ideologie étrangère ont déshonoré sous le nom de Dialectique. »

Février 1947 CHRONIQUE DU FASCISME (*suite*): Paris-Presse, *7 janvier. Un gros titre*: UNE INTERVIEW DE NGUYEN MANH HA: « Seule une nette affirmation de la politique française peut mettre fin à cette guerre fratricide. »

Le lecteur pressé a reçu le coup de marteau à la nuque: il est disposé à lire qu'une personnalité annamite éminente nous conseille le coup de poing sur la table. Vous lisez l'interview: sous un texte savamment atténué, l'ex-ministre d'Ho-Chi-Minh reproche simplement aux Français leurs variations et leurs contradictions.
Ce Soir, *9 janvier, titre deux colonnes*: DEUX SOLDATS D'ANDERS ATTAQUENT UN BIJOUTIER. *Je conseille à l'*Aube *ce beau titre*: « IL A ASSASSINÉ LA RENTIÈRE. IL AVAIT VOTÉ OUI. »

NOUS AVONS UN PRÉSIDENT. Ce n'est ni le couronnement du Louvre, ni le sacre du Printemps. C'est l'élection du Bon Marché. Alors que le moindre roi nègre, le jour de son avènement, revêt son plus beau casque de pompier et se berce trois nuits durant des clameurs de son peuple, alors que le plus indigne satrape au soir de sa victoire est saisi, ne fût-ce qu'un instant, d'un vertige sacré, et s'isole un moment en compagnie des morts pour peser leur héritage, alors que même le Père Ubu fait abattre des chevaux et organise une course au trésor le premier jour de son règne, alors que le prochain empereur de la dynastie Soong fera sans doute ressusciter tout le cérémonial de la Cité interdite, et que le jour lointain où le maréchal Staline aura un successeur il risque d'y avoir du boucan sur la Place Rouge, alors que dans le monde entier, et depuis le fond des âges, une nation accueille dans la joie et la splendeur ce phénomène surprenant qu'est la naissance de son Père, nous avons «choisi le plus brave» comme on a osé l'imprimer. Après quelques conciliabules de bonshommes noirs et gris, on a poussé dehors l'heureux lauréat, comme les petits garçons qu'on fait monter sur l'estrade à la distribution des prix, et comme les petits garçons l'heureux lauréat que l'émotion étouffait s'est effondré en larmes dans les bras de l'oncle Léon. Et puis tout le monde s'en est allé, et les autres petits garçons du pays ont eu un jour de congé, afin qu'eux au moins puissent lier, par le phénomène bien connu du réflexe conditionné, l'élection du président à un souvenir agréable. Après quoi le président et son peuple sont retombés dans la même apathie, la même impuissance. Et nous n'avons connu, ni cette identification au pouvoir que chaque Anglais possède et qui lui fait ressentir comme une affaire personnelle chaque geste de son roi, ni cette rénovation du sacré qu'ont inventée les Américains où les émissions de radio, les kilos de papier déchiré dans les rues et les orgies de coca-cola tiennent respectivement la place des oracles, des pluies de roses et des libations. Et cette laideur, cette laideur agressive des hommes politiques, cette preuve écrasante qu'ils ne pouvaient rien faire d'autre, que nulle beauté ne pouvait leur être familière, que nulle tentation ne trouvait la faille par où les détourner de cette entreprise absurde et dégradante de gouverner. Il faudra

la payer, cette défenestration du sacré. Et c'est peut-être la prescience de l'addition qui détermine leurs larmes et leurs embrassades. Il ne convient pourtant pas de s'exagérer les périls : pendant très longtemps, le peuple français s'est reconnu dans ses rois, s'est réjoui de leurs joies, s'est affligé de leurs peines. Quand il a vu qu'au fond ce n'étaient pas des cocos très intéressants, il les a trucidés. M. Auriol, lui, ne craint rien : il ne peut pas nous décevoir.

Avril 1947 *On le voit, chacun a sur l'événement l'ouverture que lui permet sa place, et les hommes sincères du premier et du douzième rang, s'ils n'en sont pas encore à se haïr, bifurquent un peu de l'entendement. Pour moi, j'avoue qu'il m'est impossible de prendre parti : l'argument «Breton au Figaro» vaut bien «Tzara au Panthéon», la Sorbonne n'est après tout qu'une université, pas si différente de ces universités américaines où Breton s'excusait de parler aux jeunes, et il n'est guère plus drôle de voir le Vieux de la Montagne surréaliste s'offrir aux quolibets des analphabètes du Quartier latin, que d'entendre Dada réciter son catéchisme tout neuf sous l'œil sévère et naïf de ses jeunes directeurs de conscience. Tout cela n'était pas très sérieux, mais comme le faible poids de ces fantômes diminuait encore, en face du masque abimé d'Antonin Artaud, debout au fond de la salle, qui portait sur le visage la marque de ces années passées à refuser le monde que Breton rêve — et Tzara parle — de transformer.*

Du jazz
considéré comme une prophétie

J'ÉTAIS SEUL L'AUTRE SOIR dans la salle du Conservatoire, ou presque seul... C'était grand pitié. Mais les filtres successifs d'une semaine troublée, d'une distribution électrique incertaine, d'une lassitude généralisée et d'une publicité insuffisante ayant retenu la plupart de ses auditeurs en puissance, c'est devant une salle presque inviolée que Boris Vian, entretint le public de « Travail et Culture » des positions, propositions, figures et paraboles accumulées en cinquante ans de jazz, dont cinq ou six de be-bop (voir plus bas, et ne pas s'inquiéter).

Cette défection du public était regrettable. Le jazz naît d'une chaleur animale, d'une sorte de couvaison mutuelle des auditeurs qui doivent se serrer, se superposer, se stratifier, se juxtaposer, s'emboîter, s'amalgamer jusqu'à ce qu'éclate l'œuf commun, générateur d'une volaille piaillante de trompettes et de saxos. La cave des Lorientais, surnommée la Basin Street du Quartier Latin, en est un bon exemple[1]. Justement, Claude Luter, l'animateur des Lorientais, était de la partie, et illustra les définitions du « vieux style » avec une perfection que son orchestre est peut-être le seul à posséder en Europe. Maîtrise

[1]. N.B. Basin Street est une rue de la Nouvelle-Orléans, où ont joué les premiers orchestres de jazz. Les lecteurs d'*Esprit* s'abuseraient grandement en pensant qu'il s'agit de la rue Bazin.

qui d'ailleurs amuse l'esprit plus qu'elle n'engage la sensibilité : il semble incroyable que de jeunes garçons, en 1947, jouent *naturellement* comme on jouait en 1920. Et l'on en vient à les regarder comme une sorte de société des instruments anciens du jazz (où le banjo fait pendant au pardessus de viole, et le trombone surbaissé des attaques du rag-time, à la trompette suraigüe de Purcell et de Hændel) capable d'intéresser, d'instruire et de délasser, mais coupée de l'évolution, du perfectionnement, de la vie même de la musique qu'elle sert. Cette matière musicale un peu criarde, un peu rocailleuse, si nous savons la distinguer de tout le faux jazz qui en exporta les procédés en contrebande, reste quand même liée à des images trop précisément datées (l'époque des jupes courtes, des faux nègres, du charleston) pour nous permettre d'y entrer de plain-pied. Il ne s'agit pourtant pas d'une mode (à la vitesse où progresse le jazz, le terme «démodé» n'aurait pas de sens : telle forme musicale n'a pas cessé d'être une mode, qu'elle est déjà un style…) mais d'un accord, d'un «bain», on serait tenté de dire : d'une culture qui nous exprime ou nous refuse. Et comme on se sent mieux en phase avec le be-bop (toujours plus bas, et pas d'impatience…).

Tout ceci n'empêchait pas la manifestation d'être absolument remarquable. Et après que Claude Luter et ses Lorientais eurent donc rompu la glace, Boris Vian harangua le peuple sur le mode familier et quelque peu farfelu qui fait le charme de ses articles et de ses traductions. Boris Vian, pour les hurons, est un grand enfant prodige découvert par Sartre le bon pasteur, et transhumé en terre littéraire depuis les verts pâturages où il pratiquait le cornet à pistons. Le Cornette Boris Christopher Vian a l'aspect nonchalant et réfléchi d'un lévrier russe qui aurait lu Kierkegaard, la lèvre dédaigneuse de Louis XIV et l'œil enfoncé du prince Troubetzkoi, un front vaste et assez rayonnant d'où les cheveux s'écartent avec admiration, et surtout un charme, une simplicité méritoires chez un jeune homme qui a déjà sa légende. Sa gentillesse arrache les spectateurs à l'étanchéité confortable de leurs accoudoirs, et les met en humeur de discuter le coup. Bref, c'est un bon spécimen d'homme bebop (encore plus bas, mais soyez sages).

Avant de nous dire ce qu'est le jazz, Vian énuméra quelques choses ou gens qui n'en sont point. Car il est effarant de constater la confusion qui règne dans l'entendement de fort braves gens, bons musiciens par ailleurs, qui défailleraient à la pensée de mettre sur le même plan Beethoven et Vincent Scotto, ou Josquin des Prés et Léo Delibes, et pour qui le « Jazz » est pêle-mêle : Duke Ellington, Glenn Miller, Jack Hylton, le Ragtime de Strawinsky, la Rhapsody in Blue de Gershwin, le Quintette du Hot-Club de France, Peter Kreuder, Al Jolson, Bing Crosby, Louis Armstrong, Yvonne Blanc — pourquoi pas Charles Trenet ? — pour ne rien dire de l'orgue de cinéma, de cet inceste musical qui se baptise « jazz symphonique », ni des gens qui prennent le swing pour une manière de s'habiller. Jusqu'au cher Roland-Manuel, grand prêtre de l'initiation à la musique, qui lors d'une récente émission définit le Blues, construction harmonique précise, comme « l'adagio du jazz » ! Quadruplez le tempo d'un blues, Roland-Manuel, il ne cessera pas d'être un blues, et — comme chacun ne sait pas — le boogie-voogie n'est autre que le blues classique appuyé sur un nouveau rythme. Maintenant faites subir le même traitement à un adagio, on verra ce que vous obtiendrez ! Mais je m'égare : après cette énumération jointe à quelques définitions assez piquantes (telle Yvonne Blanc, qui « n'a jamais vu un piano qu'à travers un brouillard »...) l'avocat passa au déluge, c'est-à-dire à ce voyage d'Amérique que les vaisseaux des négriers, comme autant d'arches de Noé, firent accomplir aux races d'Afrique, et aux musiques y adjacentes. Sur ces origines africaines du jazz, Vian fait siennes les théories de Hornbostel et de Borneman, qui ont découvert sous l'écorce apparemment rudimentaire et primitive du tam-tam et du chant noir une complexité, une science qui dépassent de loin le seul élément rythmique auquel des oreilles européennes tendraient à les réduire. C'est ainsi que, dit Borneman, « le langage du tam-tam de l'Afrique occidentale n'est pas une sorte de code morse primitif, mais une reproduction phonétique du son des mots »[2] « Ainsi, langage

2. Ernest Borneman, «Les racines de la musique américaine noire», *Jazz Hot*, décembre 1947

et musique ne sont pas rigoureusement séparés, et le standard moyen du talent musical est extraordinairement élevé. Le tam-tam, le chant et la danse sont pratiqués par tous. Les enfants apprennent à discerner les subtilités du rythme, de la mélodie et de la couleur locale comme éléments de leur langage. Faire de la musique demande un peu plus d'habileté, mais n'est jamais considéré comme un art. Les plus habiles musiciens sont les guerriers et les sorciers...» La survivance de cette musique en Amérique, sa rencontre avec de nouvelles conditions de vie et de nouveaux instruments, donnera le jazz. Il s'agit donc de bien autre chose que de superposer, comme le croient quatre-vingt-dix-neuf pour cent des meilleurs esprits, la musique populaire américaine à je ne sais quel trémoussement ancestral venu d'Afrique, et qui serait son seul apport. Le petit père Boris a d'ailleurs son idée là-dessus (et s'il ne l'a pas développée dans sa conférence, j'espère ne pas le trahir en en faisant état): si cette musique africaine, quelle que soit sa complexité, semble du moins se refuser à toute acquisition extérieure, si elle nous paraît indifférente à nos propres idées de l'harmonie et de la mélodie, c'est qu'elle n'en a pas besoin. En deçà de ses limites apparentes, en dehors des éléments décrits par Borneman, que nous avons du mal à analyser, mais que nous percevons, il en est d'autres que nous ne percevons même pas, alors que le noir les entend clairement. Il demeurera donc fidèle à cette forme faussement rudimentaire de la musique, qui lui donnera d'aussi complètes satisfactions, et sonnera à ses oreilles comme fait aux nôtres l'orchestration la plus recherchée. On a cru longtemps que les poissons étaient muets. On sait maintenant qu'ils communiquent par ultra-sons. Et de même qu'un plongeur béat considère sans émotion les poissons qui l'enguelent à voix trop haute, l'Européen cultivé regarde avec pitié le noir à son tam-tam, qui écoute l'équivalent d'un concerto brandebourgeois, ou l'une de ces «fugues polyrythmiques à douze parties» dont parle Borneman, et qui vous font rêver... (Exceptionnellement, il n'est pas question du be-bop en cette fin de paragraphe, mais patience, ça vient...)

Le point zéro de ces coordonnées du jazz, Afrique et Amérique, on peut le fixer approximativement dans le temps,

et avec certitude dans l'espace : la Nouvelle-Orléans, dont Vian fait remarquer justement qu'elle était l'un des principaux centres de fabrication des instruments à vent, et qu'un quartier réservé particulièrement prospère (c'est le cas de le dire) et accueillant, y laissait aux noirs une rare liberté. L'abondance des cabarets, beuglants, bourdeaux et lupanars exigeait la formation de nombreux orchestres, la musique et les mœurs ayant comme chacun sait une étroite correspondance. Et puis il fallait remplacer le phonographe, lequel n'existait point encore. C'est donc à l'ombre des maisons closes et des jeunes dames en fleur que le jazz vint au monde. Certains affirment même que le mot « jazz » ne désignait rien d'autre, à l'origine, que l'acte le plus communément accompli à l'ombre précitée. Et dans ce cas M. André Cœuroy, auteur d'un bouquin époustouflant où il est démontré clair comme la lune que le jazz est héréditairement, consubstantiellement et indissolublement blanc — mieux : français... — et trouve son étymologie dans le verbe « jaser », M. André Cœuroy, dis-je, aurait vraiment bonne mine. Ce quartier réservé fut d'ailleurs fermé et dispersé au lendemain de la guerre, à la suite d'une brise moralisatrice et martfericharde comme il en vient parfois aux nations. Après le déluge, l'exode. Et Vian nous retraça cette épopée : tous les musiciens se rassemblaient dans la rue, à la même heure, et jouant à grand tapage jusqu'à l'embarcadère, chacun suivi de ses bagages, de ses meubles et de ses femmes... On aura une idée assez lointaine de cet épisode légendaire en voyant le film *New-Orleans*, scandaleux par ailleurs, où tout ceci est expliqué, adouci et corrigé comme il convient. Film ingénu, d'ailleurs, qui démontre à son insu comment les blancs, ayant pressenti le merveilleux avenir de la musique de jazz, se mirent en devoir de déposséder les noirs, et de convertir en doublezons (ça, c'est du dialecte Vian) le vague salmigondis de boum-boum et de tsointsoin qu'ils en avaient tiré, quitte à fausser pour une génération l'idée même de jazz. Et voilà pourquoi, les premiers enregistrements datant de 1921, il leur fallut dix ans pour commencer à pénétrer en France, grâce à la fondation du Hot-Club. Et c'est ainsi qu'en 1947 les confusions demeurent, et que la majorité des Européens s'initient péniblement à l'âge classique du jazz,

alors qu'il en est aux prolégomènes de la musique future, avec le be-bop (ça vient, puisqu'on vous dit que ça vient...).

Quelques disques illustrèrent ce survol des grandes époques du jazz. Les derniers, et le trio d'Hubert Fol, nous apportèrent aussi le dernier mot, le dernier cri (on ne saurait mieux dire) du genre: le be-bop (là, qu'est-ce que je vous avais dit?) Be-bop ou re-bop, on n'est pas encore très fixé là-dessus. Les musiciens américains emploient les deux termes, et jusqu'à présent on suppose qu'il s'agit de la même chose, encore qu'il faille se montrer prudent, et ne pas sous-estimer la valeur des préfixes. (Vous vous rendez compte, si on s'était mis à croire que bolchevik et menchevik c'était du kif?) Je n'essaierai pas de vous définir ici le be-bop. Essayez plutôt d'en écouter, ça vaut la peine. En cinquante ans, la musique de jazz a refait le chemin de la musique « classique », l'a rattrapée, et est en train de la dépasser. La formation de jazz traditionnelle séparait nettement la section rythmique des sections instrumentales, et l'une comme les autres, si elles recouraient volontiers à des sonorités étranges, à la dissonance et aux accords transformés, s'appuyaient du moins sur les deux modes classiques de façon très orthodoxe. On sait comment la musique contemporaine a redécouvert, avec un bonheur inégal, les gammes médiévales et quelques autres babioles. Or il semble bien que sur ce terrain, le be-bop la laisse loin derrière lui, et que d'une rencontre entre Gillespie et Leibowitz, ce dernier sortirait pulvérisé. La section rythmique se libère de son rôle de soutien, et joue sa partie. La contrebasse s'éveille à sa conscience de classe, et, au lieu de peiner dans son coin, exploitée par la bourgeoisie des cuivres, bâtit en contre-chant un manifeste des contre-basses. Le piano, qui s'endormait sur sa walking-bass, découpe maintenant l'action par des accords incisifs plaqués à deux mains, ou bien enfile à l'octave de longues phrases inspirées. L'harmonie se libère aussi, et tend vers une atonalité (pardon, une dodécaphonie, pour faire plaisir à Davenson) où parfois elle parvient. Tel passage d'un disque de Duke Ellington, datant de la période prébebopique, faisait irrésistiblement penser à Alban Berg. Et enfin, il y a la nouveauté des thèmes, cette pierre de touche du be-bop, qui s'exprime par ces longues

phrases capricieuses dont je parlais plus haut, serpentant d'une gamme à l'autre avec une espèce de pureté glacée, rompant le rythme en dehors de ses articulations, le tranchant, le déchirant, et pourtant le retrouvant intact à volonté, comme le fakir dévoile intacte la femme qu'il vient de couper en morceaux, et s'achevant en ces boucles, en ces nœuds, en ces retours sur soi-même qui sont les paraphes du style, tracés de temps en temps pour en garantir l'authenticité. Rien de plus insensible que cette musique. Même la douceur y est une construction de l'esprit. D'où, paraît-il, réticences du public états-unien, contre l'enthousiasme agressif des techniciens. Mais comme elle s'accorde à l'époque : dure, intelligente, compliquée, comme la science, comme la poésie, comme l'esthétique, à demi immergée dans une lumière froide qui nous en dérobe une part et construit un hermétisme à rebours : nulle ombre ne la défend, c'est par l'éblouissement qu'elle nous échappe. Avec elle, nous entrons dans cette mince couche du surréel, cet asymptote à la ligne de démarcation du monde où tout nous mène, la courbe des performances sportives comme celle de la désintégration atomique, la vue trouble des impressionnistes, qui ont le nez sur le réel, comme la vue claire des surréalistes qui y pénètrent, et où commence précisément l'*au-delà*... Ce n'est certes pas par hasard que le disque le plus mémorable de cette mémorable soirée, une sorte de catastrophe pour dix-sept instruments due à Dizzy Gillespie, grand maître de l'Ordre be-bop, s'appelle « Things to come » — Choses à venir... Et la Trompette du Jugement jouerait une phrase be-bop, que cela ne m'étonnerait pas tellement...

À cette lumière, on comprend mieux pourquoi certaines formes de notre époque, le jazz, Bikini, la peinture abstraite, la mode, Rita Hayworth, énervent à ce point les gens confortablement installés dans le monde — ou qui voudraient l'être. En voyant le lendemain soir, au ciné-club de « Travail et Culture » (qui n'a décidément d'égale à la richesse de ses programmes que son indifférence à en informer l'opinion publique), les *Assassins d'Eau Douce* de Jean Painlevé, je comprenais aussi pourquoi le mime et la danse féroce de ses insectes s'accompagnaient d'airs de jazz... Tout ce que la peur et l'impuissance

terrent dans les consciences, d'étranges fleurs y prennent racine. À ce monde dur et fragile, asservi à toutes les forces et prodigieusement maître de sa destruction, l'Art ne peut plus apporter de réponse qu'en se niant, en faisant des tableaux avec du papier collé, de la musique avec des chocs et de la poésie avec des lettres. Il reste la science, le hasard, il reste le jazz pour en exprimer avec certitude l'ordre, les formes déchirées, la couleur et les cris.

Juillet 1948.

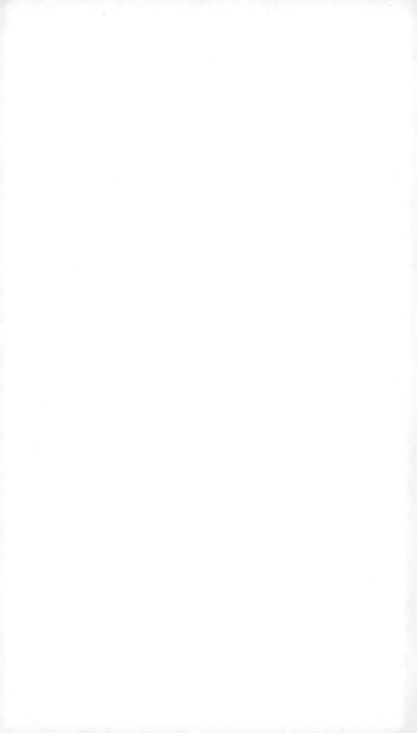

Novembre 1947 SARTER NOSTER. Pendant la guerre de 1914, on déposait en avant des lignes de petits rats en cage, pour détecter l'approche des gaz asphyxiants. Il semble que l'écrivain engagé, sauf le respect que je lui dois, se soit dévolu ce rôle héroïque, et que le sens de son engagement (volontaire) soit précisément de mettre au service de l'action la sensibilité et le flair dont sa nature d'écrivain a le privilège, en face des antennes rudimentaires du technicien et du politique. Toujours est-il que Jean-Paul Sartre a été le premier à réagir violemment et publiquement (librement aussi) à ces senteurs mêlées de lavande et de naphtaline qui s'élèvent depuis deux dimanches des prairies de France.

Cet hommage rendu, on peut avouer que l'émission qui a fait tant de bruit était assez faible. L'eût-elle été davantage d'ailleurs, que cela n'eût rien changé à rien : il y a beau temps qu'en notre pays d'exactitude les faits n'existent plus. Ou plus exactement, ils sèchent au milieu d'un concert de miroirs brandis à bout de faucille, de flèche, de sabre ou de goupillon, et de se voir ainsi jugés, prouvés, niés ou justifiés en image, sans personne qui s'intéresse à leur pauvre mais honnête existence de faits, ils finissent par douter de leur propre réalité, et s'évanouissent à leur tour dans un au-delà d'où il n'est pas certain qu'un historien dégagé aille un jour les déloger. Pour s'en persuader, il suffit de considérer un quart d'heure avant chaque repas cette évidence : si Sartre avait commencé ses émissions politiques en attaquant les communistes, ce sont les journaux de droite qui auraient brandi l'étendard de la liberté totale d'expression, et l'*Humanité* qui aurait crié au scandale.

Car le fond de la querelle ne réside pas dans le contenu réel de l'émission, où Sartre avait beau jeu de clouer le bec d'un gaulliste peu convaincant incarné par Chauffard : il semble même qu'il eut été de bonne guerre de laisser un peu d'avance à l'adversaire, et de le régler plus sûrement après l'avoir doué d'une certaine astuce, alors que le personnage fabriqué à cette fin paraissait plus bête que nature – si c'est possible. Mais on voit ce qui a déchaîné en quelques heures l'indignation d'une population bourgeoise enivrée de sa victoire et de son apparente impunité : l'assimilation faite par un des collaborateurs

de Sartre, et que tous les Parisiens ont pu faire plus ou moins ingénûment, à savoir que sur ses affiches électorales, M. de Gaulle avait la gueule d'Hitler. Cela ne se discute pas. Dans la même journée un crieur de journaux (du *Monde*, qui plus est), un ivrogne fieffé, un pharmacien de première classe, et un économiste distingué m'ont dit la même chose, sans que rien n'indiquât clairement qu'ils s'étaient concertés à l'avance. Comment s'en étonner, d'ailleurs : il existe dans ce domaine une sorte d'obscure attirance qui fait ressembler certaines affiches à ce qu'elles craignent le plus de ressusciter. On se souvient de l'affiche antiaméricaine du temps de l'occupation, ou Fiorello La Guardia avait la tête de Laval, et de cette affiche du Parti Communiste, l'une des premières dans Paris libéré, qui était décalquée sur une page de *Signal*. Là comme ailleurs, la magie se rattrape, et réalise en sous-main ces mystérieuses alliances qui font les affiches du R.P.F. et le lapsus freudien.

Le scandale et le divertissement résident donc beaucoup moins dans l'émission elle-même que dans ses à-côtés : Bénouville et Henry Torrès qui opposent à Sartre leur goût des gens « normaux et sains », l'*Huma* qui écrit « M. Sartre attaque de Gaulle, seuls les naïfs se laisseront prendre » et surtout *Paris-Presse*. On sait que les journaux, pour rester dans les métaphores d'une philosophie élémentaire, sont semblables au chien de Pavlov : au moindre signe, sans qu'il soit même besoin de leur présenter leur nourriture, ils se mettent à baver. Mais *Paris-Presse* se surpasse :

> Au cas ou l'émission aurait été réalisée *avant la victoire du R.P.F.*, on pourrait considérer que la diatribe de M. Jean-Paul Sartre est le fait d'une coïncidence malheureuse. L'audition d'hier soir prouverait alors que *l'ordre ne règne pas à la Radiodiffusion Française* [c'est moi qui souligne, il y a de quoi] puisque aucun responsable ne s'est avisé dans la journée de lundi qu'il était *opportun d'en différer la diffusion*... Si, au contraire, le pamphlet sartrien a été conçu, composé et enregistré dans la journée de lundi, il est alors facile d'*établir la préméditation*.

On a bien lu : dans le cas d'une « victoire » du R.P.F., un organisme soucieux d'« ordre » a le devoir de « différer » toute atteinte à la personne du vainqueur. Curieuse consécration d'une attitude habituellement flétrie sous le nom d'opportunisme. On pourrait supposer là-dessus que *Paris-Presse* la prend à son compte, si d'autres signes non équivoques ne laissaient supposer les puissantes raisons qui décident ce journal à se mettre du côté du manche – si j'ose m'exprimer ainsi.

Une dame indignée et nettement sartrifuge me dit : « Il est si laid qu'il a besoin de s'en prendre aux autres. » Comme j'ai vu la veille cette fausse bande d'actualités que la firme américaine Metro Goldwyn Mayer a fabriquée avec quelques images anodines et un vaste extrait du discours de Vincennes pour servir la propagande électorale du général, et que j'ai encore dans l'oreille les rires des enfants, émus de l'incroyable laideur de ce monsieur, dont les multiples mentons semblent conçus uniquement pour supporter le nez, comme les coussinets d'un arbre de couche – j'ai d'abord envie de rire, moi aussi. À la réflexion, cette phrase m'éclaire. Je me souviens d'avoir lu dans Montherlant qu'un public féminin ayant à choisir le plus bel homme de France, on désigna Jean Bouin, qui était difforme, mais qui incarnait le mythe de l'athlète. Sans doute, de Gaulle incarne-t-il pour beaucoup de dames le principe mâle (une sorte de répons à la Sainte, Vierge, pour ces âmes pieuses et simples) et après tout, un bulletin de vote c'est moins compliqué qu'un adultère.

Reste à savoir ce qui se compose réellement au bout de cette consultation démocratique de la lassitude et de la mauvaise conscience qui a donné au R.P.F. sa majorité. Lorsque Sartre la juge, et il la juge sainement, c'est au nom d'une troisième force, d'un refus d'accepter le choix entre les deux blocs. Mais au fond, qui l'accepte profondément en dehors d'une minorité aux deux extrêmes ? Est-ce que la plupart des électeurs même de de Gaulle ne voient pas en lui un moyen précisément d'échapper au dilemme des influences étrangères, en se réfugiant dans cette France seule, dans ce Pays réel que nous commençons à connaître ? Un des apports du marxisme, c'est cette certitude éprouvée que, quoi que l'on fasse, il n'y a pas de

combat à trois. Les scouts de Ville-d'Avray, les fils d'hommes d'affaires de Neuilly, les dames d'Oloron-Sainte-Marie ne font pas de politique et refusent le dilemme, mais ils portent en chœur leurs voix à de Gaulle. Or, il semble bien qu'il y ait une troisième force : celle qui passe en chacun de nous. Sortis de là, les socialistes irréductibles, les néo-travaillistes français, les M.R.P. forts de la fidélité au néant, les fascistes clandestins pourront bien chercher le tiers chemin, ils déboucheront un jour dans l'une des deux routes nationales. Avec cette multitude de troisièmes forces et l'éparpillement dans l'espace de son ancien empire, joint aux subtiles pénétrations qui s'exercent sur son territoire, la France montre une fois de plus avec éclat qu'elle demeure le pays de Pascal : son centre est partout, et sa circonférence nulle part.

Or, il n'y a plus de centre. Le seul problème est, malgré toutes les tentatives de confusion, le match socialisme-capitalisme. Et tout essai de coiffer cette lutte d'un chapeau ou d'un képi rassembleur et bénisseur est en réalité une aggravation du désordre. Cela revient à joindre artificiellement des éléments liés à l'une des forces en cause, et sollicités par une illusion dont l'abandon les ruine : c'est ainsi qu'on a vu dans le fascisme des gens qui cherchaient la mort du capitalisme et d'autres qui y voyaient son meilleur moyen de survie. Nous commençons à être édifiés sur le culte de ces dieux bicéphales ; le coup de l'Union Sacrée, le coup de l'État français, le coup du Rassemblement, on nous le fait une fois, deux fois... Pour nous, c'est fini. Il restera suffisamment de bonnes familles et de braves cœurs pour marcher aux prochaines sollicitations : la garde meurt, et ne se rend pas à l'évidence.

J'avais un ami qui était possédé de cette passion du rassemblement : un jour, il a voulu rassembler deux fils électriques, il a fait sauter tous les plombs. C'est la pensée de ces ténèbres qui dirige mon sentiment envers le néo-gaullisme, et me fait donner à son chef le grade auquel il a vraiment droit, celui de général de division...

Cette pensée, et cette image, passée rapidement dans le cours des actualités, et qui résume pour moi tout le drame du R.P.F. : Malraux, rêveur, dominant cette foule de Vincennes

dont la moitié au moins était de l'espèce qui offrait des épées d'honneur aux officiers franquistes, du temps qu'il écrivait l'*Espoir*...

Mars 1947 DEUX PETITS NÈGRES. On l'a déjà remarqué à propos du Dakota perdu dans la montagne. C'est au moment où une certaine saturation de l'horreur émousse la pitié que notre société se découvre des trésors d'inquiétude, pour la personne humaine. Ainsi, c'est au moment où des millions d'enfants grecs, hindous ou palestiniens vivent dans le royaume même de la mort, que les députés travaillistes demandent instamment la grâce de deux petits nègres américains condamnés à l'électrocution. Cela me rappelle quelque chose de très précis : le patron qui le jour de sa fête serre la main d'un ouvrier choisi, ému de tant d'honneur, pour que tout le monde reprenne plus allégrement le travail le lendemain.

Mars 1948 LA SCIENCE ET LA VIE. Il circule en ce moment en librairie une curieuse publication. Sous le titre: **Le Da Costa encyclopédique**, fascicule VII, volume II, dans une présentation ma foi très encyclopédique, commençant de façon abrupte en haut à gauche de la première page par un «festations inexplicables» qui laisse supposer une infinité de définitions préliminaires, s'achevant sur la description des extases mystiques de Marie-Ange, et des bonbons y afférents, passant par des définitions qu'on attendait vainement de la science jusqu'à ces jours derniers, telles que «**Hectoplasme** — Ectoplasme dont la masse pesée dans le vide équilibre exactement celle de cent centimètres cubes d'eau distillée», «**Et cætera** — Ce que les parents ne veulent pas dire aux enfants», «**Exagération** — Il n'y a rien d'exagéré», reproduisant pour la première fois à notre connaissance le fac-similé du «Permis de Vivre» dont nous sentions la promulgation inéluctable depuis quelque temps, qui n'est délivré que pour un an et n'est valable que s'il porte le poinçon de contrôle pour le mois en cours, dont l'absence ou l'invalidation entrainera la peine capitale, aggravée pour les étrangers d'une mesure d'expulsion... cette publication, dis-je

(due, avouons-le, à Patrick Wabberg, poète surréaliste célébré par Harold Kaplan dans la **Partisan Review** pour ses combats en Magnésie contre le mauvais esprit Mala-Parth) se présente pour les gens d'esprit droit et de sens rassis comme une bonne plaisanterie — et comme telle, témoigne d'une force et d'un **sérieux** que l'on chercherait vainement ailleurs...

Janvier 1952 — *LE CHAT AUSSI EST UNE PERSONNE. Esprit fit naguère cette démonstration (plus aventurée) au sujet de la femme. Nous aimerions la reprendre au sujet du chat, et à l'occasion de ce salon du Chat qui vient de drainer rue Berryer plusieurs milliers de Parisiens à l'âme tendre. Car la presse était grande, la queue débordait les perrons de l'hôtel de Rothschild comme si un seul gros chat s'y abritait, et le défilé dans les salles, les voix feutrées, les temps d'arrêt, évoquaient les visites aux souverains morts. À moitié morts qu'ils étaient, pauvres tounets, tant de chaleur que d'ennui, que d'hommages. Qui vous trouve mauvaise mine vous rend malade. Qui vous traite en momie vous rend momie. Nous n'avons pas de chats, ce sont les chats qui nous ont. Les chats sont des dieux, la forme la plus répandue et accessible du dieu, cela est hors de discussion. Mais ne pourrait-on mieux comprendre leur discrétion, leur devoir d'invisibilité, l'effort incessant qu'ils font de s'intéresser à des souris, à des pelotes, à des chattes aussi, pour nous inciter à respecter leur incognito de dieux? Cette exposition et ses fastes nous apparaissaient comme une gigantesque gaffe, celle du valet déguisé qui dit à voix haute «Monseigneur» à son maître déguisé. Et ces chats dans leurs boxes, ainsi reconnus, dénoncés, statufiés, somnambules réveillés, sortilèges interrompus, nous offraient l'aspect hébété de Louis XVI à Varennes. Dans les contes, le prince déguisé en chat, reconnu, disparaît. Ils disparaissaient. Par les seuls moyens qui leur restaient en cette prison: le sommeil, la planque. L'un filait en douce, on le rattrapa (c'était un blanc, il tranchait sur le plancher sombre, il maudissait son père). Un autre griffa un mannequin tremblant (bien fait). Un autre se cachait sous les voiles de sa cage. Ils étaient pourtant beaux: persans bleus comme la fumée des cigarettes, fumés sans doute par les siamois voisins, aux nez tachés de nicotine comme des doigts — abyssins au poil court, comme des scouts — russes au poil court, comme des russes — et d'autres, au*

masque de Fantômas, au jabot de Robespierre, au nez de Cléopâtre et le chat bolivien, du genre grenouille-bœuf, dans une vitrine. Mais quoi, les femmes aussi sont belles, et il est relativement mal considéré de les enfermer trois jours dans des cages de verre pour l'admiration des masses. Et cette admiration même, il faudrait l'examiner de plus près. Ignorons les aspects commerciaux, snobs ou bêtifiants de l'affaire. Mais il y a un autre problème, et à peu près complètement escamoté par notre époque, qui est de notre attitude générale envers les animaux. Je serais moins sévère, pour la dévotion au chat, la chambre particulière du roi Karoun et la littérature circonvoisine si je n'y voyais qu'une aliénation de l'homme. Il en est d'autres, et de plus graves. Mais l'animal aussi en sort aliéné, et là ça ne va plus. Je suis sérieux: l'humanité a un devoir de dialogue avec la création. Elle s'en tire passablement vis-à-vis des plantes, des éléments et du Bon Dieu. Mais vis-à-vis des animaux, une déviation la guette à chaque instant: ne plus les traiter en animaux, au nom du devoir de dialogue avec les animaux, mais en substituts humains. La vieille fille et son perroquet, la divorcée et son chat, Léautaud et sa guenon, trahissent l'humanité, ils trahissent l'animalité aussi. L'odieuse formule de nos cendriers, de nos assiettes: «Plus je vois les hommes, plus j'aime mon chien» contient en germe cette amputation de toute une part du monde créé, cette méprise par laquelle je m'appauvris sans enrichir l'autre. Qui pourrait nous sortir de là? Entre l'animal-refoulement, l'animal-bébête, le caniche royal, le singe pitre, le chat d'exposition et l'indifférence hautaine que nous témoigne l'animal sauvage, il y aurait une intercession à ménager. Peut-être serait-ce la tâche d'un nouvel ordre, religieux. Peut-être serait-il souhaitable que cette tendance, naturelle à dialoguer, avec les planètes qui semble saisir l'Église à un niveau élevé de la hiérarchie se consacre, à un niveau plus humble, à la perpétuation de relations simples et pures avec le monde animal — que, nous ayons des ordres animaliers comme des ordres herboristes ou musiciens...

Till the end of time

P AT CORMON VENDAIT des tas de choses froides dans une boutique qui ressemblait elle-même à un frigidaire. Le lendemain du jour V-Japs, lorsque commença cette pluie qui ne devait pas cesser avant le surlendemain, il vint à sa porte pour voir le spectacle.

Les gens se mettaient à courir ou entraient dans les maisons. Le ciel s'était vidé d'un coup, comme un terrain de jeu. Quelque part au-dessus de la tête de Pat, une réclame lumineuse tourneboulait et baignait les façades de gros coups de langue bleue, mouvante, balancée, qui donnaient le mal de mer. Au ras du trottoir, une conduite crevée sculptait des gargouilles d'eau. Petit à petit, un fantôme de ville renversée creusait la rue, et des bonshommes doubles, comme des découpages dépliés, voltigeaient dans le vide.

Jerry apparut dans la boutique comme le monde créé du chaos. Les sept jours de la Création, roulés en boule dans sa canadienne, filèrent à travers la pièce-chaos, dans l'éclairage chaos pointillé de la pluie-chaos, laissant Jerry-Adam en uniforme des Marines, couleur de Paradis Terrestre. L'Éternel, je veux dire Pat, l'accueillit d'assez mauvaise grâce, mais Jerry ne sembla pas s'en préoccuper du tout.

— On l'a quand même finie, cette bonne vieille guerre, dit-il avec satisfaction.

— Nous avions le Droit pour nous, dit gravement Pat.

— Sûr, dit Jerry. C'est une bonne chose, le Droit. Et la Bombe aussi c'est une bonne chose. Deux bonnes choses pour nous, eh, Pat ? Nous sommes un grand pays.

— Un soldat ne doit pas plaisanter sur ces choses, dit Pat.

— Excusez-moi, dit Jerry. Je n'ai pas encore eu le temps d'apprendre comment un soldat se comporte chez les civils. À force de vivre dans les trous à renard, on devient tout à fait renard soi-même. Il va falloir que j'apprenne le langage des poules. Alors je pourrai vous faire la conversation sans vous choquer.

— Dites-donc, sacré fils de...

— Ne soyez pas grossier, Pat. Si les anges vous entendent, ils iront le répéter à tous les gens bien de cette ville, et ils vous retireront leur clientèle.

— Je suis désolé que vous soyez fou, dit Pat.

— J'en suis ravi, dit Jerry.

La nuit tombait. La lessive de lumière continuait, houleuse, de plus en plus écœurante.

— Fichu temps, dit Jerry. J'avais une date au Parc, elle est noyée. J'irai plutôt au Flit Flat. Vous n'irez pas ?

— Sûrement, dit Pat, sûrement que je vais courir par un temps pareil pour entendre un sacré sale nègre baver dans une trompette.

— Je vois, dit Jerry. Vous avez encore des idées sur les nègres. C'est un préjugé, si vous savez ce que cela veut dire. J'en ai rencontré de l'autre côté des mers qui buvaient tout à fait comme des hommes.

— Si vous voulez savoir ce que je pense, vous êtes un type fichu, Jerry, dit Pat. Mon garçon, vous vous êtes mis à plaisanter et à divaguer sur les choses. Vous n'êtes plus bon à rien, si vous voulez savoir mon avis.

— Vous êtes rudement bien comme cela, Pat, dit Jerry. Vous gesticulez devant la vitrine, et la pluie vous allume de tous les côtés, tout à fait comme le singe dans cette bonne vieille chose de Sandburg, vous savez...

Et Jerry se planta devant la porte, dans la lessive de lumière, en déclamant gaîment :

C'était un arbre d'étoiles planté sur la carte verticale du Sud
Et un singe d'étoiles grimpait et descendait dans cet arbre d'étoiles...

— Voilà maintenant votre damnée poésie, grogna Pat, et il lui tourna le dos.

La nuit était maintenant tout à fait tombée. Un flot de serpentins en papier jetés d'une fenêtre, la veille, s'était entortillé autour du bras d'un lampadaire au-dessus de la boutique, et cette branche lumineuse, raturée par la pluie, avait l'air poudrée de la neige phosphorescente que l'on met sur les arbres de Noël.

— C'était seulement un rêve, oh hoh, yah yah, loo loo, seulement un rêve, cinq, six, sept, cinq, six, sept, achevait Jerry dans l'enthousiasme.

— Il n'y a pas un grain de sens dans tout ce que vous dites, remarqua aimablement Pat.

— Vous ne comprendrez jamais qu'il y a des mots qui déboulonnent le monde, dit Jerry très excité. Rien ne tient plus en place, tout à fait comme si la baraque où nous sommes se mettait tout d'un coup en route, tenez, et allait se balader à travers toute la ville.

— Moi j'ai les pieds par terre, dit rageusement Pat. Et vous pourriez parler comme cela pendant des semaines, sans que ni vous ni moi nous ne cessions d'avoir les pieds par terre, et la même rue à la même place, et toute la vieille cambuse autour, jusqu'à la fin.

— Jusqu'à la fin, dit Jerry. Mais justement, il faudra bien qu'elle vienne, la fin. Hein, si la vieille cambuse craquait, hein, Pat ?

Pat haussa les épaules avec exaspération. Il haïssait Jerry, qui venait toujours lui raconter des histoires à moitié rêvées, on ne pouvait pas savoir si c'était sérieux ou s'il se moquait de vous, je me demande s'il trouve tout ça dans les livres ou bien, et le comble, on ne peut pas envoyer promener comme cela un soldat décoré, blessé, et tout. Et cette espèce de malaise qui suivait ses visites, comme si dans ses folies il avait touché en vous une plaie, quelque chose de caché, de honteux, une douleur endormie dont le sens était perdu, mais qui durait, qui durait comme le remords. Et rien que d'y penser, la douleur se réveillait, une espèce d'oppressement, de dégoût, comme si le monde d'un coup perdait sa raison d'être, comme si une femme à votre

côté brusquement se décomposait. Justement, Pat voyait une femme sortir de la pluie, et son visage de morte dans le tournis bleu et violet de la lumière. Sur la porte maintenant, puis dans la boutique, et demandant la permission de s'abriter pendant l'averse. Pat grognait un vague acquiescement, tout pris dans une nausée de lumière violette et de fin de monde. Les gargouilles d'eau prises de hoquet. La branche d'arbre de Noël lustrée par l'éclairage mouvant, vibrant sous cette lueur morte, ondoyante, cette espèce de caresse obscène, veule, obstinée.

— Vous savez ce que j'ai pensé, continuait Jerry plus bas. C'est une chose à ne pas trop dire, mais vous, ça n'a pas d'importance, vous n'y croirez pas. Vous savez ce que nous sommes des tas à avoir pensé, dans les trous à renards et ailleurs ? La seule chose que nous ayons ramenée avec nous ?

— Je ne vous écoute pas, dit Pat. Il appliquait toute sa volonté à ne pas mettre ses poings sur sa bouche, à les garder dans ses poches.

— C'est cela, Pat, tout juste. La fin de la vieille cambuse. Ne me prenez pas pour un de ces cinglés qui braillent que le monde va sauter parce que nous avons offensé l'Éternel. Pas du tout comme une explosion, ou une colère céleste. Quelque chose, si vous voulez, comme... la pourriture. Les villes en cendres, vos jambes et vos mains et la table et les pierres qui se mélangent, qui ne font plus qu'un, comme les chaînes et les pieds des prisonniers. Et une boutique comme la vôtre, Pat, qui se démantibule et avance à travers les rues, jusqu'à la mer.

La femme le regarda avec surprise. Elle avait un beau visage de guerrière du Nord, et une bouche violente, gonflée, brillante de pluie. Le haut du visage était voilé par l'ombre de la porte. La bouche demeurait en pleine lumière, étrangement désarmée et offerte. Depuis qu'il l'avait vue, Pat sentait son souffle se faire plus court.

Jerry semblait avoir perdu complètement de vue la fin du monde et ses prophéties. Perché sur un coin de comptoir, il faisait une imitation de Frankie Boy Sinatra. Dehors, l'éclairage mouvant paraissait plus rapide, plus impitoyable, entraînant les façades dans son manège, tirant la ville à la faire craquer. Pat regardait la bouche de la femme, luisante comme un fanal. Ma

Nancy, chantait Jerry, les mains ouvertes dans un geste d'adoration. Les gargouilles d'eau couleur de vitrail. Sur les lèvres de la femme, la lumière versait sa caresse violette, impure. Pat tremblait. Jerry sauta sur ses pieds, enfila sa canadienne, toujours chantant.

— … Vous ne pouvez lui résister, désolé pour vous, elle n'a pas de sœur, pas une… Je m'en vais au Flit Flat, c'est trop triste chez vous, Pat. Je vous laisse, tâchez d'être correct avec la fille. Adieu, sœurette. Je vous reverrai, Pat. Il plongea dans la pluie, la lumière morte, les façades dansantes. Pat et la femme demeurèrent un long moment immobiles, derrière la vitrine, dans le silence. Et le mouvement frôleur des ombres sur la bouche de la femme, dans une lumière de péché.

Ici se place une chose bizarre. Pat Cormon croyait connaître à fond sa rue et son paysage quotidien. Dans cette ville construite à l'équerre, tout coïncidait, tout s'imbriquait. Lorsqu'on était debout au centre de sa porte, la porte d'en face s'encastrait exactement dans la vitre plus petite. Dans ses heures de désœuvrement, Pat en avait fait plus d'une fois l'expérience, clignant d'un œil, puis de l'autre pour la voir faire un saut de côté. S'était-il toujours trompé, ou était-ce encore un effet de cette sacrée lumière, on aurait juré que la porte, de l'autre côté de la rue, débordait nettement sur la vitre. Pat se mit à cligner des yeux, puis s'aperçut qu'il devait avoir l'air complètement idiot, et s'arrêta. Sacrée lumière.

— Il avait l'air agité, votre ami, dit la femme. Pat regarda sa bouche avec stupéfaction, comme s'il découvrait seulement qu'elle pouvait aussi parler. Elle avait une belle voix lisse, sombre, vivante, comme ses lèvres.

— Je pense qu'il était saoul, dit Pat. Il parlait de la fin du monde.

— C'est intéressant, dit la femme avec un petit rire. Ça m'intéresse même tout particulièrement. Elle appuya son front à la vitre. La lumière monta le long de son visage. La chair autour de ses yeux était un peu plus pâle. Quand elle baissait les paupières, on eût dit deux tombes fraîchement recouvertes. J'avais un ami, qui m'a donné rendez-vous pour la fin du monde. Depuis, j'attends.

«Allons bon, pensa Pat avec haine, voilà des confidences, maintenant.» Et en même temps il regarda de l'autre côté de la rue. Ses yeux se plissèrent. Sacrée lumière. L'autre porte avait encore l'air d'avoir bougé.

— Vous avez une belle voix, dit Pat. Et il s'étonna d'avoir dit cela.

— Oui... Lui aussi me parlait de ma voix. Il disait... qu'elle existait en dehors des mots, comme la musique. Et aussi que l'Ange de la Mort l'appellerait avec ma voix.

— Il est mort? demanda Pat, pour dire quelque chose.

— Même pas, dit la femme. Elle releva la tête. L'ombre retomba jusqu'au ras de la bouche, mordant un peu de la lèvre supérieure. Pat la regardait de biais, le souffle court, et s'apercevait en même temps avec crainte qu'il n'osait plus regarder l'autre porte.

— Il m'écrivait: «Ta voix reste en moi comme une blessure ouverte. Comme une blessure qui m'appellerait avec des lèvres vivantes, avec tes lèvres.» Vous écrivez des choses comme cela, vous?

En l'entendant parler de ses lèvres, Pat s'était mis à frissonner comme une bête qui souffre.

— Non, je n'écris pas des choses comme cela. Je ne pense pas, je ne dis pas des choses comme cela. C'est encore des balivernes, cria-t-il, comme l'autre avec sa fin du monde.

— Oui, dit-elle, et vous n'y croyez pas. Et pourtant...

Sa voix était restée très calme. Et pourtant l'autre côté de la rue n'est plus tout à fait à sa place. Et vous le savez.

Pat se retourna avec épouvante.

— Qu'est-ce que vous dites?

— Et vous n'osez plus le regarder.

Elle baissa la tête. Et de nouveau la montée de la lumière jusqu'à ses cheveux pâles, de nouveau ses yeux fermés, fraîches tombes, de nouveau des morsures mauves et bleues, comme des cernes, sur sa bouche.

Pat sentit que quelque chose dans sa tête devenait dur et se recroquevillait, pendant que tout le reste bougeait terriblement. Il osa regarder au dehors. La porte d'en face était maintenant à la hauteur de la vitrine droite. Elle dérivait encore

nettement. Les deux côtés de la rue glissaient lentement, comme deux vaisseaux se croisant bord à bord. Pat suffoquait de peur. Il entendit vaguement la femme prononcer un nom, un nom de cinéma, le nom d'un cinéma qui se trouvait un peu plus loin, vers la gauche, de l'autre côté de la rue. Il le répéta machinalement, et le répéta encore, à la limite du bafouillement, quand il vit le cinéma lui-même, masse étincelante, carrée, polaire, projeter un grand bloc de lumière blanche dans la décomposition ruisselante de la rue.

— Vous avez peur ? dit la femme.

Alors Pat se met à trembler. Du fond de la nuit, les maisons s'ordonnent et se dressent comme des pans de décors. Elles ont la raideur et la menace des grands lions ailés assyriens. Un mouvement se fait dans la ville. Les démons chargent les façades sur leur dos pour apprêter le spectacle. Le manège écœurant de la lumière violette, mauve, bleue, entraîne tout cela et dirige la marche. Comme un lourd plateau ébranlé, la rue tourne de plus en plus vite. Les fenêtres folles chassent à courre autour du fanal clair, de la bouche de cette femme. L'obsession de cette bouche saisit Pat. Les gargouilles d'eau hoquettent vers elle, guerriers mourants aux pieds d'une femme désirée. La lumière tire les maisons, égare et abandonne les maisons comme des enfants perdus, et s'échappe des maisons pour biffer cette bouche d'un coup de langue rageur et impur, avant que de disparaître. L'Ange de la Mort appelle avec Sa voix. Et du fond des trous à renards, Jerry et tous les morts font des signes aux villes qui passent. On fait de la maison-stop, mais personne ne s'arrête. Pat devine tout ce qui va se passer, la boutique jusqu'au bout de la ville, et puis la mer. Et devant les vitrines, aussi fixes, aussi inertes qu'avant, comme des passants ou des voitures, les phares vissés dans la nuit, les images brouillées des appels de radio, quêtant le secours des étoiles, et les navires glissant en silence sous les fenêtres, dans la buée, marqués au fer rouge par leurs feux. Et cette bouche. Marqués au fer rouge par cette bouche. Les grands navires appelant au secours.

— Les grands navires appelant au secours... dit la femme.

— Écoutez... dit Pat. Je ne sais pas ce que vous êtes venue faire ici...

Il frissonnait. La femme était près de lui, sa bouche chaude et désarmée comme un oiseau mort. Il s'aperçut qu'il n'avait même pas deviné son corps, perdu dans l'ombre et confus dans le mélange des lumières, mais d'où montait quelque chose qui était à la fois une promesse et une menace. Il n'osait pas regarder ses yeux, mais il sentait dans le souffle de plus en plus proche un parfum de corps mouillé de pluie, de fruit mordu, et comme un goût d'anéantissement.

D'un coup, il se jeta en arrière.

— Filez, dit-il avec fureur, je ne sais pas ce que vous êtes venue faire ici, mais filez, avant que... avant que...

Elle resta un moment sans bouger, face à lui, sans même affecter de surprise. Ses mains à lui battaient le comptoir, sans parvenir à se poser. Dehors, on ne voyait plus que le bras du lampadaire, semblable à une branche d'arbre de Noël, étincelant dans la nuit sous le gribouillage de la pluie. Quelque part au-dessus de leur tête, une réclame lumineuse tourneboulait et baignait le monde de gros coups de langue bleue, caresse impure, lente, obstinée.

Et la bouche immobile, dans l'ombre maintenant, comme une bête prête à bondir.

— Filez, répéta Pat.

Elle se retourna, mit son capuchon, posa la main sur la porte. Pat ferma les yeux, entendit le bruit de la porte. Il sortit à son tour, la suivit du regard. La rue était à sa place, les portes bien alignées. Il la suivit longtemps du regard. Elle avançait à petits pas dans la pluie, d'une démarche bien régulière, bien nette, la tête un peu baissée sous le capuchon. Une passante comme les autres.

Pat rentra, tout mouillé. La pluie tombait plus calme, plus droite. Un fantôme de ville renversée habitait la rue. La lumière tournait. Au ras du trottoir, une conduite crevée sculptait des gargouilles d'eau. Pat secoua la tête, comme pour en chasser, avec les gouttes de pluie, les spectres morts et les scories de cette si drôle, si drôle d'époque.

Octobre 1945.

The texts contained in this volume, all of them originally published in the magazine Esprit, *were written by Chris Marker between 1945 and 1952. Gathered together here for the first time, they constitute a portable archive of Marker's reflections on the period. Despite their apparent eclecticism, these texts cohere for their remarkable sensitivity to events that both capture and exceed their own historical moment. One might call these curious morsels—that straddle their own present and other presents still to come and that continued to interest Marker throughout the decades that followed—*eternal current events.

Table of Contents

The Deviant Musician	9
Poles	9
News Brief	10
Cross My Heart and Hop a Train	11
The Dog and the Bread	14
Imported from America	15
The Three Little Pigs	16
The Living and the Dead	19
[And while we wait for a classless society?]	41
[But let's get back to serious matters.]	41
Regarding Earthly Paradise	42
A Lecture by Louis Aragon	42
Imaginary Current Events (1)	44
Eternal Current Events	47
The Separated	49
The Skinny Cows	53

The Fat Cows	53
The Medium Cows	54
Newsreel (1)	54
N.B.	57
The Apolitician of the Month I	57
The Apolitician of the Month II	62
Newsreel (2)	63
Romancero of the Mountain	67
Les Enfants Terribles	77
Imaginary Current Events (2)	77
Chronicle of Fascism (continued)	81
We Have a President	82
[We've seen it, every person has a point of entry...]	83
On Jazz Considered as a Prophecy	85
Sarter Noster	95
Two Little Negroes	99
Science and Life	99
Cats are People Too	100
Till the end of Time	105

Le musicien errant	117
Poles	117
Information	118
Croix de bois et chemin de fer	119
Le pain et le chien	123
Importé d'Amérique	123
Les trois petits cochons	124
Les vivants et les morts	127
[En attendant la société sans classes?]	149
[Mais revenons au sérieux.]	149
À propos de paradis terrestre	150
Une conférence de Louis Aragon	150
Actualités imaginaires (1)	152
Actualités éternelles	155
Les séparés	157
Les vaches maigres	161

Les vaches grasses	161
Les vaches moyennes	162
Newsreel (1)	162
N.B.	165
L'apolitique du mois I	165
L'apolitique du mois II	170
Newsreel (2)	171
Romancero de la montagne	175
Les enfants terribles	185
Actualités imaginaires (2)	186
Chronique du fascisme (suite)	189
Nous avons un président	190
[On le voit, chacun a sur l'événement l'ouverture...]	191
Du jazz considéré comme une prophétie	193
Sarter Noster	203
Deux petits nègres	207
La science et la vie	207
Le chat aussi est une personne	208
Till the end of time	211

Eternal current events would not have been possible without the collaboration of Tânia Raposo, who designed the book, and Julien Van Anholt of ISTI MIRANT STELLA, whose rereading of the texts and translations was as valuable as his input regarding the publication's content and design. A special thanks to Jérôme de Vienne for his comments on the final draft of the translation. The letterpress cover was printed by Milo Wippermann of Ugly Duckling Presse and Mitch Anzuoni of Mercurial Editions.

The text is typeset in *Mercure* by Charles Mazé, published in 2021 by Abyme; *Modale Antique* by Emmanuel Besse, published in 2024 by Formagari; *Produkt* by Berton Hasebe, published in 2014 by Commercial Type and *William* by Maria Doreuli, published in 2016 by Typotheque.